Chillida

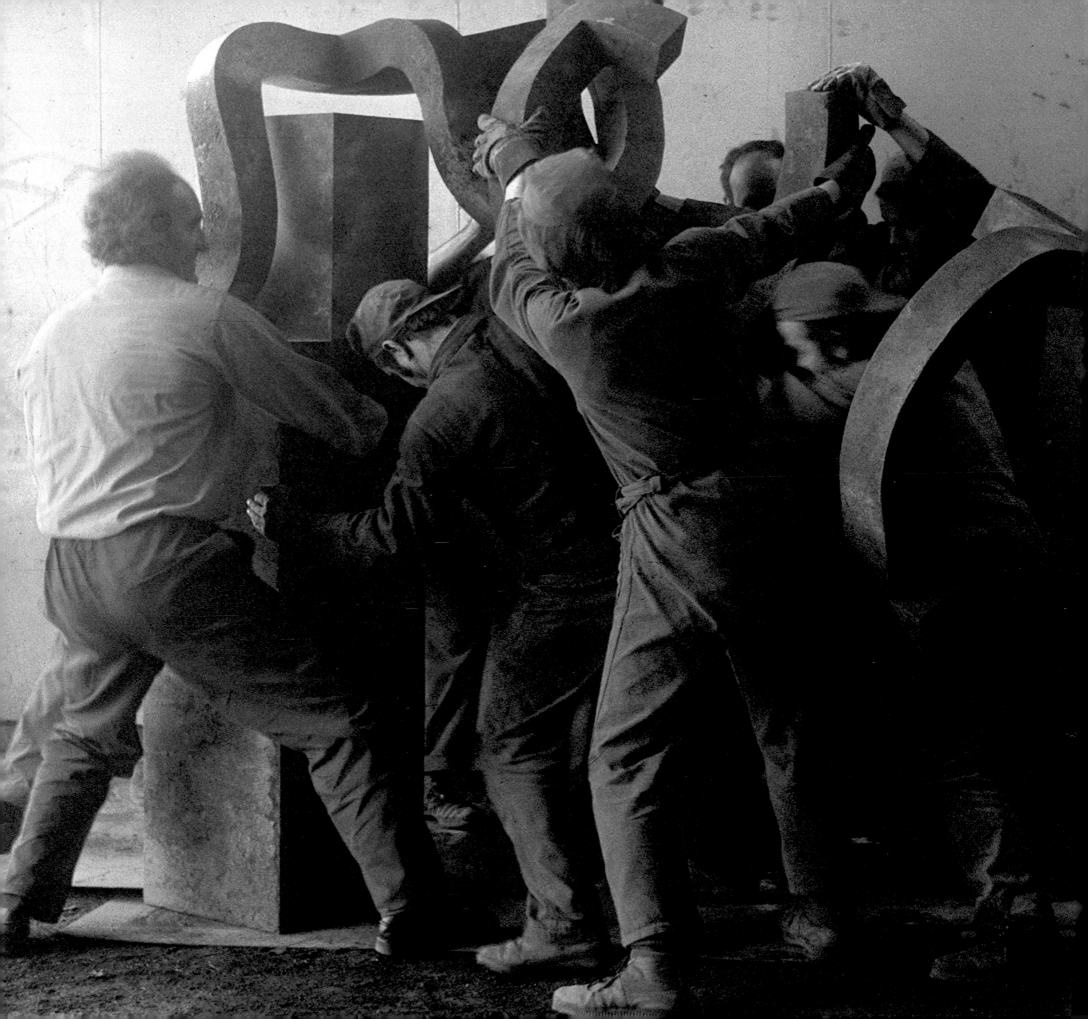

Chillida

Peter Selz

Postscript by
James Johnson Sweeney

Harry N. Abrams, Inc., Publishers, New York
in Association with J. M. Tasende

To James Johnson Sweeney with high esteem

Editor: Phyllis Freeman
Designer: Darilyn Lowe

Library of Congress Cataloging-in-Publication Data

Selz, Peter Howard, 1919—
 Chillida.

 Bibliography: p. 193.
 Includes index.
 1. Chillida, Eduardo, 1924— —Criticism and
interpretation. 2. Chillida, Eduardo, 1924—
—Interviews. I. Chillida, Eduardo, 1924—
II. Title.
NB813.C45S4 1986 730′.92′4 85—20146
ISBN 0—8109—0799—2

Printed and bound in Japan

TITLE PAGE: Chillida helping to install *Stele for
Salvador Allende*

Contents

From Space with its brother Time,
under the pressing heaviness of gravity
feeling material as if it were a slower space
I ponder with amazement over my ignorance.
I work to know. I value learning over knowledge.
I believe I must venture into making what I know not;
Seek to visualize where I do not see;
Strive to recognize what I cannot discern;
Attempt to identify within the realm of the unknown.
Along the unfolding of these processes,
which resemble those of creation in science,
many hardships arise.
We have the hands of yesterday
but we lack those of tomorrow.
I have a conception of the work before I undertake it,
but I do not know,
nor do I want to know at the moment of creation,
how will it be.
I possess many facts about the work in which I am living,
but will not allow this knowledge
to inhibit my freedom nor the breath of the present.
I believe works conceived *a priori* are born dead.
Adventure, as it skirts the unknown,
can at times
bring forth art.

Letter to Peter Selz, October 1984

Preface and Acknowledgments

Although Eduardo Chillida's work is in the permanent collection of many of America's major museums, and he has been honored with prizes, commissions, and important exhibitions in this country, his reputation, until now, has rested primarily on his European renown. Working in his studio in San Sebastián, he continues to pursue his exploration of sculptural form and its metaphysical significance with an extraordinary combination of energy and wisdom. His holistic imagination and understanding of form and space make it possible for him to integrate his essentially private sculpture with architectural and environmental space and to give modern sculpture a meaningful function in the urban fabric. At this time, when some of the creative energy of younger sculptors has turned from land and earth art in remote areas toward urban site sculpture for public use, Chillida's environmental works stand as significant exemplars.

In enumerating the individuals helpful in the generation of this book, I wish, above all, to express my greatest gratitude to the artist himself for his generous cooperation and the many hours he has given me in San Sebastián and Basel during the summer of 1984. I also want to express my special appreciation to Gisèle Michelin, whose attentive devotion to the work of the artist has greatly facilitated the research. I want to thank Pili Chillida for the early and strong commitment she has given to this project and for the patient dedication she has demonstrated throughout.

I have dedicated this book to James Johnson Sweeney, critic, museum director, and pioneer witness of modern art. Mr. Sweeney was an early advocate of Chillida's art, organized the retrospective exhibition of his work in Houston in 1966, and graciously provided the Postscript to this volume.

My sincere thanks are extended to Jose Tasende for his contribution to the organization and development of this undertaking, for providing photographs, and for untiring assistance during the working process. In addition, Mary Beth Hynes and Betina Tasende were extremely helpful in pursuing many of the details.

I wish to acknowledge my gratitude to the University of California, Berkeley, which granted me a Humanities Research Fellowship enabling me to find the time to undertake the research for this document. I also want to express my thanks to Cecilia Gil-Tienda for her help during the research on the project. Sr. Pedro de Sancristoval y Murua, director of the Cultural Council of Álava, was most helpful in providing information regarding the Plaza de los Fueros in Vitoria-Gasteiz. My wife, Carole Selz, not only recorded my interviews with the artist, but was of great assistance in many provocative discussions about the work. Kristine Stiles read the unfinished manuscript and made useful suggestions. The manuscript profited greatly by having gone through the capable hands of two editors, Lorna Price of the University of California Press and Phyllis Freeman of Harry N. Abrams.

To those who have supplied photographs, I want to say that their assistance in providing such excellent material has been a most valuable contribution. I wish to mention particularly Català-Roca, who is responsible for the major portion of the photographs.

Peter Selz
Berkeley, California
November 1985

**Text by
Peter Selz**

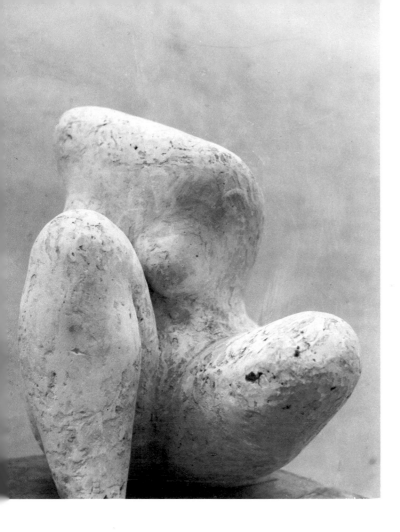

The Significance of Materials and Processes

It was the process of forging iron that first gave Eduardo Chillida full access to his powers as a sculptor. Forging is the method by which metal was shaped when it first came into use some six thousand years ago in the Mediterranean world. Forging also had an important tradition in the Basque country, where the legendary blacksmith Tubal Cain is said to have introduced it about 3000 B.C. With the ample iron mines at the foot of the Pyrenees at their disposal, Basque artisans during the Middle Ages forged iron into suits of armor, into exquisite grill-work, into scythes, harrows, plows. This ancient art of heating the hard metal, bending and hammering it into shape, and drawing it out into space enabled Chillida to give tactile expression to his sculptural concepts.

Time and growth were needed before Chillida had his significant encounter with iron. Born in San Sebastián in 1924, he went to Madrid in 1943 to begin architectural studies at Colegio Mayor Jiménez de Cisneros. Soon his interest in sculpture grew, and in 1948 he went to Paris, where he set to work modeling. He worked in clay, but realized that working with this inert material was not for him. Chillida then began to carve in stone and blocks of plaster from which he chiseled torsos of women and men, sculptures which are remarkable for the initial works of a young artist. *Form* (1948, fig. 1), the female torso, is all curves. Closed and protective, the figure turns in on itself in a body gesture of self-absorption. In contrast, *Torso* (fig. 2), the male figure of the same year, is frontal and erect, vigorous and angular. Just as *Form* alludes to Brancusi's sensuous *Princess X* (1916), *Torso* with its stress on a vertical elongation recalls the older sculptor's *Torso of a Young Man* (1917). But in place of Brancusi's pure symmetry of geometric cylinders, Chillida's carving has a more organic connotation; its shading em-

1. *Form.* 1948. Plaster, 17 × 14 × 14 in. (0.43 × 0.35,5 × 0.35,5 m.). Collection the artist

Quotations from Chillida, unless otherwise attributed, come from interviews with the author, in San Sebastián, May 1984.

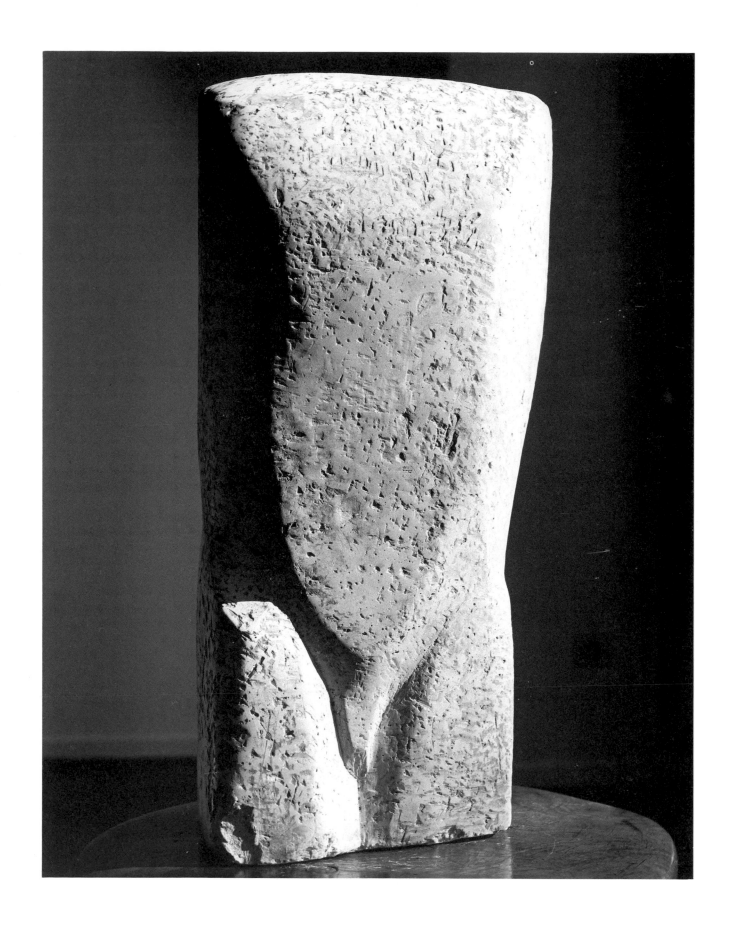

phasizes the loin and the slight indication of an advancing leg. The young sculptor, living in Paris and admiring the antiquities in the Louvre, had a passionate interest in early Greek sculpture, and *Torso*, with its austerity and potential energy, markedly resembles sixth-century Greek kouroi. But Chillida felt intuitively that the deeply admired art of the Greeks was too seductive and he had to follow a different path. "Greek art," he recalls, "was dangerous for me."

Recognition came early to Eduardo Chillida when in 1949, after only one year's work as a sculptor, Bernard Dorival, curator of the Musée d'Art Moderne, in Paris, invited him to exhibit at the prestigious Salon de Mai. Despite his early success, the young artist felt it was necessary to find his own style, away from the daily impact of the Paris art world. In 1951 he returned to the Basque country and began to learn forging from an old blacksmith in Hernani, not far from San Sebastián. It was in the resistant quality of iron that Chillida found his own strength. He needed the challenge to work with matter even harder and more recalcitrant than granite, to gain mastery over the unyielding material. Under hammering, marble or even granite may break or split, but iron can be molded, its hardness submits to fire. The French philosopher Gaston Bachelard observed, "The stone was mass and never muscles. Eduardo Chillida wanted to know muscular space without fat and heaviness. The world of iron is all muscles. Iron is the straight, the certain, the essential force."[1]

After returning to the Basque country, Chillida wanted above all to capture and penetrate space rather than occupy it, and primarily for that reason he rejected working with massive blocks of stone or plaster and turned to a ductile material, iron, which when heated sufficiently can be bent to shoot and curve into space. Chillida learned how to work with the bellows, how to stoke the fire, how to handle the hammer as an elongation of his hand. He imbued his work with a sense of craftsmanship steeped in the indigenous Basque tradition, forging—to paraphrase James Joyce—in the smithy of his country "the uncreated conscience of his race."

Always true to the craftsmanship of sculpture, Chillida has insisted on personally sculpting virtually all of his pieces even when younger contemporary sculptors turned their maquettes over to fabricators. In 1957 Meyer Schapiro noted that

> In a number of respects, painting and sculpture today may seem to be opposed to the general trend of life. Yet, in such opposition, these arts declare their humanity and importance.
>
> Paintings and sculptures, let us observe, are the last hand-made, personal objects within our culture. Almost everything else is produced industrially, in mass, and through a high division of labor. Few people are fortunate enough to make something that represents themselves, that issues from their hands and mind, and to which they can affix their names.[2]

Chillida is one of these rare individuals. He pays a great deal of attention to the working process, refusing to make working drawings or maquettes. Often with only a general design in mind, he launches into the process, develops his thoughts during the procedure, corrects and changes as he works, and permits the shape to grow along its own rhythm. He explains that there is no need to make what he already knows. If he had the work clearly in mind before setting out to do it, there would no longer be a need for making it at all. He would only be copying himself, would be confusing today's work with yesterday's thought. He must create precisely what he does not yet know. Even now that he has assistants and some of his larger pieces have to be made in factories, Chillida not only supervises the work, but feels free to intervene, to make decisions on the instant and make changes on the spur of the moment.

The German philosopher Martin Heidegger has held Chillida's sculpture in high esteem since 1962, when he first learned about his work.[3] Surely part of the appeal for Heidegger was Chillida's sense of workmanship, which corresponds to Heidegger's concept of "truth-setting-itself-to-work"—a process that depends more on the artist's listening to the voice of inner necessity, or his inner truth, than on his creating a work of art through the process of rational decision.

Explaining the dialectic of being both *homo faber* and *homo sapiens*, Chillida writes:

> This force which I detect in wood and iron is merely the beat and rhythm of something which I feel to be immanent. Although I am the one who determines the outer form, I am simply obeying, in and through the form, that necessity which decrees the development of all living forms. When I begin I have no idea where I'm going. All I can see is a certain spatial constellation from which lines of strength gradually emerge. A direction makes itself felt; and sometimes it leads where I have never penetrated before, compels me to take first one new direction, and then another—both equally unexpected....I perceive something that I call, for want of a more appropriate word, the "emanation" of form; I gradually absorb it and as it were inhale it.[4]

But important as artisanship and craftsmanship are in Chillida's sculpture, he explains that "My work is much more concerned with my mind than my hands. I use my hands, but they are not the origin of my work." His most successful work is truly in a state of equilibrium between hand and mind.

Ilarik (*Funeral Stele*, 1951, fig. 3) is Chillida's first work in iron and begins to announce the metal's possibilities in his hands. It is rather simply constructed and appears almost like a geometric configuration, reflecting his early training in architecture. His approach to building is denoted in his work with elemental features such as planes that, like the sides of a building, change their appearance

below: 3. *Ilarik (Funeral Stele)*. 1951. Iron,
29 × 4 × 4 in. (0.73,5 × 0.10 × 0.10 m.).
Collection Ida Chagall, Paris

right: 4. *From Within*. 1953. Iron, 38¾ ×
11 × 16 in. (0.98,5 × 0.28 × 0.40,5 m.).
Collection The Solomon R. Guggenheim
Museum, New York

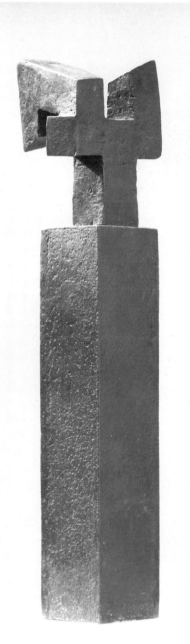

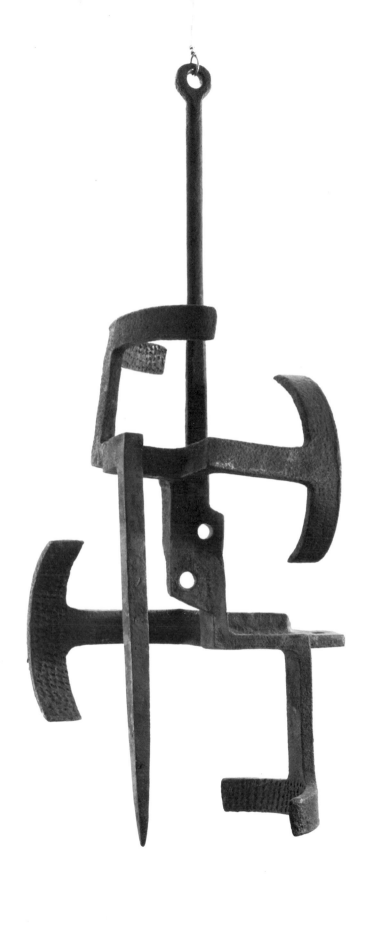

with alterations of light and angle and vision. But even in this very early sculpture, Chillida avoids the tyranny of a rigid angle whenever possible. In its general configuration *Ilarik* assumes his contact with an ancient native tradition—the early Basque funeral steles standing firm and upright in the earth, pointing toward the sky.

Two years later, in *From Within* (fig. 4), the artist's ability to forge iron is no longer tentative. The iron is stretched and penetrates the air with sharp angularity. The work resembles an ancient anchor, but instead of gripping the bottom of the sea, *From Within*, lacking a base and defying weight, wants to be suspended from the air. Released from solid mass, space is center and substance of this sculpture, which points freely to all directions of the compass. *Vibration I* (1955, fig. 5) appears to be made of long nails bent into sharp, aggressive arrows. The sharp points in many of Chillida's pieces of the mid-1950s, reminiscent of fishhooks, scythes, or pitchforks, convey a sense of provocation and struggle.

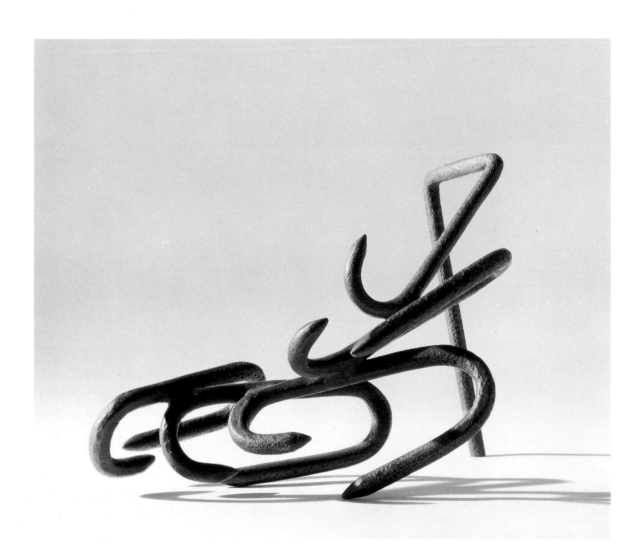

5. *Vibration I*. 1955. Iron, 9 × 14 × 8 in. (0.23 × 0.35,5 × 0.20 m.). Collection Staatsgalerie, Stuttgart

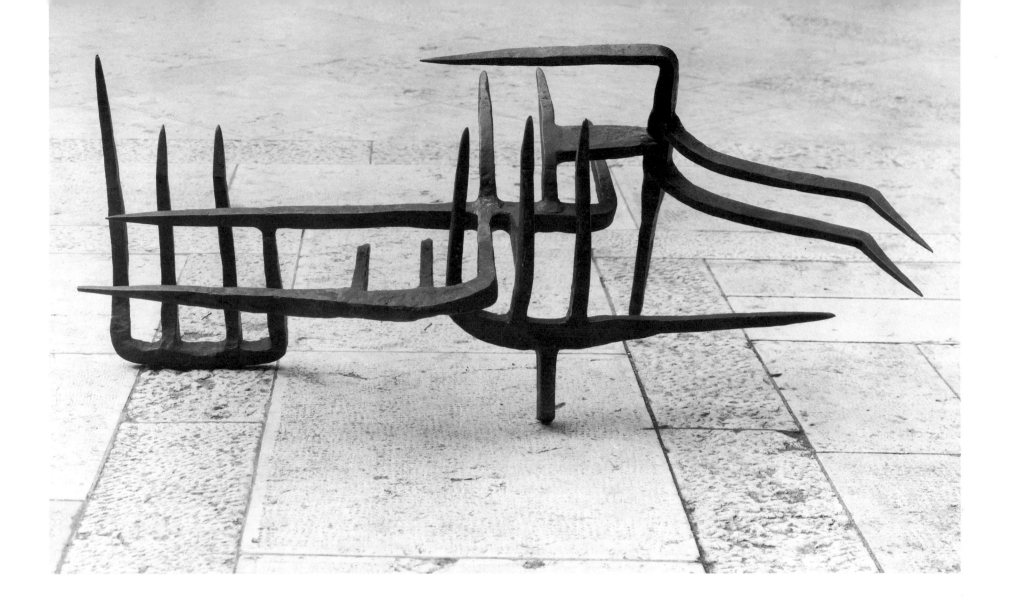

6. *Silent Music I*. 1955. Iron, 25 × 59 × 22
in. (0.63,5 × 1.50 × 0.56 m.). Collection Öf-
fentliche Kunstsammlung, Kunstmuseum, Basel

In *Silent Music I* (1955, fig. 6) and *In Praise of Air* (1956, fig. 7), Chillida
has fully mastered the material and is able to articulate it according to his wishes:

> A piece of iron is an idea in itself, a powerful and unyielding object. I must
> gain complete mastery over it, and force it to take on the tension which I
> feel within myself, evolving a theme from dynamism. Sometimes the iron re-
> fuses to give in. But when I eventually reach my goal I always know; the indi-
> vidual fragments crystallize with a sudden shock and form a whole. Nothing
> can now separate the space from the force which encircles it.[5]

In *Silent Music I* the original hard iron bars remain visible in a brittle state,
but have crystallized into powerful prongs jutting into space. The piece recalls
some primitive musical instrument, perhaps an iron harp or lute, or tuning forks
resounding to eternal tones.

15

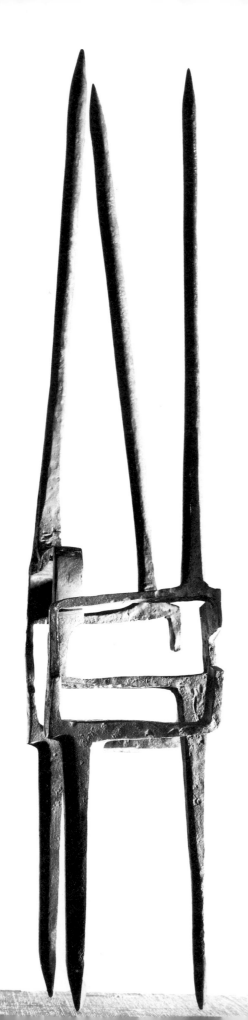

In Praise of Fire (1955, fig. 8) appears like a composition of tongues of flames frozen in an ancient twisted grate, or a well-used but no longer functional implement with some of its aggressive spikes pointing into space, while others seem determined to dig into the ground. Verticality is the essence in *In Praise of Air* (fig. 7) of a year later, which resembles a gigantic three-pronged tuning fork yielding the sounds of air and wind. The center of this extraordinary work is a void—not emptiness, but a space encaged in a spatial structure. Although hardly four feet in height, this work appears like a large and monumental ideogram of energy. Its general configuration seems to predict the monumental wind combs of two decades later.

Chillida frequently works in series, enabling him to focus on certain concepts and directions by making variations on a general theme as it develops, until his particular concern has found resolution. This conceptual structure is clearly expressed in the titles of his work, which often give clues to their meaning. Characteristic of this approach are the twelve variations on the theme of *The Anvil of Dreams*, completed between 1954 and 1962. The words "dream" and "anvil" signify the fusion of material and craft with poetry and vision basic to Chillida's work. This series actually picks up some of the compositional devices first suggested in *Ilarik*. On very high pediments the artist has placed semigeometric forms, but at times the forms claw and clench, or as in *The Anvil of Dreams II* (1954—58, fig. 9), the shapes evoke the sense of a bird in flight—an image which immediately appealed to Georges Braque, who traded one of his works with Chillida to acquire it in 1961. Several sculptures of the series are airy and almost skeletal in shape; others are full of opposing tensions; in some of the later ones the thin ductile rods are exchanged for broader planes (see figs. 10—14).

After the mid-1950s Chillida's forms acquire more breadth. In place of spikes and tusks there are now larger planes and flatter elements, and he is able to extend and cantilever the work far into the surrounding space. The sculptures seem to have more weight and power, and often invoke a sense of great struggle. The broken iron bars move in one direction, then reverse themselves suddenly, creating a feeling of dynamic discord. Yet eventually the clash is resolved. The upward-striving *Gesture* (1957, fig. 15) rises on its taut spine and reaches toward the sky much like a plant striving toward the sun. In the same year Chillida created a horizontal work, which he entitled *Trembling Irons III* (fig. 17), suggesting the agitated and dynamic quality of the metal itself. The parallel orientation of the earlier pieces has now given way to more complex and irregular, contrasting configurations. Perhaps the most successful of all these pieces is called *Articulated Reverie* (*Homage to Bachelard*, 1958, fig. 18). Bachelard, the philosopher who considered imagination and reverie as well as reason to be the creative forces leading toward knowledge and insight, had concluded his poetic essay on the artist by writing: "Since I pinned three photographs of Chillida's work to the corner of

opposite: 7. *In Praise of Air.* 1956.
Iron, 52 × 13 × 9 in. (1.32 ×
0.33 × 0.23 m.). Private collection,
Zurich

below right: 8. *In Praise of Fire.*
1955. Iron, 26 × 21⅝ × 21⅝ in.
(0.66 × 0.55 × 0.55 m.). Collection
Museo Civico, Turin

my bookshelf, I wake up better. I am more alive right away. . . . Old philosopher though I am, I breathe like a smith."[6]

In these works the process of forging remains visible. The blows of the hammer on the surfaces yield a sense of organic vitality to the finished sculptures, which, although suggesting natural forces, are clearly the products of man.

Somewhat similarly composed is the series the sculptor entitled *Rumor of Limits* (fig. 19). Chillida has given much thought to the concept of limit, which is both an end and a beginning, something which cannot be grasped because it is always changing. In time the present is the limit: constantly vanishing, it is the moment between the past and the future. In space the limit is similarly laden with mystery because it cannot be defined, and because of its enigmaticness, it is in

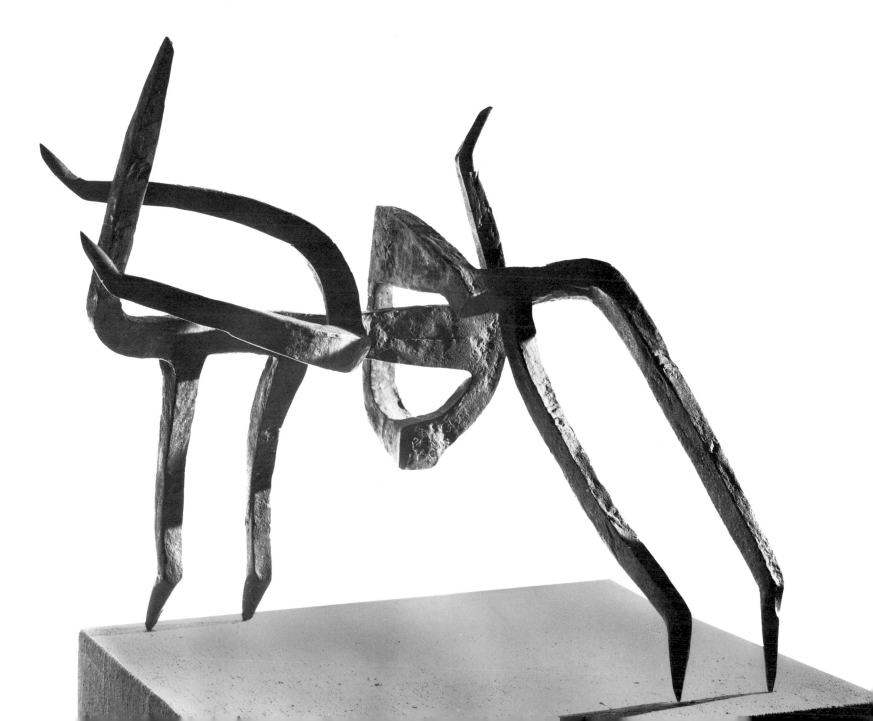

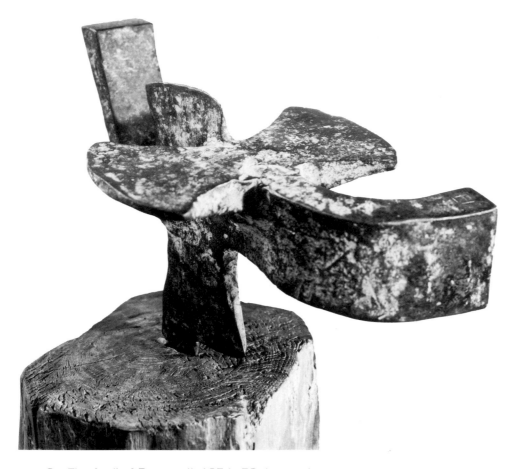

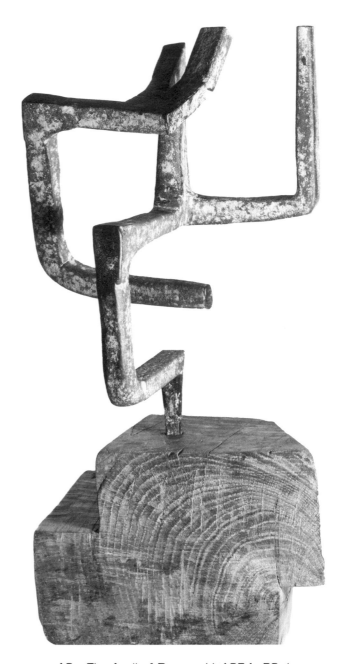

9. *The Anvil of Dreams II*. 1954—58. Iron and wood, 26 × 13 × 7 in. (0.66 × 0.33 × 0.17,5 m.). Collection Claude Laurens

10. *The Anvil of Dreams V*. 1954—59. Iron and wood, 17 × 14 × 12 in. (0.43 × 0.35,5 × 0.30,5 m.). Private collection, Houston, Texas

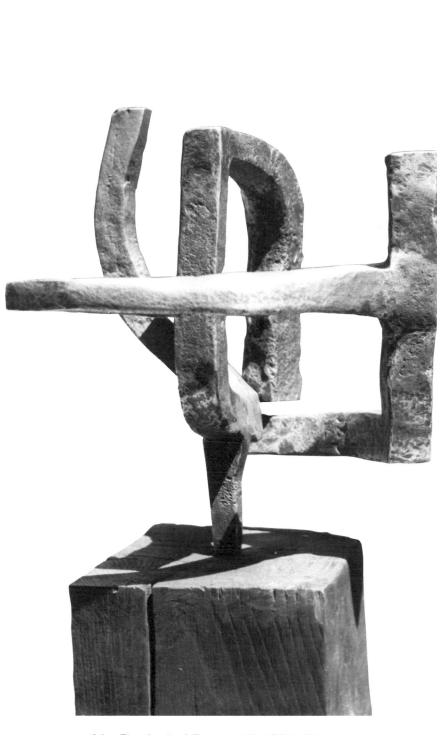

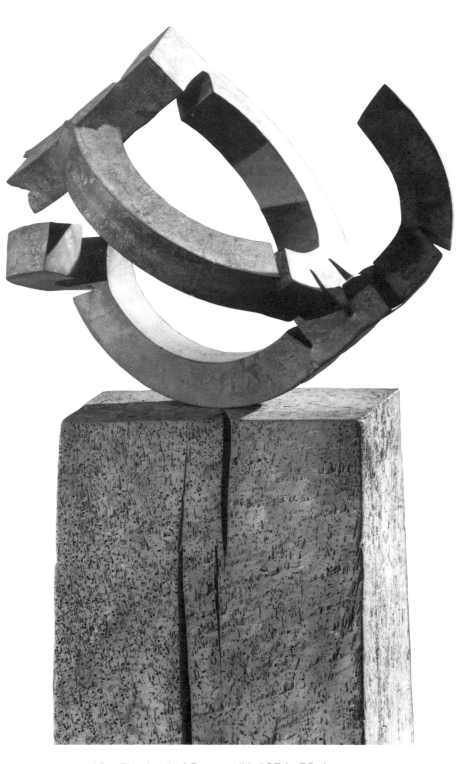

11. *The Anvil of Dreams VII.* 1954—59. Iron and wood, 37 × 19 × 14 in. (0.94 × 0.48 × 0.35,5 m.). Collection Städelsches Kunstinstitut, Frankfurt

12. *The Anvil of Dreams IX.* 1954—59. Iron and wood, 55 × 22 × 13 in. (1.39,5 × 0.56 × 0.33 m.). Collection Kunsthaus, Zurich

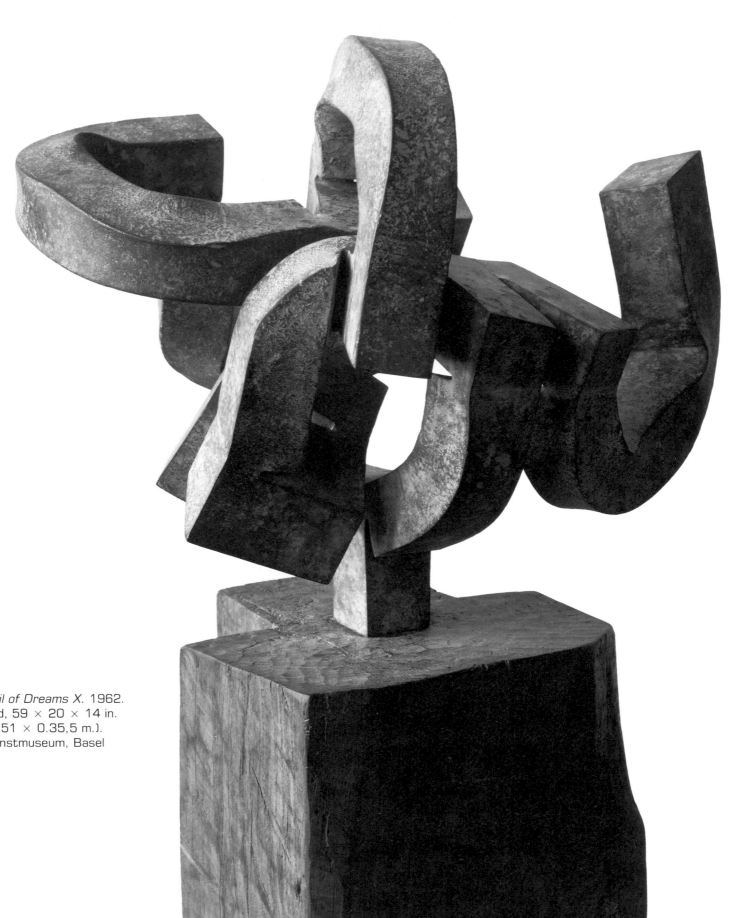

13. *The Anvil of Dreams X.* 1962.
Iron and wood, 59 × 20 × 14 in.
(1.49,5 × 0.51 × 0.35,5 m.).
Collection Kunstmuseum, Basel

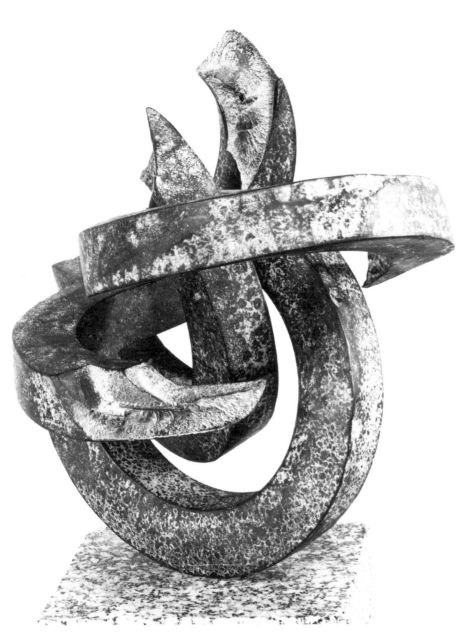

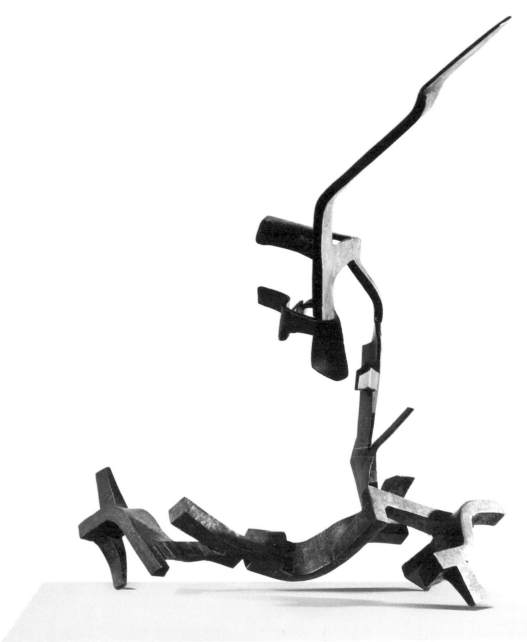

14. *The Anvil of Dreams XI*. 1962.
Iron and granite, 28½ × 5½ × 9½
in. (0.72,5 × 0.14 × 0.24 m.).
Collection Munson-Williams-Proctor
Institute, Utica, New York

15. *Gesture*. 1957. Iron, 20 × 37 × 17 in.
(0.51 × 0.94 × 0.43 m.). Collection Galleria
Nazionale d'Arte Moderna, Rome

right: 16. *Trembling Irons I.*
1955. Iron, 9 × 15 × 13 in.
(0.23 × 0.38 × 0.33 m.). Col-
lection Juan Huarte Beaumont

below: 17. *Trembling Irons III.*
1957. Iron, 11 × 28 × 16 in.
(0.28 × 0.71 × 0.41 m.).
Private collection, Madrid

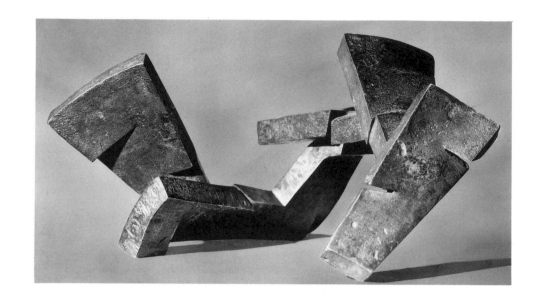

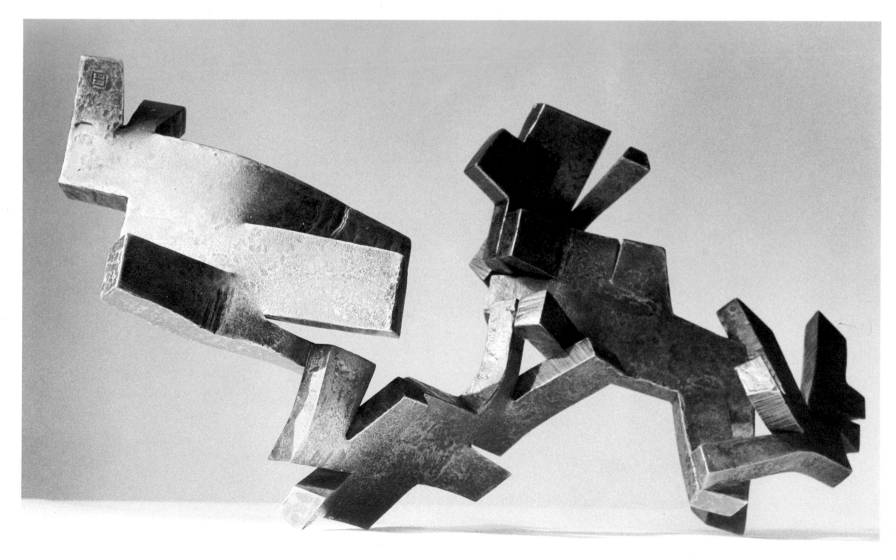

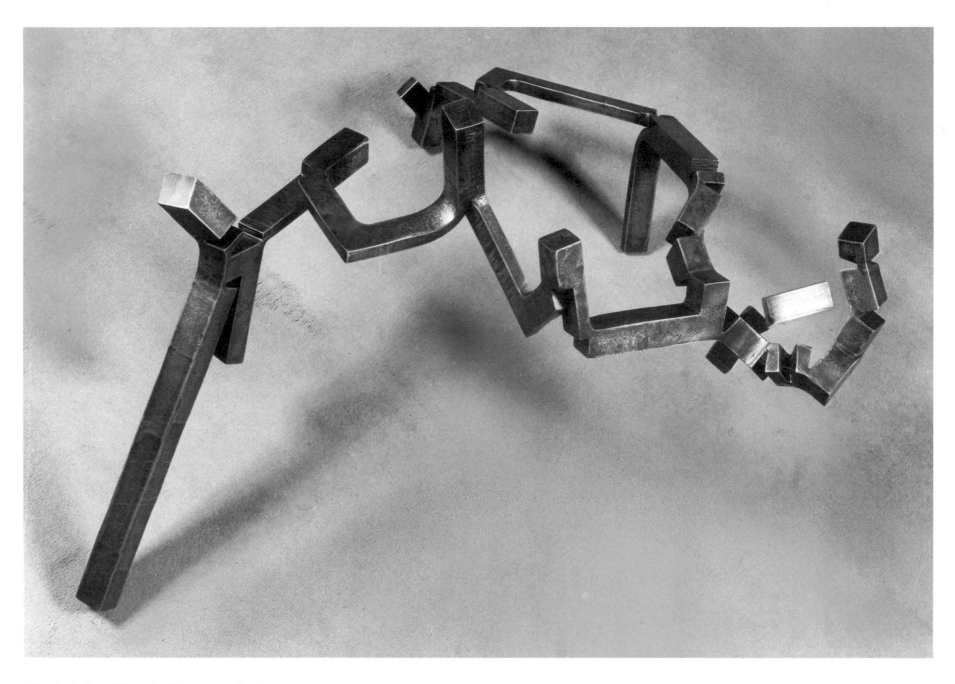

18. *Articulated Reverie (Homage to Bache-lard)*. 1958. Iron, 15 × 33 × 19 in. (0.38 × 0.84 × 0.48 m.). Collection Arthur E. Kahn

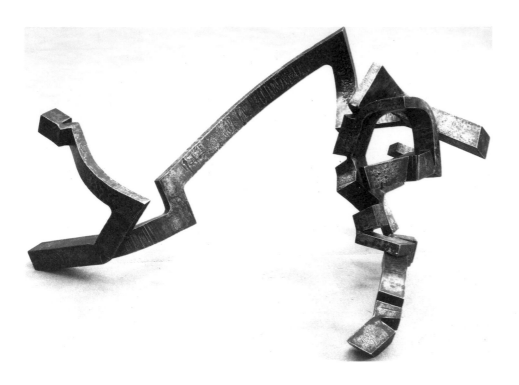

19. *Rumor of Limits III*. 1959. Iron, 36 × 45 × 30 in. (0.91,5 × 1.14 × 0.76 m.). Private collection, Los Angeles

20. *Rumor of Limits IV*. 1959. Iron, 41½ × 37 × 30 in. (1.03 × 0.94 × 0.76 m.). Collection Washington University, Saint Louis, Missouri

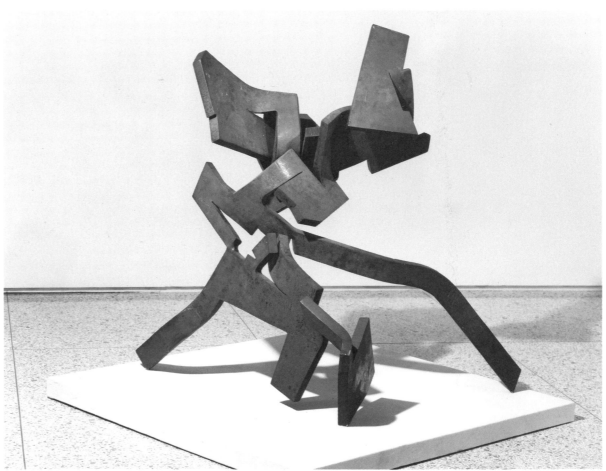

21. *Wind Comb II*. 1959. Iron, 12 × 19 × 7 in. (0.30,5 × 0.48 × 0.18 m.). Private collection, London

22. *Modulation of Space I*. 1963. Iron, 21½ × 27½ × 16 in. (0.54,5 × 0.70 × 0.40,5 m.). Collection The Tate Gallery, London

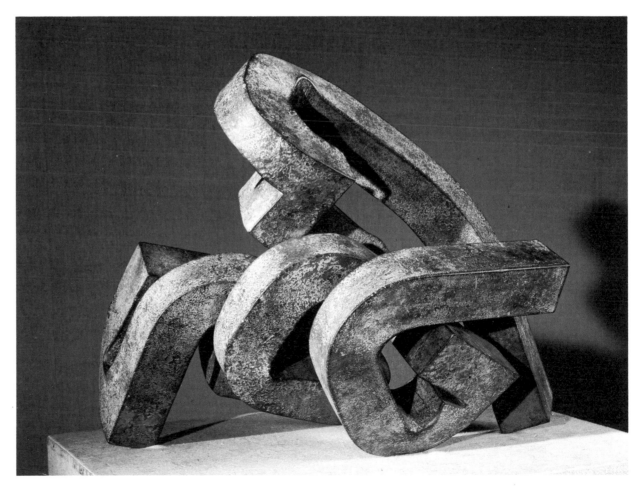

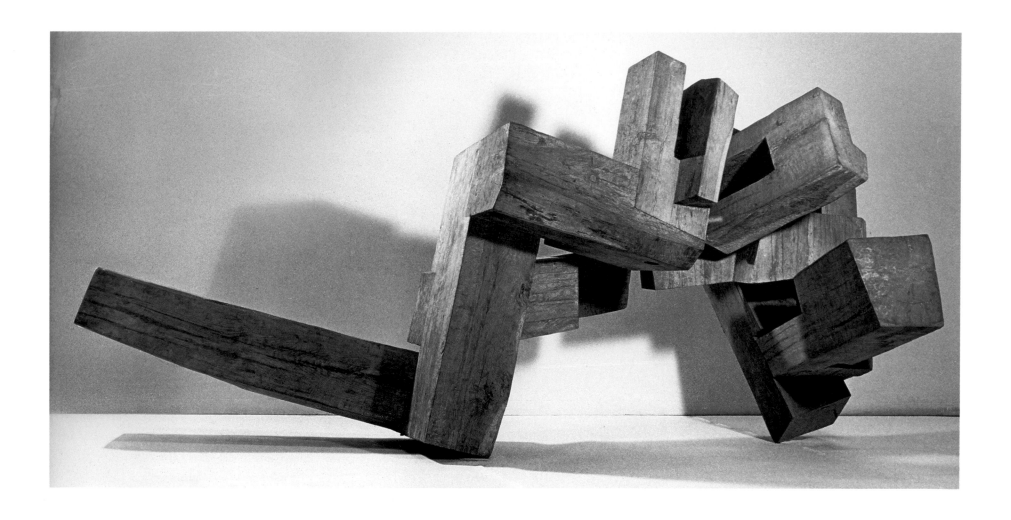

23. *Abesti Gogora I (Rough Chant I)*.
1960–61. Oak, 60 × 133 × 64½ in.
(1.53 × 3.37,5 × 1.74 m.). Collection The
Museum of Fine Arts, Houston, Texas.
Museum purchase

the realm of rumor. *Rumor of Limits IV* (1959, fig. 20), bending and coiling in all
directions, sprawls over the ground yet rises up over forty inches. More than his
other works, this particular piece is endowed with an anthropomorphic quality, as
it seems to cross space with a giant stride.

As early as 1952–53, Chillida made the first of a series of wind combs,
consisting largely of vertical and horizontal planes that were welded together. In
Wind Comb II (1959, fig. 21), he rejected stationary, somewhat rigid geometrical
forms, and instead forged a work of six diagonal fingers stretched into space. The
hand, Chillida explains, is of great importance, and he is able to observe the ar-
ticulation of space by means of studying the movements of his own hand, which,
furthermore, has the advantage of always being around to observe. Splayed fin-
gers are vulnerable to the impact of space, a clenched fist can envelop it without
shutting it off. The artist has made innumerable drawings and etchings of his
hand, his fist, his fingers (see fig. 115). The ambidextrous Chillida draws his right
hand with his left and his left with his right. To Chillida the hand is both an ever-
present tool and a metaphor of substance in space. *Wind Comb II* is an iron hand,

set in tension, ready to encounter the wind, and to filter the wind through its presence.

In the early 1960s the metal bars become more squared and often resemble industrial iron beams. *Modulation of Space I* (1963, fig. 22) is made from a single piece of iron bent into multiple shapes. The work regulates, it adjusts, it modulates the space, inside and out; it hugs the ground, but it also twists and rears like a gigantic curved ribbon. Octavio Paz relates: "In the fall of 1958, on a path in Navarre, Chillida saw an abandoned beam half-hidden in the grass. He stopped at once and recognized it. Or rather, he heard it, for as he later told Claude Esteban, he thought he heard it say: 'It is I.' "[7]

That particular beam from Navarre was once incorporated in *Abesti Gogora IV* (*Rough Chant IV*, fig. 26) but was later removed before the artist considered the work complete, in 1964. The first free-standing wooden sculpture, *Abesti Gogora I* (fig. 23), was made in 1960–61; working with wood occupied much of Chillida's attention in the early 1960s. The wooden sculptures are much larger in scale than the iron pieces, and they look much heavier. Here Chillida's early inclination to architecture orients itself toward building powerful constructions. He did not carve the wooden blocks but constructed the heavy tectonic beams into works. The natural grained surface and the knot holes are visible, just as he never disguised hammer blows in the forged iron pieces, but availed himself of the elemental nature of the squared, sawn timbers. The angles and edges, the rectilinear quality of the beam, are respected in these works. The timbers are joined and interlaced in massive asymmetric constructions, mostly horizontal or diagonal in direction. *Abesti Gogora III* (fig. 25), a highly compact work, nearly twelve feet in width, spreads broadly across the space. Indeed the *Abesti Gogora* series—made from the timber of Basque oaks—are robust works with a great physical presence.

Before very long, however, Chillida ceased working in wood. He felt that the wooden sculptures controlled the space too much, that they were too hermetic, that the chambers of the void were too inaccessible, unable to communicate his deep spatial concerns. However, the large wooden sculptures were the point of departure for his first major public commission, the nineteen-foot-wide *Abesti Gogora V* (fig. 27), made of granite and designed for the grounds of The Museum of Fine Arts in Houston in 1966. At the time of its installation, which was arranged to coincide with Chillida's first major exhibition in the United States, James Johnson Sweeney, then director of the Houston museum, referred to Chillida as "the foremost sculptor of his generation, internationally."[8]

Chillida's first important one-man show had been at the Galerie Maeght in Paris in 1956; Gaston Bachelard wrote the introduction to the catalogue. Chillida came to the attention of the American art world in 1958, when he received the Graham Foundation Prize, which was awarded by a jury that included Grace L. McCann Morley, Ludwig Mies van der Rohe, and James Johnson Sweeney. Also in

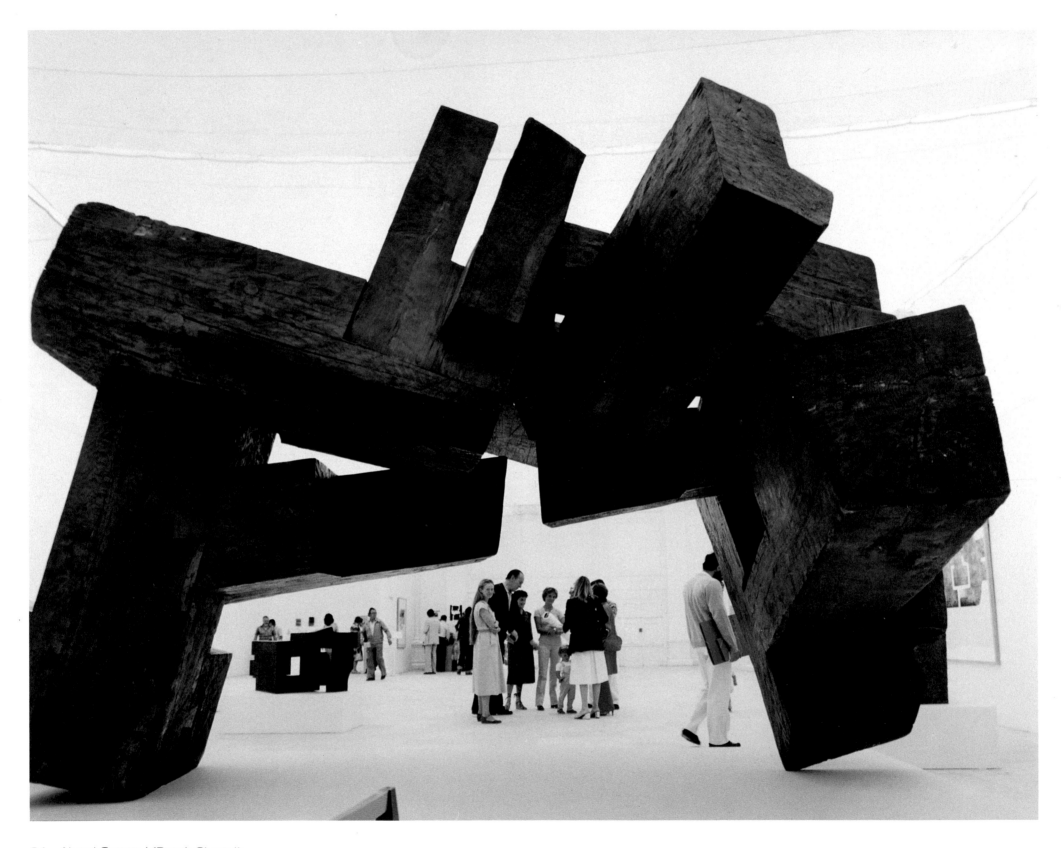

24. *Abesti Gogora I (Rough Chant I).*

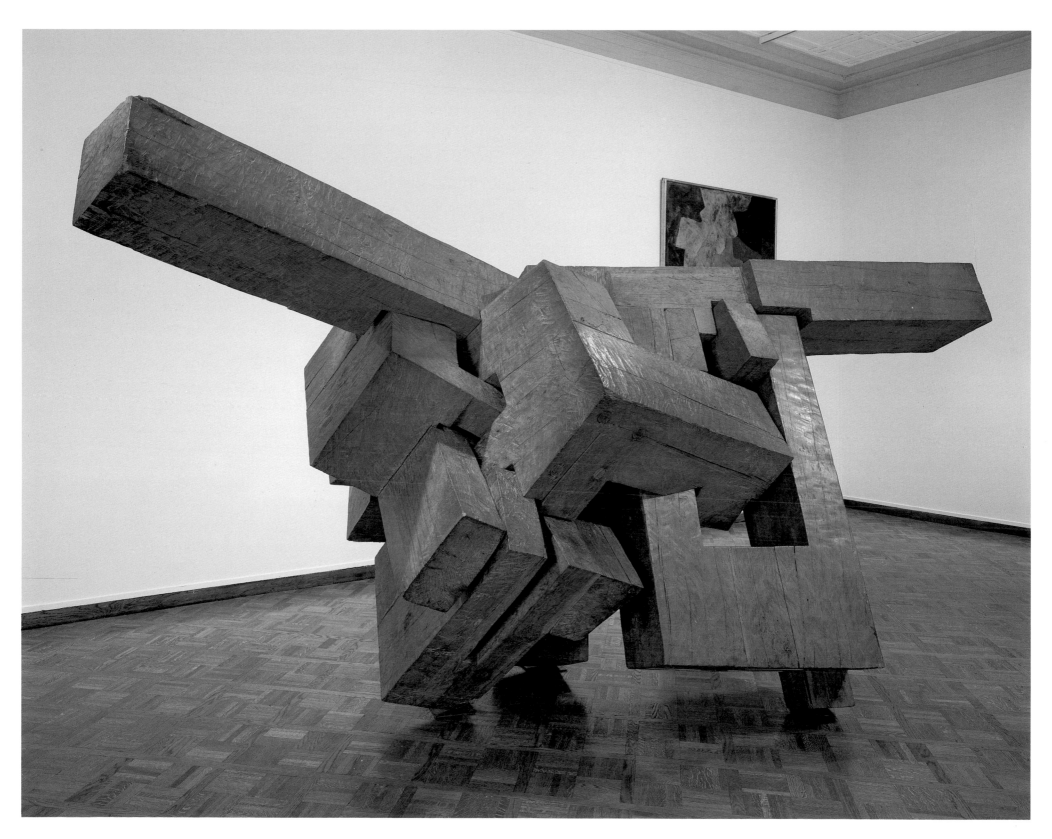

25. *Abesti Gogora III (Rough Chant III)*.
1962—64. Oak, 81½ × 136 × 72½ in.
(2.07 × 3.46 × 1.83,5 m.). © The Art Insti-
tute of Chicago. All rights reserved

1958 he received the International Grand Prize for Sculpture from the Commune of Venice at the XXIX Biennale. This was the year in which Mark Tobey was accorded the same award for painting.[9] In 1962 Chillida was again paired with a major American painter when Arnold Rüdlinger, the ingenious director of the Basel Kunsthalle, opened two simultaneous one-person exhibitions, one of Mark Rothko and the other of Chillida. In 1979, as recipient of the Andrew W. Mellon Prize, he was featured together with Willem de Kooning in one-man shows at the Carnegie Institute.

While working with granite on the *Abesti Gogora* series and a few other smaller free-standing pieces, he also began to work in forged steel on another series, titled *Around the Void*. Surely growing from his experience of working with squared wooden timbers, the steel sculptures are also made of angular blocks, and in many of them curvilinear forms are avoided. In these very densely composed pieces the planes are straight, almost rigid, as they encompass the central space. *Around the Void I* (1964, fig. 28), with its kinetic interplay between positive and negative forms, can be read almost like an emblem for the encirclement of space. A great sense of potential energy is also achieved in *Around the Void IV* (1968, fig. 30), with the open area resembling a nest between the intersecting diagonal branches. Although these large steel sculptures were forged in a factory, the artist made sure that we can see the stress marks, the tensile strength, the great energy that was exerted at the "bending moments" of the work. Making this stress visible strengthens the visual dynamics of the sculpture (fig. 29).

Whereas the series of *Around the Void* measure space as the heart of the matter, *Gnomon* (1965, fig. 31) is composed of irregular layers of impermeable bars of steel. "Gnomon" is Greek for the "carpenter's square" and the "pointer in the sun dial"; the title, Chillida points out, refers to the pivotal discovery by the Greeks of the right angle formed between an object and its shadow, which became basic to the perpendicular aesthetic of Greece and subsequent Mediterranean cultures. Chillida's *Gnomon* is a compact sculpture, stable and architectural, but its apparent solidity is broken by secret labyrinthine passageways inside the heavy block. Its structure is basically one of right angles, but each bar manifests an individual deviation from the rigid rule of strict geometry. Even in a condensed work such as this, the dialectic between matter and void is maintained and we are reminded that "gnomon" is also the Greek for "rule of life" and "code of regulation" and, beyond that, it is the description of a learned person, an interpreter, discerner, or wise man.

As noted earlier, Chillida has always been passionate about Greek sculpture, but attempted to avoid its seductive beauty. One day in 1962 he noticed in a glass case in the Louvre the recently discovered hand of the *Nike of Samothrace*. He was fascinated by the transparent quality of the marble and came to feel that it might no longer threaten the integrity of his work. In pursuit of this discovery he went to the British Museum to study and explore the Elgin Marbles,

and in 1963 he traveled to Greece, where he not only admired the sculpture, but, above all, began to comprehend the meaning of physical light in Greek sculpture and for the Greek mind. Thereafter light assumed a salient role in his work.

Upon returning from Greece, Chillida made a few tentative carvings in marble, but found that even the best newly quarried Pentelic marble did not have the quality of light that he found in the surface of the ancient sculptures. It was then that he discovered alabaster, with its intrinsic translucency.

Chillida recalls:

> For a long time I have worked in a dark workshop. One did not need light in order to look at my earliest sculptures; I also did not have that need myself. They were like very harsh drawings in space. Then I needed to find light again to play upon the sculpture and for that I found a material in which light is able to enter and irradiate the clefts.[10]

26. *Abesti Gogora IV (Rough Chant IV)*. 1964. First Version (with beam). Wood, 39 × 51 × 39 in. (0.99 × 1.29,5 × 0.99 m.). Present Version, collection Museo de Arte Abstracto Español, Cuenca

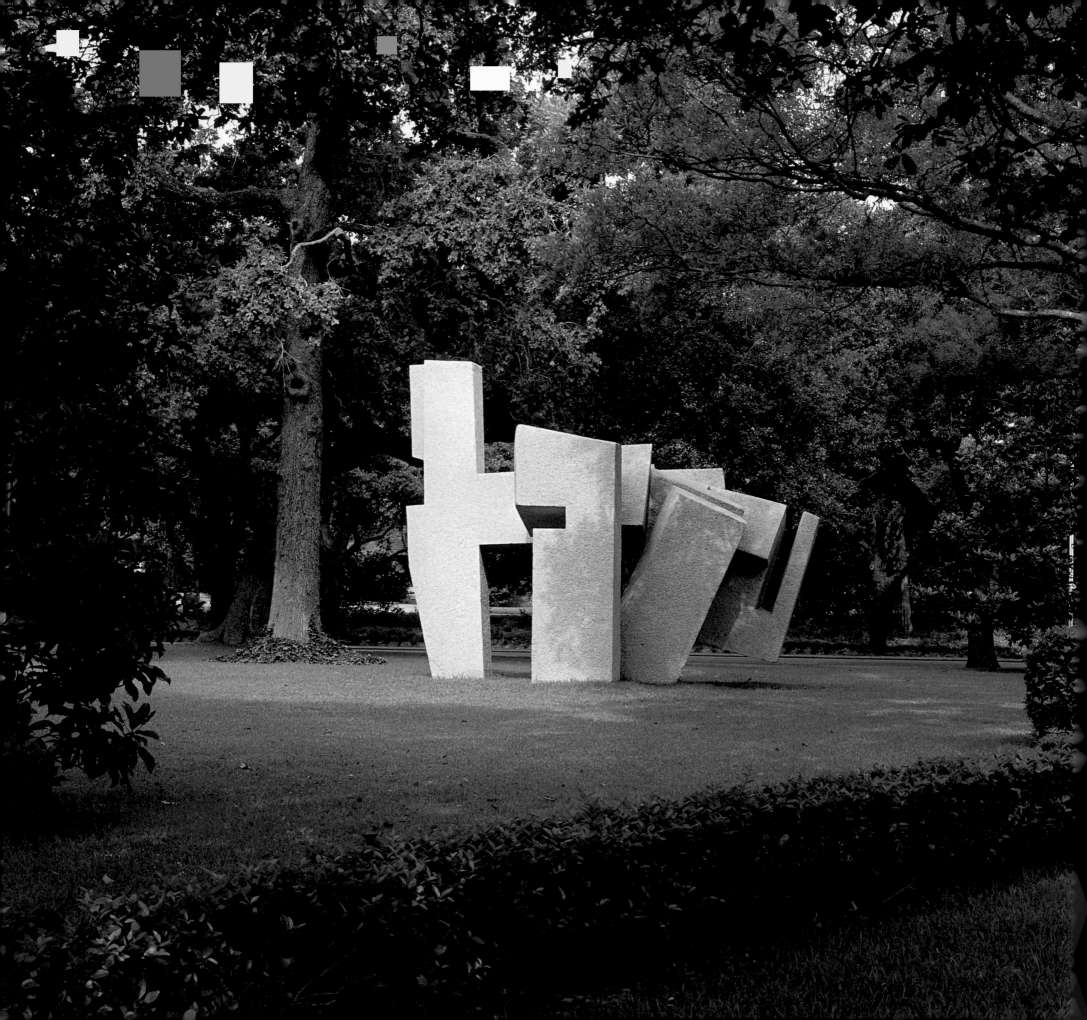

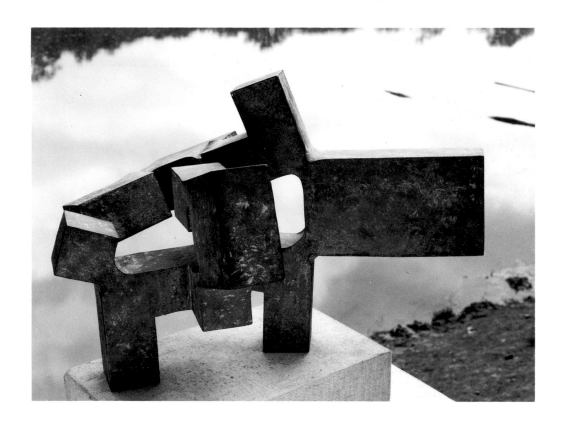

28. *Around the Void I.* 1964. Steel, 12⅝ × 19¹¹⁄₁₆ × 16½ in. (0.32 × 0.50 × 0.42 m.). Collection Museo de Bellas Artes, Bilbao

29. *Around the Void II.* 1965. Iron, 16½ × 20½ × 14 in. (0.42 × 0.52 × 0.35,5 m.).

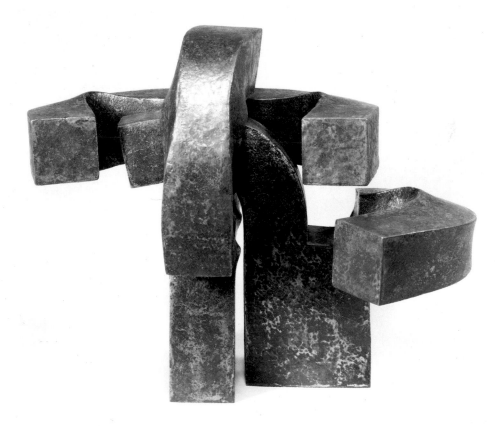

opposite: 27. *Abesti Gogora V (Rough Chant V).* 1966. Granite, 183 × 231 × 168½ in. (4.65 × 5.87 × 4.28 m.). Collection The Museum of Fine Arts, Houston, Texas. Gift from Houston Endowment, Inc., in Memory of Mr. and Mrs. Jesse H. Jones

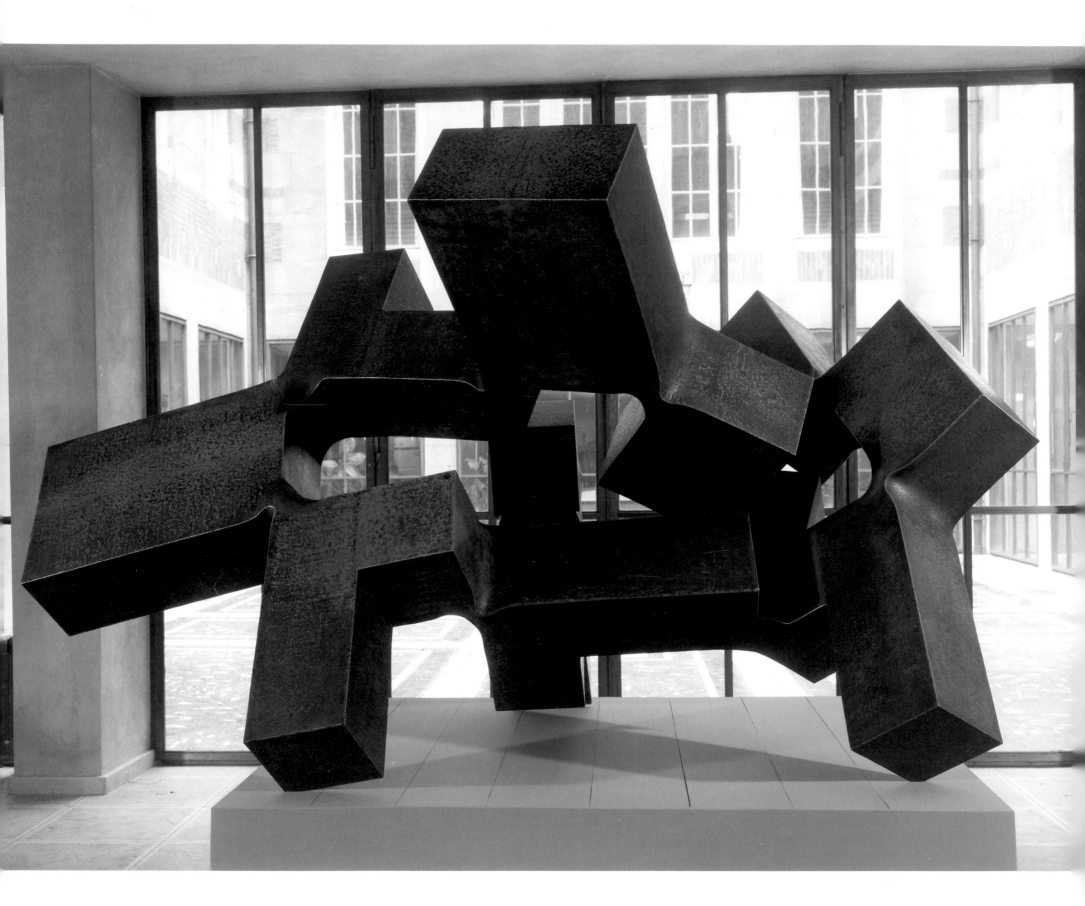

His first work in alabaster was done in 1965 and is dedicated, significantly, to Kandinsky, an artist who was, above all, concerned with the spiritual and mysterious essence of art. *Homage to Kandinsky* (1965, fig. 32) consists of an alabaster block into which a large opening has been cut, almost separating it into two strata. They in turn are linked by three upward-thrusting solid shafts whose oblique position contrasts sharply with the perpendicular aspect of the piece. The alabasters of the late 1960s, pieces like *Bakuntza* (1968), or *Project for a Monument* (1969, fig. 33), appear even more architectonic. They could almost be models for imaginary habitations or whole visionary cities—but they are not models for larger projects. Like all of Chillida's work, they can exist solely in the dimension in which they have been conceived, which is appropriate to the material. Because they give visual evidence of internal space, these sculptures are discernible in three-dimensional form to a greater extent than most buildings. They are also vari-

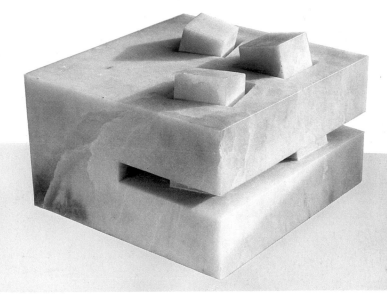

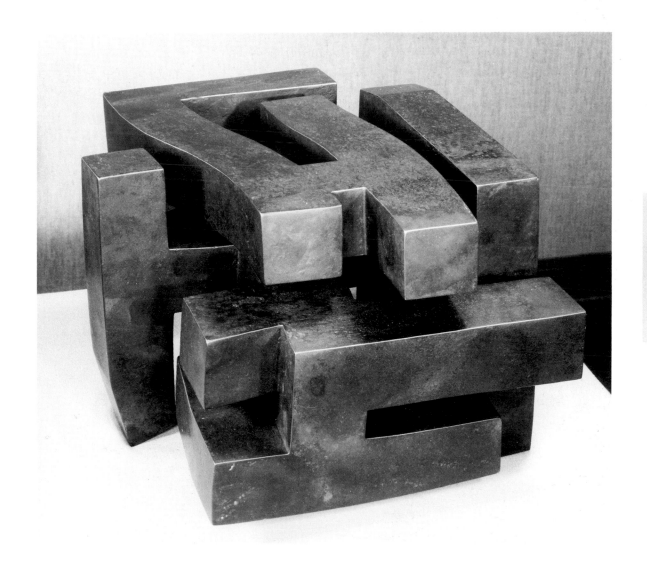

left: 31. *Gnomon.* 1965. Steel, 14 × 15 × 16½ in. (0.35,5 × 0.38 × 0.42 m.). Collection Bartolomeo March, Spain

above: 32. *Homage to Kandinsky.* 1965. Alabaster, 8 × 13 × 14 in. (0.20,5 × 0.33 × 0.35,5 m.). Collection Galerie Adrien Maeght, Paris

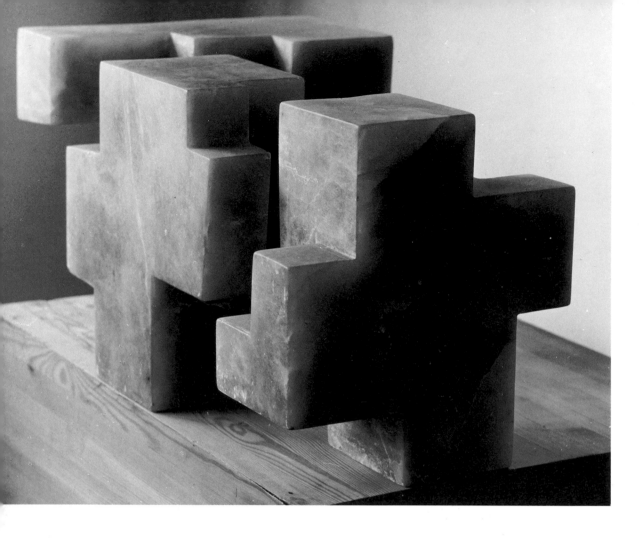

33. *Project for a Monument.* 1969. Alabaster, 14 × 16 × 16 in. (0.35,5 × 0.40,5 × 0.40,5 m.). Collezione d'Arte Contemporanea, Musei Vaticani, Rome

right: 34. *Gasteiz.* 1975. Alabaster, 4 × 12½ × 11½ in. (0.10 × 0.32 × 0.29 m.). Collection Museo de Bellas Artes, Bilbao

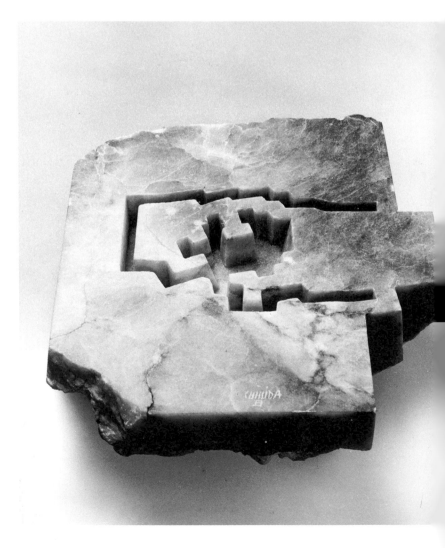

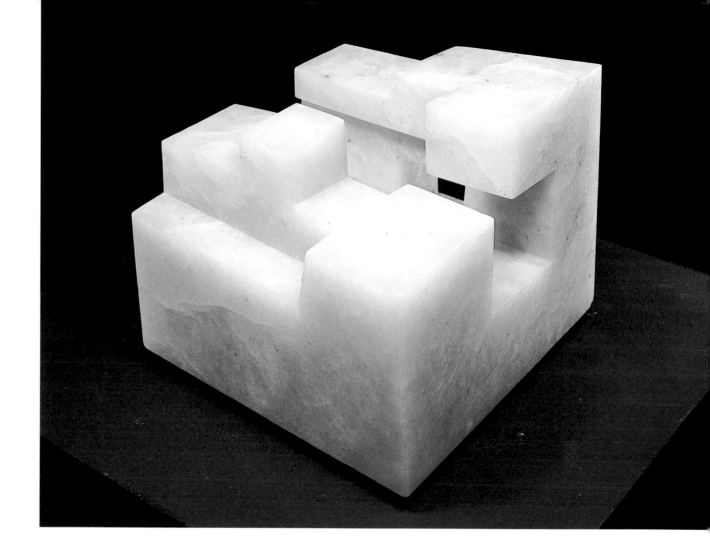

35. *House of Light II*. 1977. Alabaster, 12 ×
13½ × 10 in. (0.30,5 × 0.34 × 0.25,5 m.).
Stiftung Sammlung Bernhard Sprengel

ations of a theme of geometry, but, like the entasis developed by Greek architects
in the fifth century, Chillida makes use of dilations and other slight irregularities,
avoiding a ninety-degree angle whenever possible in the joining of horizontal and
vertical planes. It is these choices that give the work its sense of harmony in or-
ganic equilibrium.

As the sculptor continued working in alabaster, the pieces became more
complex. By carving into the solid but translucent stone, he was able to create
transparencies of space. His alabaster works are no longer made up of parts,
such as bars of iron or beams of wood, that delimit space. By cutting grooves,
shafts, and passages into the blocks, he is able to illuminate the space of hard
matter. And in keeping with the character of all his sculptures, the marks of the
chisel are never obliterated.

Gasteiz (1975, fig. 34)—the first design for his large public space in the
city of Vitoria-Gasteiz—or works such as *House of Light II* (1977, fig. 35) or
Homage to the Sea II (1979, fig. 36) have false doors but also secret entrances,
leading to concealed chambers, creating mysterious works in which the light is the
core of the rock. In *Homage to the Sea* the veining of the stone itself suggests
foaming waves, while the channels cut into the alabaster relate to the deep can-

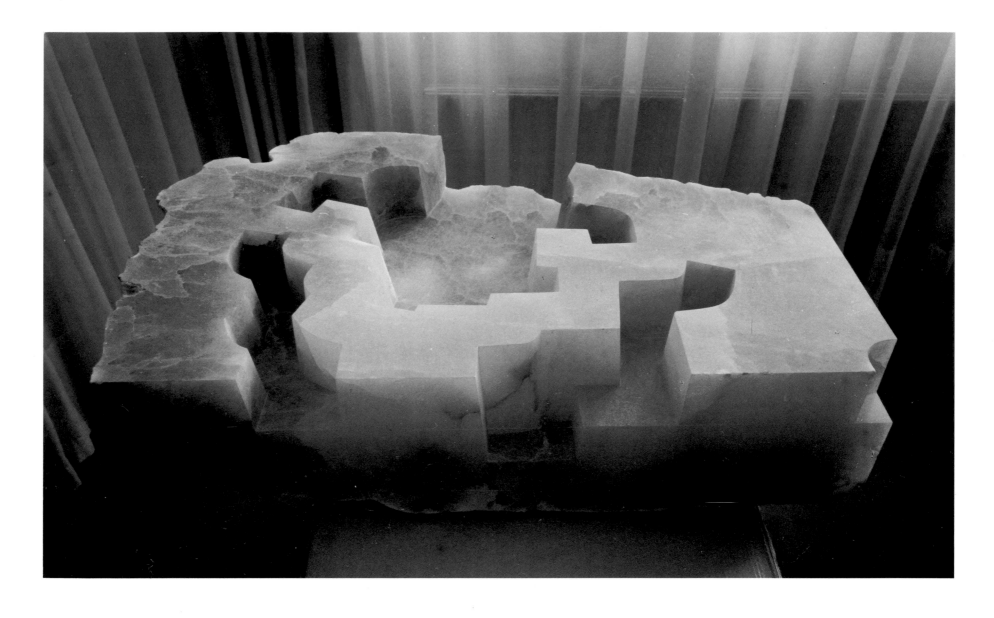

36. *Homage to the Sea II.* 1979. Alabaster, 12 × 27½ × 31½ in. (0.30,5 × 0.70 × 0.80 m.). Collection Antoni Tàpies

opposite: 37. Chillida with *Homage to the Sea III* (left) and *Mendi Huts (Hollow Mountain)* (right). Collection the artist. Photo, San Sebastián, 1984

yons of the ocean floor. But this is too literal an interpretation of a work filled with mystery. *Homage to the Sea*, with its irregular inlets, is basically a horizontal flat bed open to the flow of water, which Chillida explains is "the queen of the horizontal." In contrast, the encounter with light is vertical and therefore it strikes from the top in *House of Light*, which is also more cubic in form. Again Chillida deals with the interaction of form, light, and space. The eye is led from the outside to the interior. By means of light one gains access to the core of the object; it is this inner space that energizes the work. The shadows formed in the process become as much a substance as the stone itself. The fissures penetrate to a numinous place of silence.

The culmination of Chillida's work in alabaster, thus far, is a series of five works in *Homage to Goethe* (1977–79, figs. 38 and 39), the Olympian genius

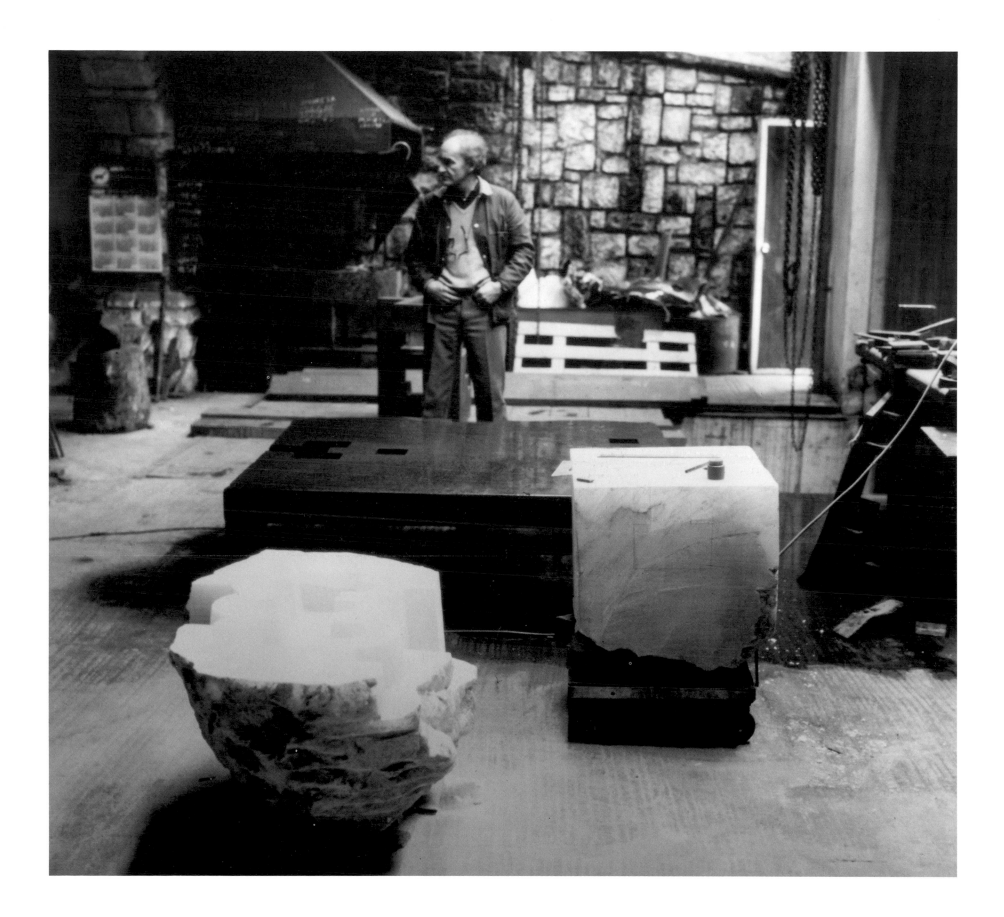

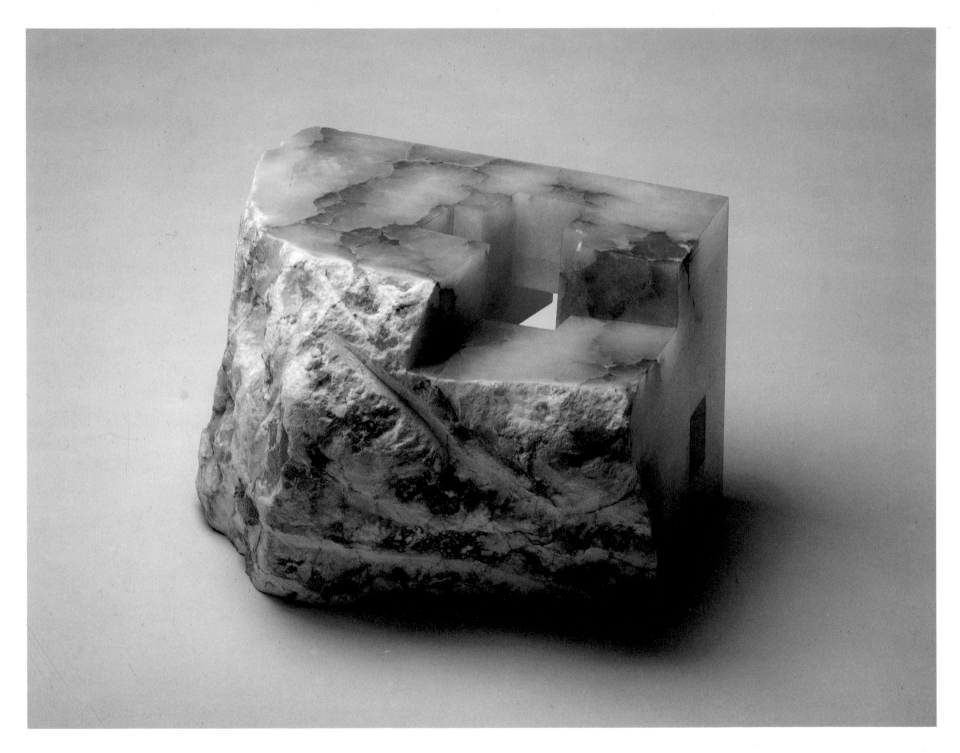

38. *Homage to Goethe III.* 1977. Alabaster,
15 × 19 × 22 in. (0.21,5 × 0.23 × 0.25,5
m.). Collection Galerie Maeght Lelong, Zurich

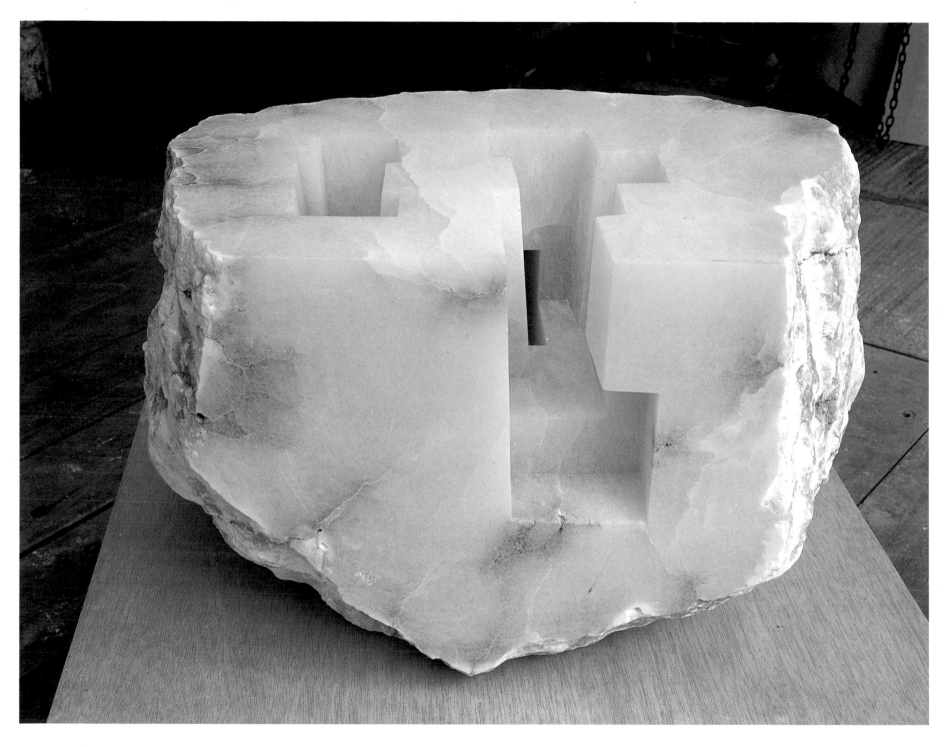

39. *Homage to Goethe V.* 1979. Alabaster,
20½ × 35½ × 24 in. (0.52 × 0.90 × 0.61
m.). Collection the artist

whose last words are said to have been "More light." "Working with light," Chillida relates, "showed me that I was in the territory of Goethe." These sculptures with a rough and unpolished outer crust permit the light to enter their involuted cavities. It is then taken through bridges and labyrinthine passages—channels of adventure and discovery—until the light comes to rest in cells of luminous vibration. Octavio Paz discerned that

> The alabaster sculptures do not try to enclose inner space; neither do they claim to delimit or define it: they are blocks of transparencies in which form becomes space, and space dissolves in luminous vibrations that are echoes and rhymes, thought.[11]

Chillida, who continues today to work in alabaster, feels that these contemporary carvings are still in their beginning state. Above all, he hopes to gain access to a large quarry where he can have huge layers and chunks of stone blasted and carved on a gigantic scale. The stone extracted would become the property of the workers. What would be left would be a massive mountainous matrix with many entrances, disclosing the dualities of mass and void.

Chillida's first sculpture on a very large scale, *Abesti Gogora V* (see fig. 27), was made with granite in 1966. Then, in the early 1970s, he continued working big, using steel for *Monument* in Düsseldorf (figs. 40, 41, and 88), commissioned by the Thyssen Company as a gift to the city.

He also became very much interested in using concrete for its specific properties. Almost in contradiction to his general dictum of "truth to material," he set out to deal with the weight of concrete, wishing to deny its appearance of gravity. He recalls being in a factory and focusing on the space between a heavy sculpture and the floor as a crane lifted the object toward the ceiling. The artist felt that it was the shaft of air that seemed to be holding the sculpture's weight, and wanted to find a way to demonstrate the elevational strength of space by making solid material appear to float.

When asked to submit a large sculpture for a public space in Madrid, the artist chose to fabricate a big concrete work, *Meeting Place III* (1971–72, fig. 43), to be suspended under the Castellana Bridge, an installation not permitted under the Franco regime. The next work, *Meeting Place IV* (fig. 44), weighing fifteen tons, hangs in the Museo de Bellas Artes in Bilbao. Levitated in space, it looks like gigantic pincers moving toward inevitable closure.

The even larger and still heavier *Meeting Place V* (fig. 45) of 1974 consists of two segments, the larger of which seems to be ready to impinge on the space of the smaller, a crescent open to the sky. This work, reaching a height of over eight feet, is firmly secured to the ground.

All these sculptures in ferroconcrete had to be engineered and fabricated in industrial plants. The artist made certain that the form work was kept rough, that

opposite: 40. *Monument*. 1970–71. Steel, 141⁷⁄₁₆ × 169⅛ × 196½ in. (3.59,5 × 4.30 × 4.99 m.). Collection City of Düsseldorf

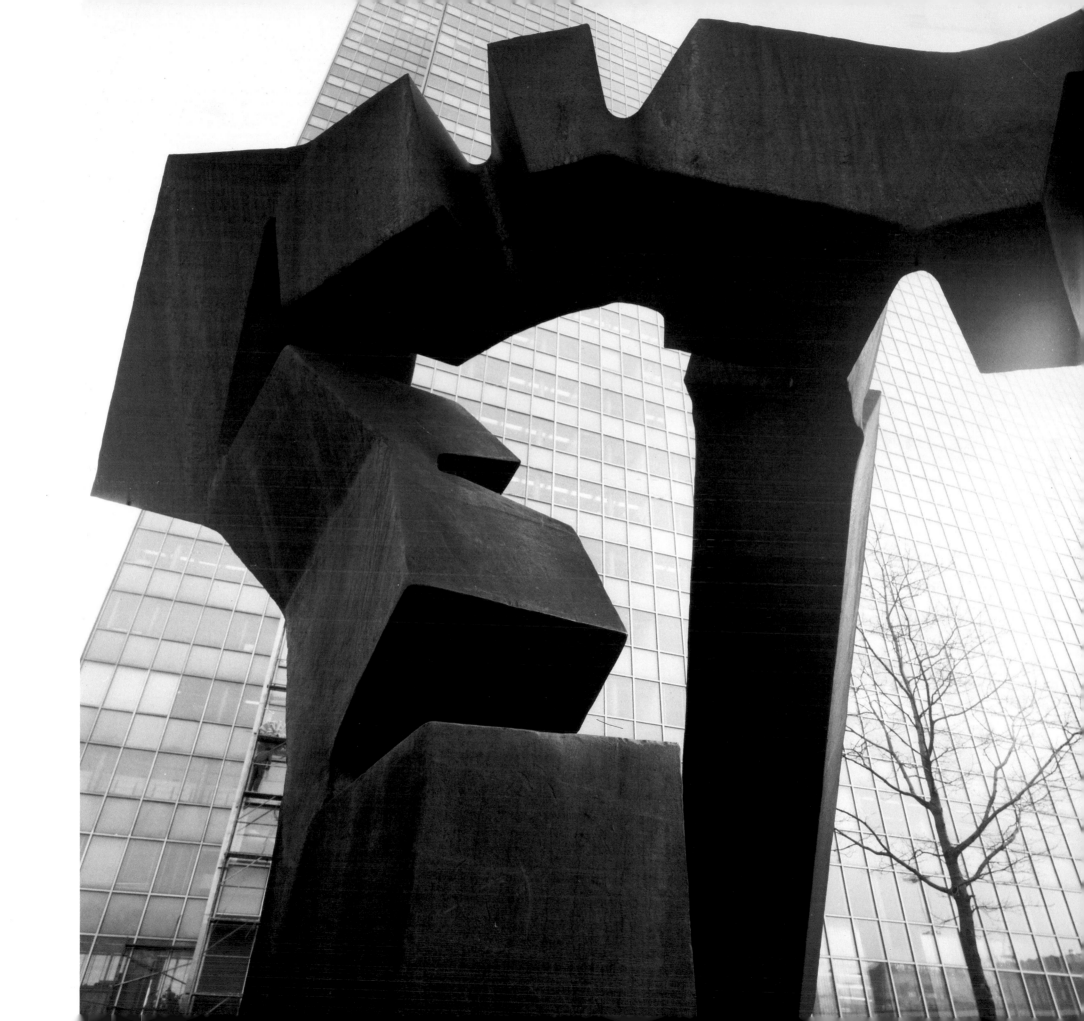

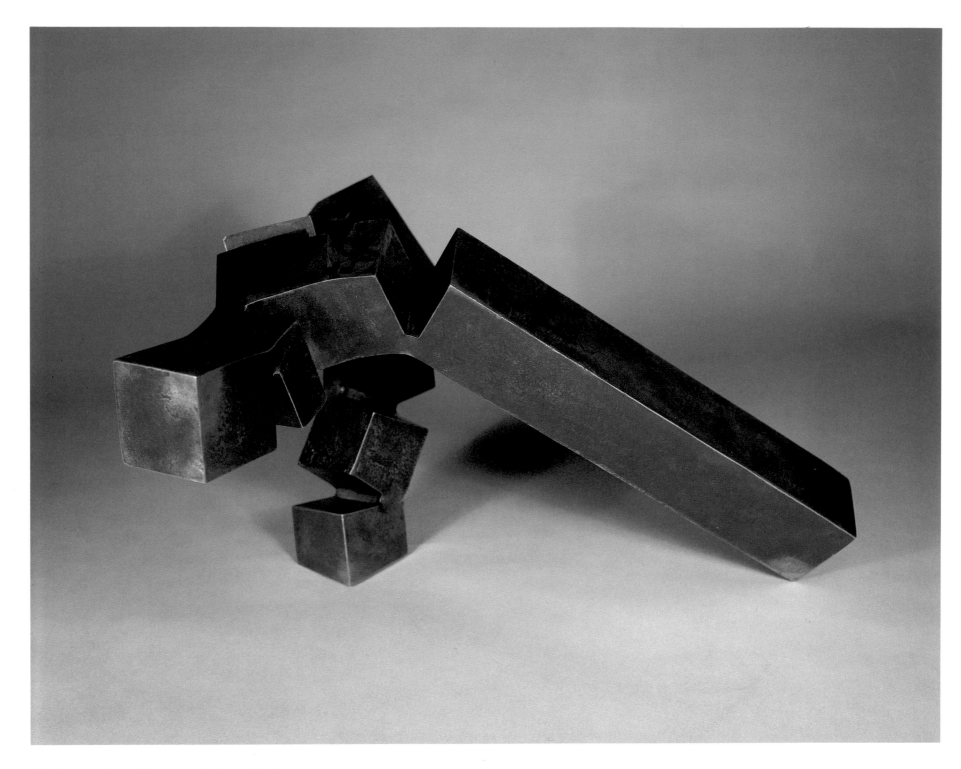

41. *Project for a Monument in Düsseldorf.*
1970. Steel, 11¾ × 20 × 17 in. (0.30 ×
0.51 × 0.43 m.). Collection Menil Foundation,
Houston, Texas

the process of forming and making it remained visible, giving a sense of enormous strength and power to these works.

As an art student, Chillida had initially worked in clay, but he soon rejected its pliable, soft, nonresistant qualities; a quarter of a century later, in 1973, he made a brief attempt to work once more in ceramic clay with Joan Gardy Artigas—the son and successor of Josep Llorens Artigas, who had collaborated with Joan Miró in creating their ceramic sculptures at the Fondation Maeght in Saint-Paul-de-Vence. Then, in 1977 he saw the German artisan Hans Spinner preparing a finely ground fireclay in the same studio at the Fondation Maeght. Chillida touched this hard *terre chamotte*, which contained a relatively high proportion of iron oxide. It had a consistency very different from that of the clay he had worked with in his youth: it was quite powdery, rougher and stronger, almost recalcitrant, and it seemed right. He then began to work with this clay, which would be fired to a very high temperature in a wooden kiln, resulting in a crude, solid, and rugged

42. *Meeting Place II*. 1971. Steel, 90½ × 114 × 88½ in. (2.30 × 2.90 × 2.25 m.). Collection Banco Urquijo, Madrid

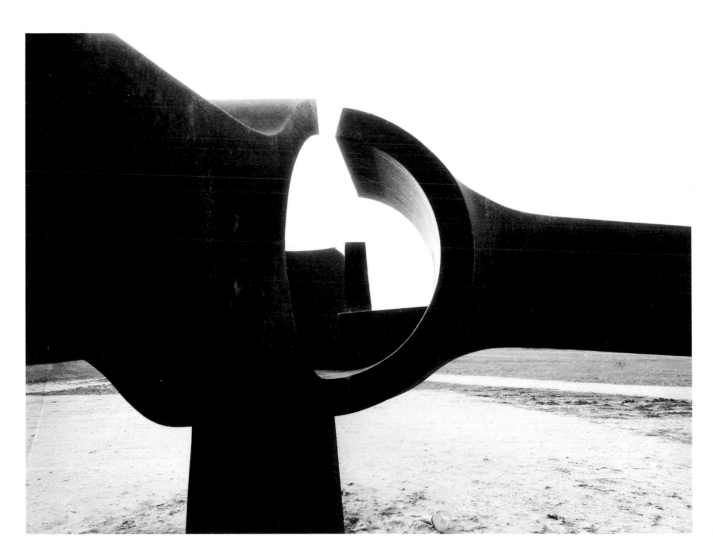

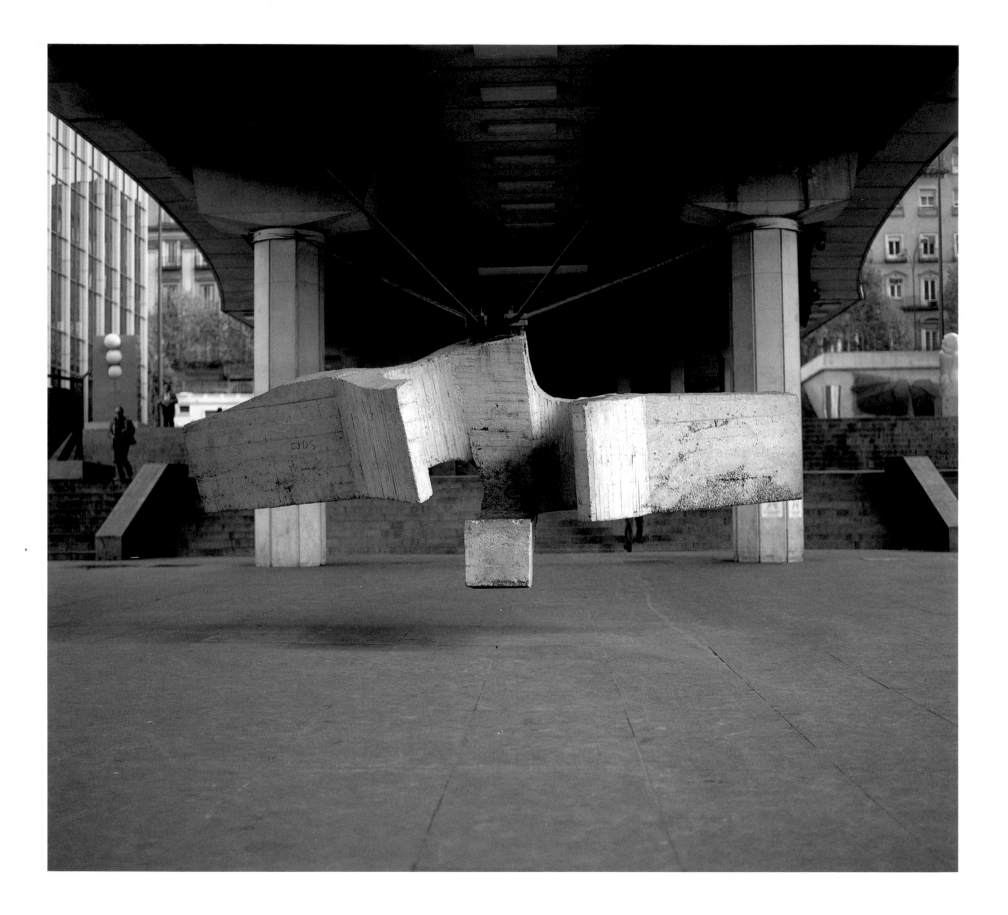

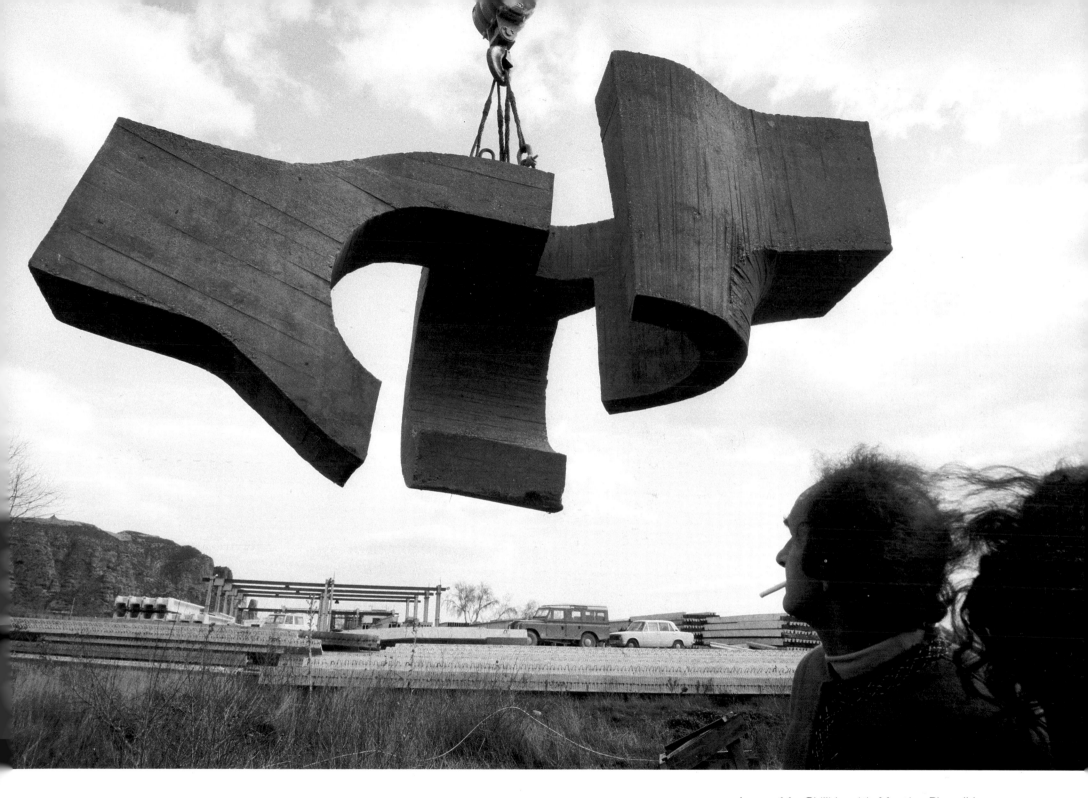

opposite: 43. *Meeting Place III.* 1971–72.
Reinforced concrete, 79 × 200 × 69 in.
(2.00 × 2.54 × 1.75 m.). Collection Museo
de Escultura al Aire Libre del Paseo de la
Castellana, Madrid

above: 44. Chillida with *Meeting Place IV*.
1973–74. Concrete, 84½ × 185 × 157½
in. (2.13 × 4.70 × 4.00 m.). Collection Mu-
seo de Bellas Artes, Bilbao. Photo, 1984

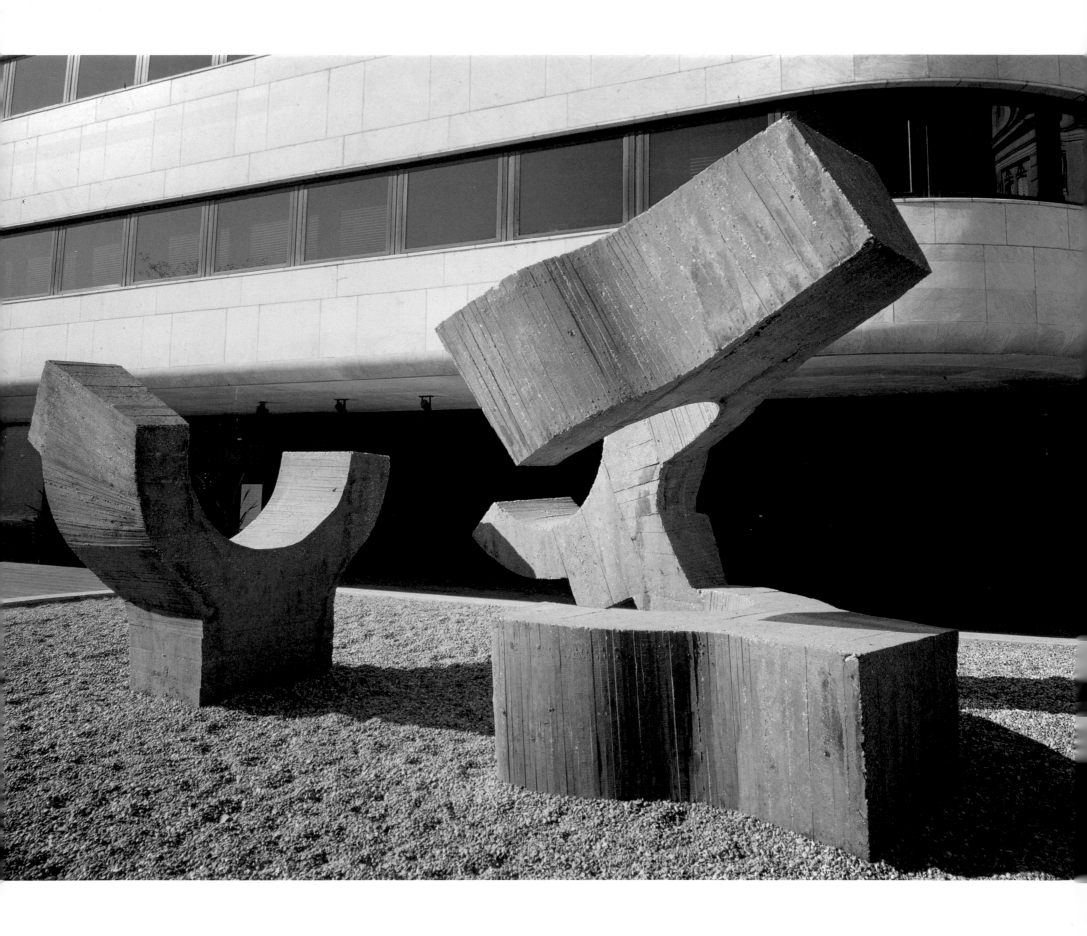

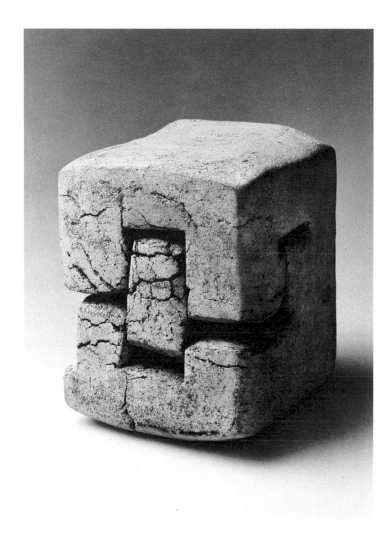

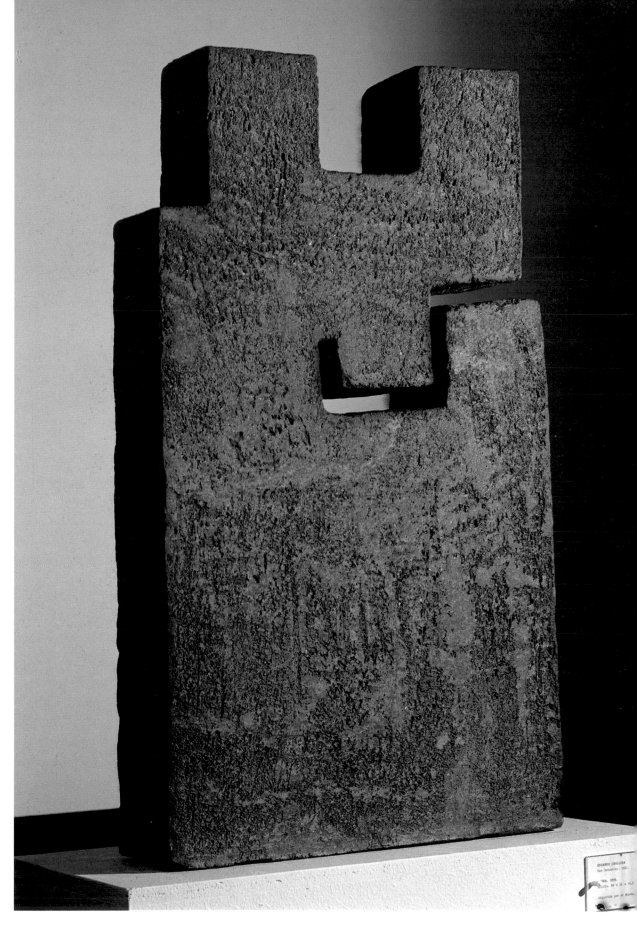

opposite: 45. *Meeting Place V*. 1974. Concrete, 102 × 200½ × 114 in. (2.59 × 5.10 × 2.89,5 m.). Collection Fundación Juan March, Madrid

above: 46. *Lurra VII (Earth VII)*. 1977. Fired clay, 6 × 5 × 5 in. (0.15 × 0.12,5 × 0.12,5 m.). Private collection, West Germany

right: 47. *Lurra (Earth)*. 1979. Fired clay, 35¹¹⁄₁₆ × 20⅛ × 6½ in. (0.89 × 0.51 × 0.16,5 m.). Collection Museo de Bellas Artes, Bilbao

48. *Lurra XXXV (Earth XXXV)*. 1979. Fired clay, 10 × 12 × 7½ in. (0.25,5 × 0.30,5 × 0.18,5 m.). Private collection, London

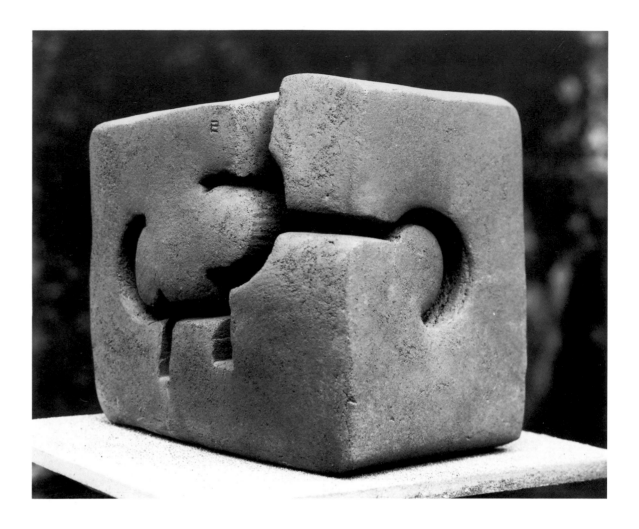

material. Like Martin Heidegger, Chillida saw the earth as revealing itself in the work of art. But in his *Lurra* (*Earth*) pieces (figs. 46–56) it is the earth placed upright. Some of the finished pieces are standing slabs with somewhat angular insertions. Others are powerful rocklike cubes that appear to be made of pieces that can be wedged into each other as in a three-dimensional puzzle. Many are massive silent blocks, broken by notches, crevices, and cracks that denote an ineffable and unknown space within. All of them share the organic quality of the earth and are certainly the artist's closest approach to nature itself.

The predominant material throughout Chillida's career has been metal. Having forged iron, he began around 1965 to work in steel, selecting an alloy that eventually oxidizes to a rich velvety-brown rust that also protects the metal core.[12] *Oyarak II* (*Echo II*, 1965–70, fig. 58) is a large, heavy, richly colored steel piece resting on a single footing and daringly cantilevered. It recalls the pivotal feats of early modern architecture, such as the Galerie des Machines at the Paris International Exposition of 1889, in which the weight-bearing trusses appear to be barely touching the ground, practically obliterating the division between load

below: 49. *Lurra (Earth)*. 1981. Fired clay, 8 × 13¼ × 5 in. (0.20,5 × 0.33,5 × 0.13 m.). Collection Museo de Bellas Artes, Bilbao

below right: 50. *Lurra (Earth)*. 1982. Fired clay, 7¼ × 4¼ × 4¼ in. (0.18 × 0.11 × 0.11 m.). Collection the artist

and support and creating a counterpoise of enormous forces. A similar dynamic equilibrium or floating mass is achieved in *Oyarak II*. Its horizontal and vertical oval rings, set in different directions, are like ripples in the water or, indeed, like visualizations of an echo in space.

Chillida's earliest work in forged iron was in the form of a funerary stele, and bore the Basque name for such a sepulchral slab, *Ilarik* (see fig. 3). He had always liked the oblong vertical stance of the early Basque stones, and in the 1970s he returned to this formal device and enlarged its possibilities and connotative ramifications. He used the stele motif with all its historic and emotional im-

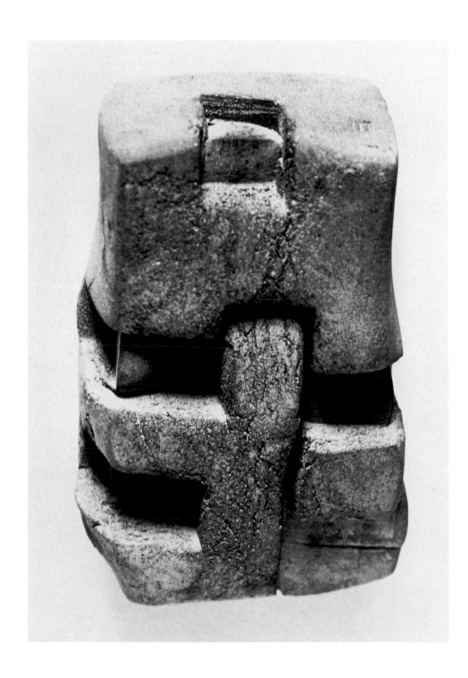

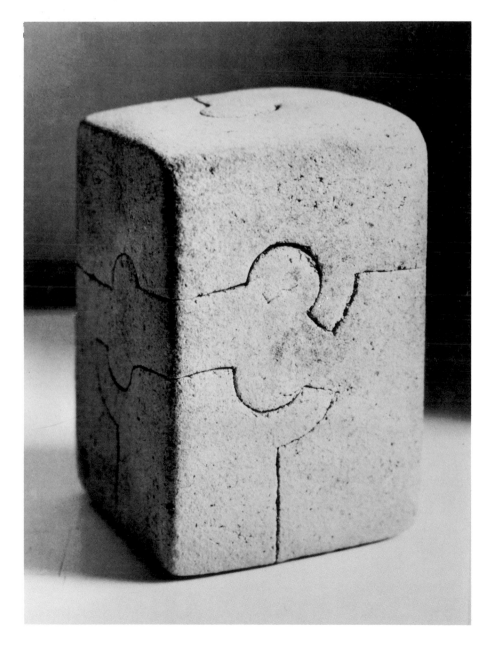

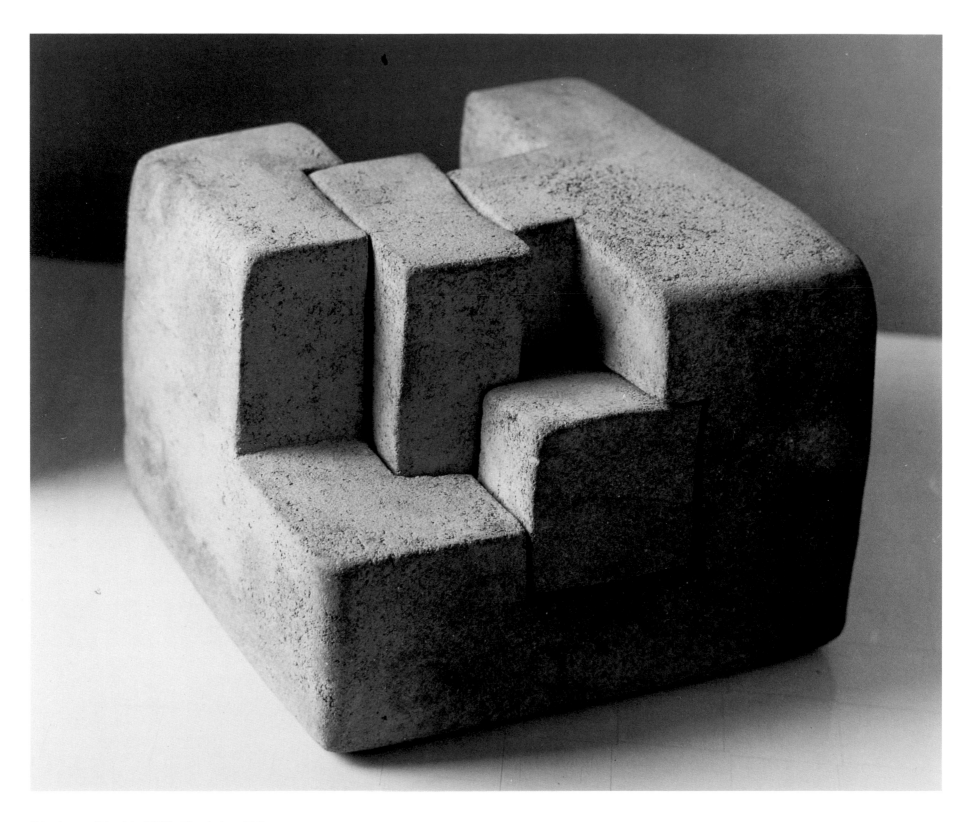

51. *Lurra (Earth)*. 1982. Fired clay, 7¾ ×
10¼ × 9¼ in. (0.19,5 × 0.26 × 0.24 m.).
Collection the artist

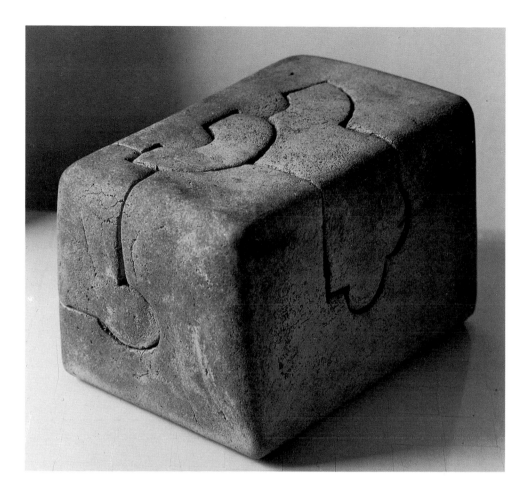

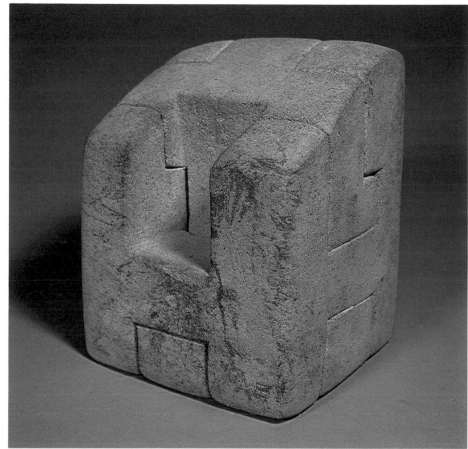

52. *Lurra (Earth)*. 1982. Fired clay, 9 × 14¼ × 9½ in. (0.23 × 0.36 × 0.24 m.). Collection the artist

above right: 53. *Lurra I (Earth I)*. 1983. Fired clay, 9½ in. (0.24 m.). Collection Mr. Leigh Block, Santa Barbara, California

plications: the upright votive monument, commemorating the honored dead not only in ancient Egypt, Mesopotamia, and Greece, but also in Chinese and Maya cultures. But closer to home were the Basque funeral steles dating back to the fifth century B.C., whose general configuration was retained in Christian cemeteries in the Basque country up to the nineteenth century. They generally consist of a rectangular vertical lower section which comprises two-thirds of the total height, while the geometrically rounded upper part is rather narrative in nature and may represent the head of the deceased. Chillida's open-ended series of steles are sculptural eulogies for innovators, philosophers, poets and scientists, progressive political figures, liberators, and humanists. He designed a *Liberty Door* (1983, see fig. 76) for Caracas and a *Monument to Tolerance* (1982, see fig. 111) for Seville. Almost uniquely among contemporary artists, he uses abstract form to address political and humanitarian issues.

In 1972 he dedicated an intricate five-foot-high stele to Manolo Millares, the Spanish painter who had come from the Canary Islands and lived in Franco's Madrid, where he created roped and coarsely sewn pictures that were often stitched with bandages and painted in black, white, and red. Millares's paintings are passionate outcries against the real world. Although refusing human subject

53

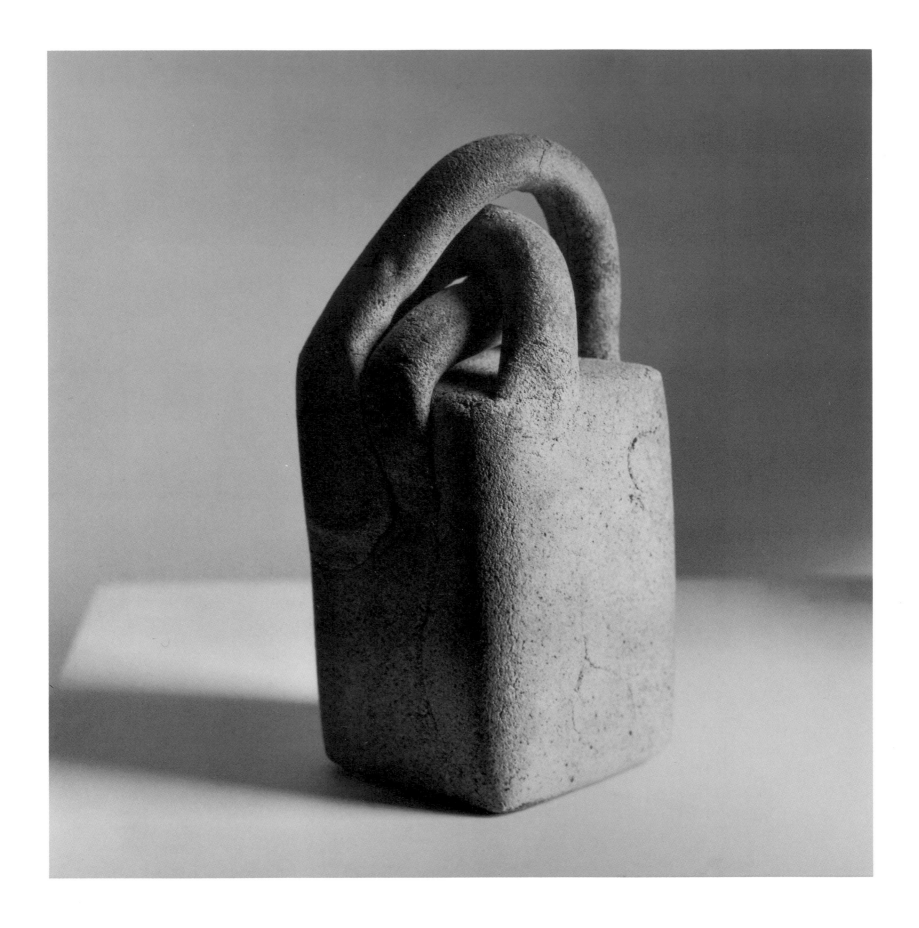

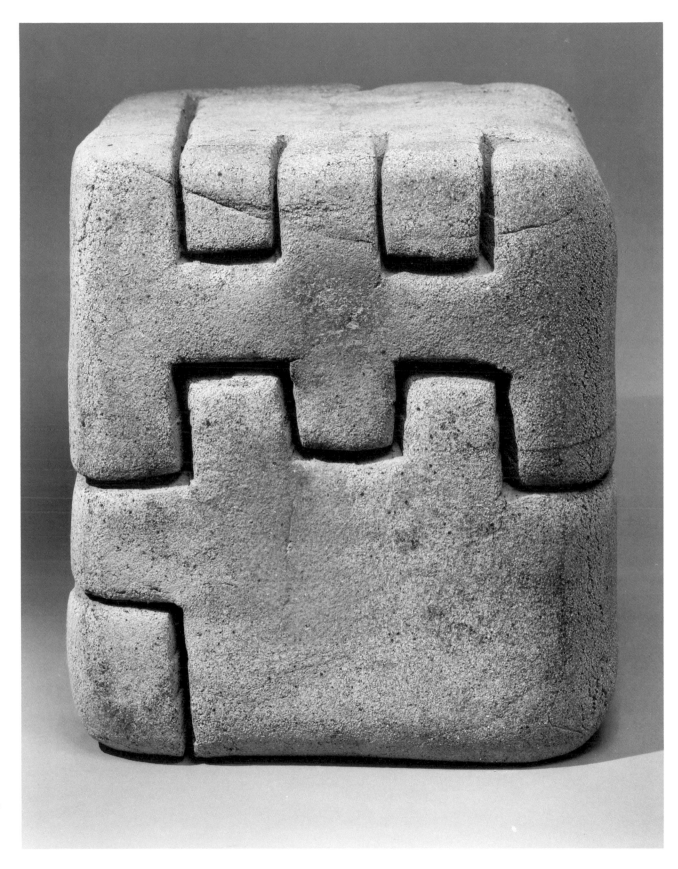

opposite: 54. *Lurra (Earth)*. 1984.
Fired clay, 9 × 4¼ × 4 in.
(0.22,5 × 0.11 × 0.10 m.). Collection the artist

55. *Lurra (Earth)*. 1985. Fired clay, unique,
11¹³⁄₁₆ × 11 × 10⅝ in. (0.30 × 0.28 ×
0.41 m.). Collection Tasende Gallery,
La Jolla

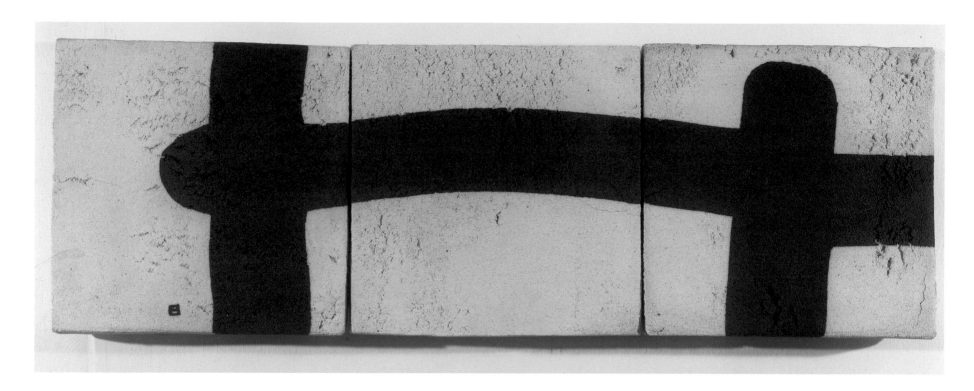

56. *Lurra (Earth)*. 1985. Fired
clay, unique, 15 × 45¼ × 2⅜ in.
(0.38 × 1.18 × 0.60 m.). Collec-
tion Tasende Gallery, La Jolla

right: 57. *Oyarak Txiki (Small
Echo)*. 1970–80. Steel, 8½ × 5 ×
4½ in. (0.21,5 × 0.12,5 ×
0.11,5 m.). Private collection,
Switzerland

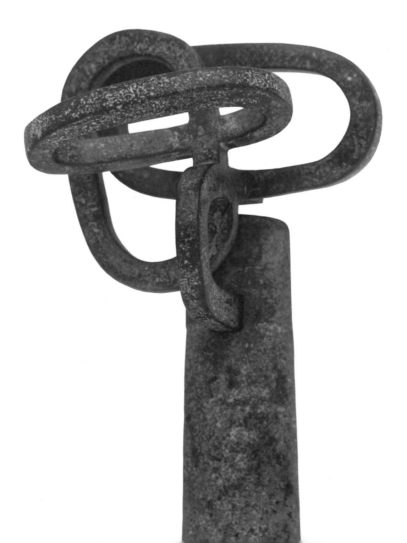

opposite: 58. *Oyarak II (Echo II)*.
1965–70. Steel, 79 × 88½ × 79
in. (2.00 × 2.25 × 2.00 m.).
Private collection

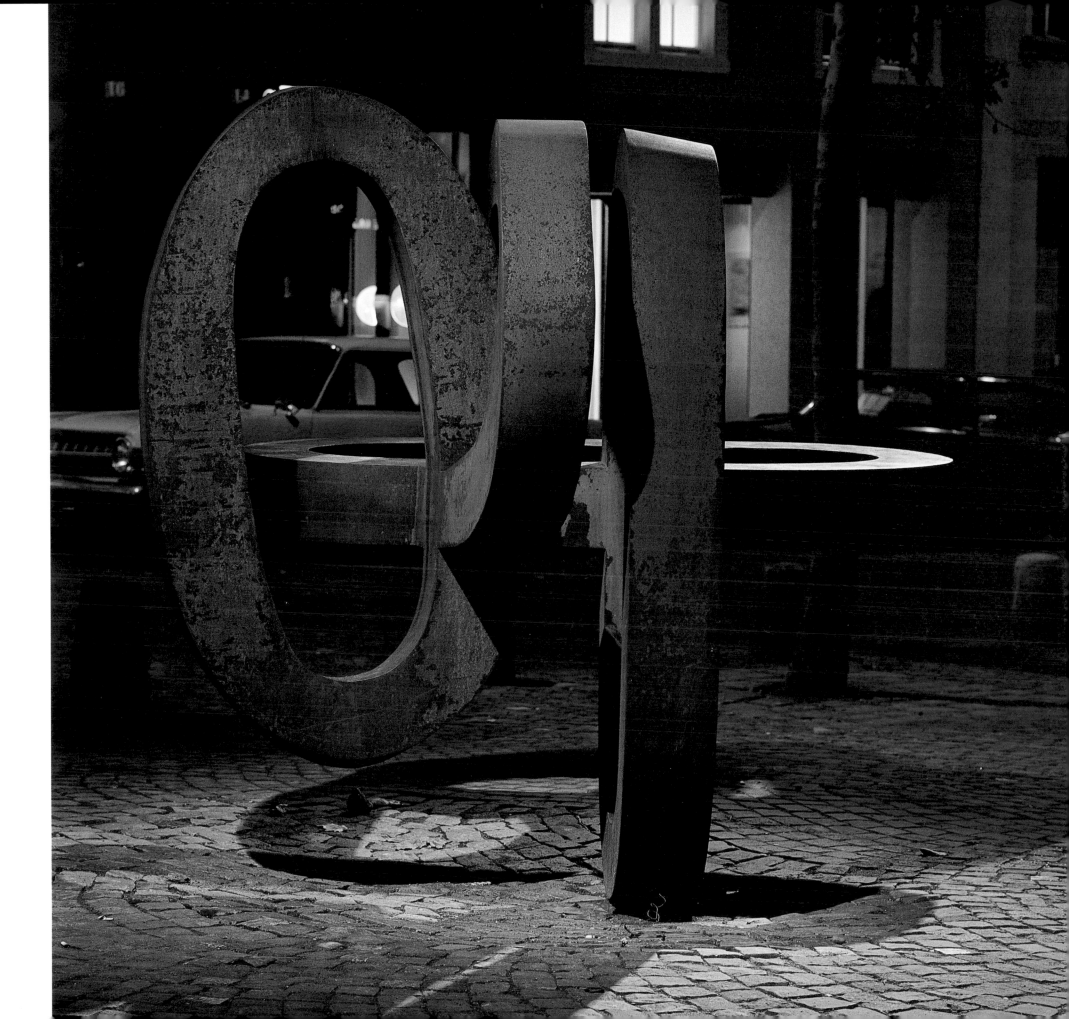

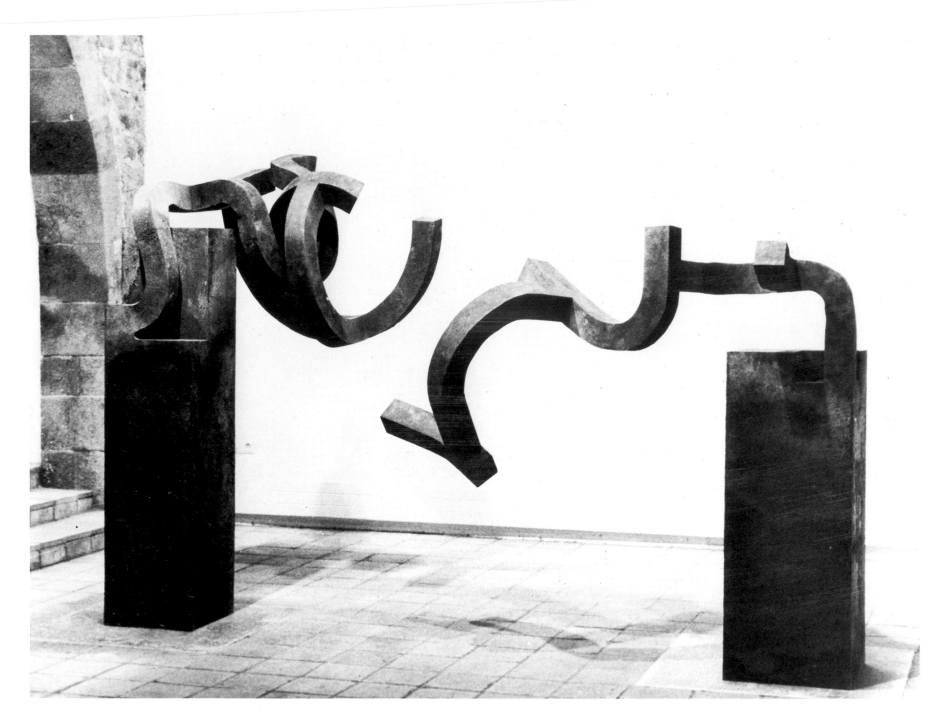

59. left: *Stele for Salvador Allende.* 1974.
Steel, 81 × 52 × 63½ in. (2.06 × 1.32 ×
1.61 m.). Private collection, Switzerland
right: *Stele for Pablo Neruda.* 1974. Steel,
66½ × 78½ × 32½ in. (1.69 × 1.99,5 ×
0.82,5 m.). Private collection, Tehran

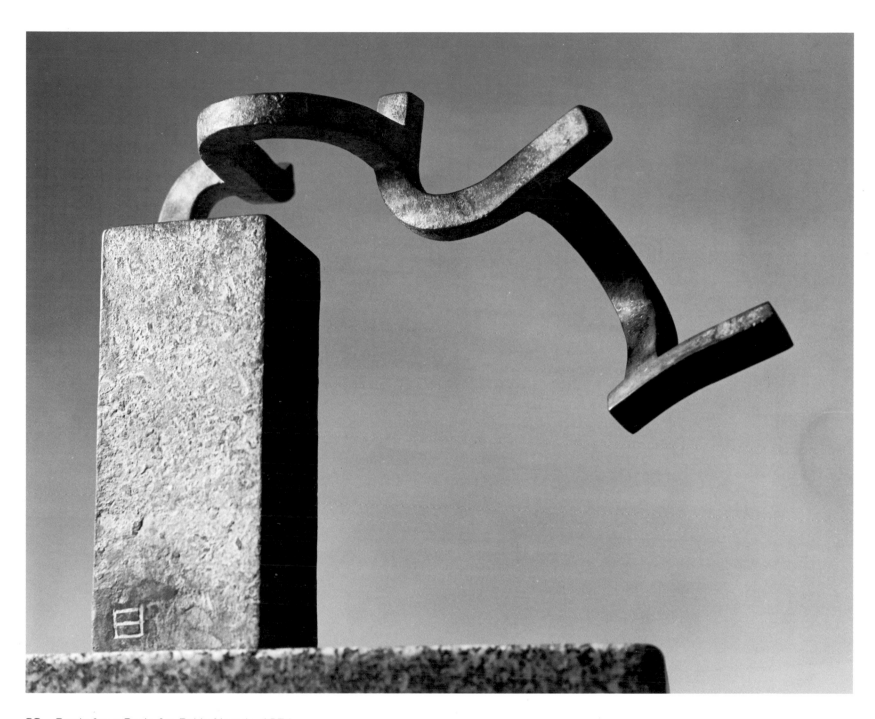

60. *Study for a Stele for Pablo Neruda.* 1974.
Steel, 5½ × 7 × 1½ in. (0.14 × 0.18 ×
0.4 m.). Collection the artist

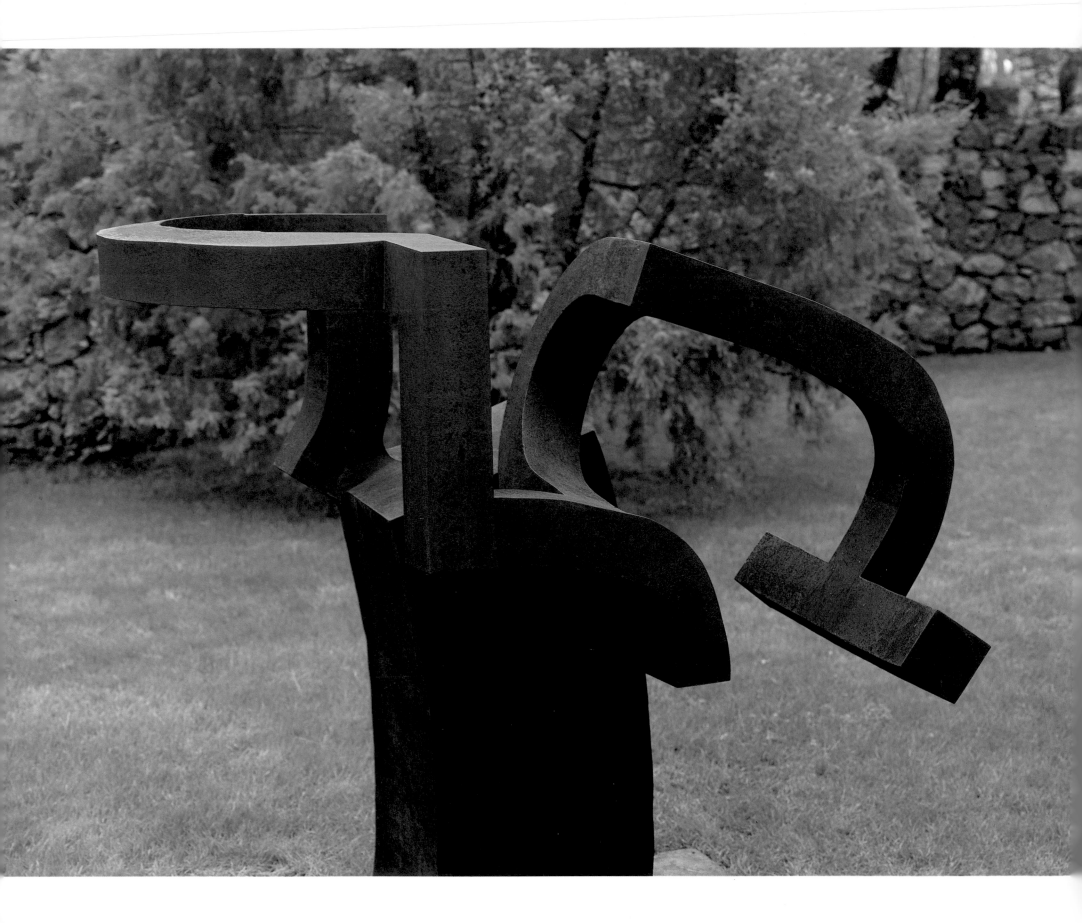

matter, these paintings are deeply human in content and bear titles made up of new word coinages such as *Antropofuma* or *Humunculos*. Millares died in 1972 at forty-six and Chillida's memorial stele for him (fig. 61) is a cantilevered sign of curved surfaces and their shadows embracing empty space.

In 1974 the sculptor decided to make steles for two Chilean heroes who had died a few days apart, Pablo Neruda and Salvador Allende (figs. 59 and 60). Neruda, Nobel laureate for his evocative and committed poetry, diplomat, and Communist partisan, is commemorated with a triple arc made from a single steel bar that swings from its pedestal into the freedom of space. Allende, the first freely elected Socialist head of state in the Americas, who was overthrown and killed in a bloody coup in 1973, is memorialized with a large steel stele whose curved decussate arms pulsate in the void. These two steles relate to each other and were originally shown as a pair.

In the same year Chillida made a *Stele for Giacometti* (fig. 62), who was a good friend as well as an artist he greatly admired. The low stele comes closer to the crowded Surrealist cages and enclosures Giacometti made around 1930 than to the master's later figures, whose weightlessness withstands all intrusions of space.

In 1977 Chillida fashioned a stable column with a sinuous filament emerging from its solid shaft, creating a tangled cluster—the flowing, organic form in contrast to the solidity of the supporting cylinder. He dedicated this stele (fig. 63) to the memory of Henri Bergson, the French philosopher, who taught that the material world, known and measured by the intellect, is resisted by an all-pervasive life force which is free and vital, which can be experienced and remembered, but resists mensuration.

Chillida speaks with great devotion of Novalis, the great mystic poet of early German Romanticism, who believed that the world was sustained by an invisible universal spirit that made itself manifest in the inner being of the artist. It was Novalis who, perhaps more than anyone else in his time (1772–1801), anticipated modernity and who, in fact, suggested a theoretical basis for abstract art when he wrote that painting, "truly visual music, consists of arabesques, patterns, ornaments."[13] The small stele dedicated to Novalis (fig. 64) has rounded swinging forms, which almost, but not entirely, close the circle—a unity which is sought, but never found. The *Stele for Edgar Allan Poe* (fig. 65), one of the giants of American literature, in contrast, is all angles, blocklike and severe. It consists of geometric forms, ciphers asymmetrically disposed.

Around this time, Chillida's sculptures of respect take on other forms. His *Homage to Calder* (1979, fig. 66) is a huge, heavy hanging sculpture in which three circular elements enclose space on four sides and, at the same time, swing in the space surrounding the steel forms. For Calder, inventor of the mobile, everything is in a state of flux, and Chillida himself has observed that instability, not stability, is the only constant element.[14]

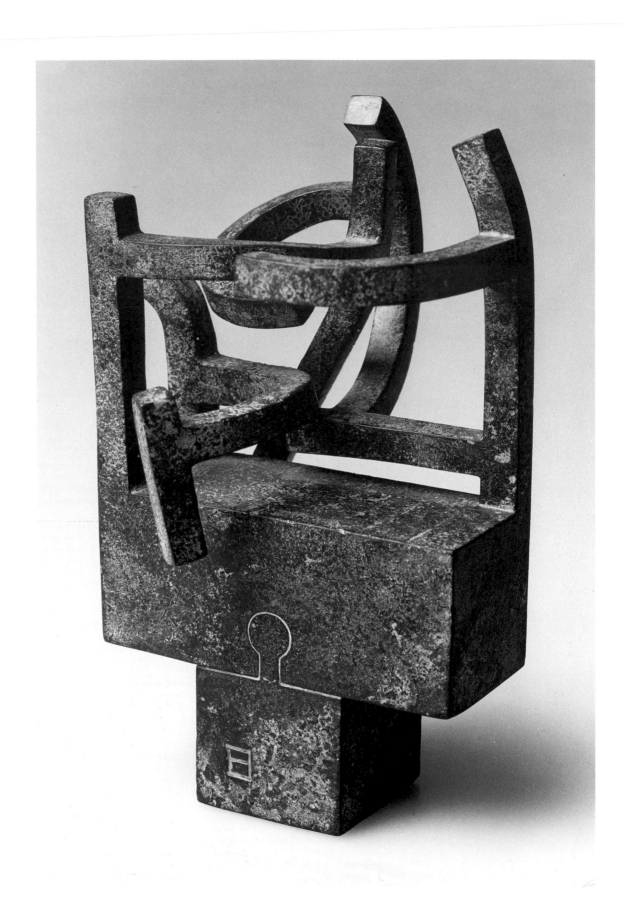

62. *Stele for Giacometti.* 1974. Steel, 7½ ×
4 × 5 in. (0.19 × 0.10 × 0.12,5 m.). Collec-
tion Mr. and Mrs. Bruno Giacometti

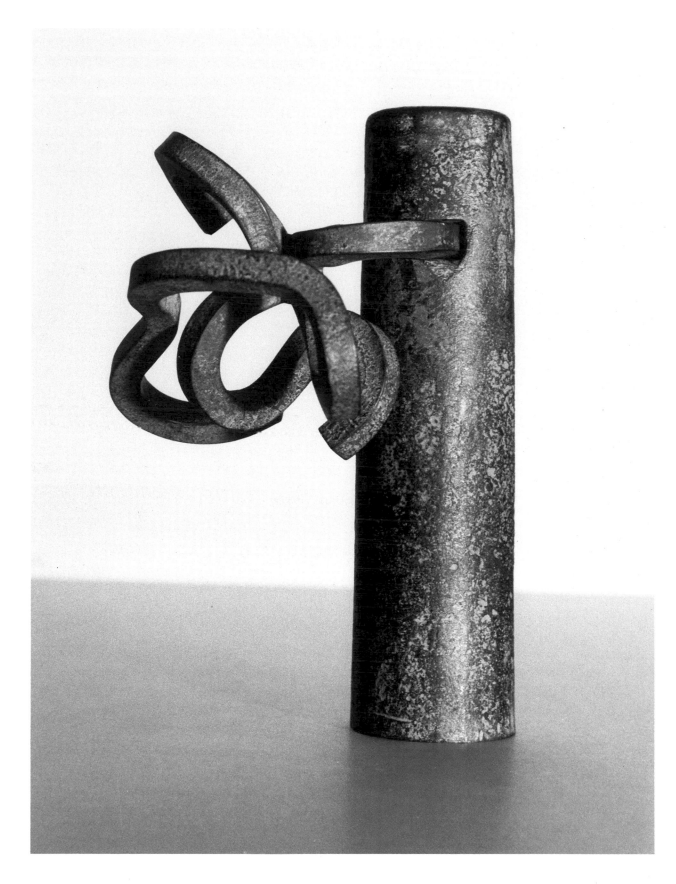

63. *Stele for Bergson.* 1977. Steel,
8 × 5 × 4 in. (0.20,5 × 0.13 ×
0.10 m.). Private collection, West
Germany

below: 65. *Stele for Edgar Allan Poe.* 1978. Steel, 9 × 7 × 5 in. (0.23 × 0.18 × 0.13 m.). Private collection

opposite: 66. *Homage to Calder.* 1979. Steel, 75 × 87½ × 67 in. (1.90,5 × 2.22 × 1.70 m.). Collection Galerie Maeght Lelong, Paris. Photo, San Sebastián

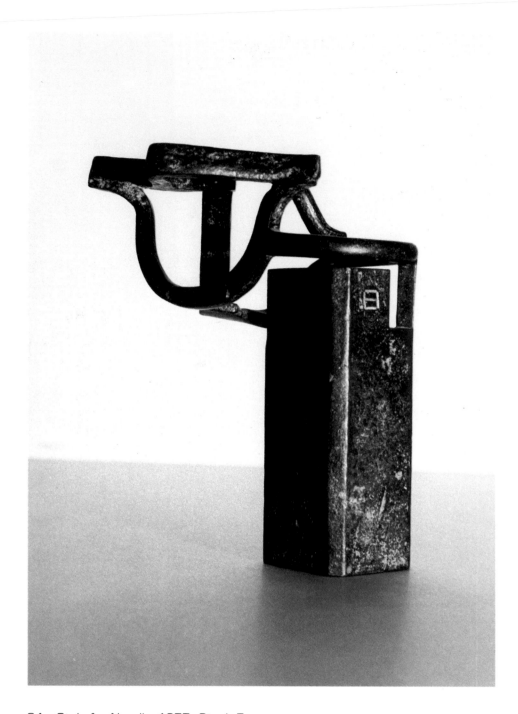

64. *Stele for Novalis.* 1977. Steel, 7 × 6½ × 5 in. (0.18 × 0.16,5 × 0.13 m.). Private collection, West Germany

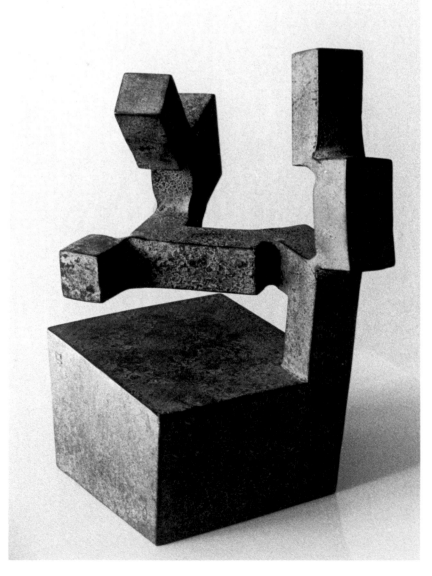

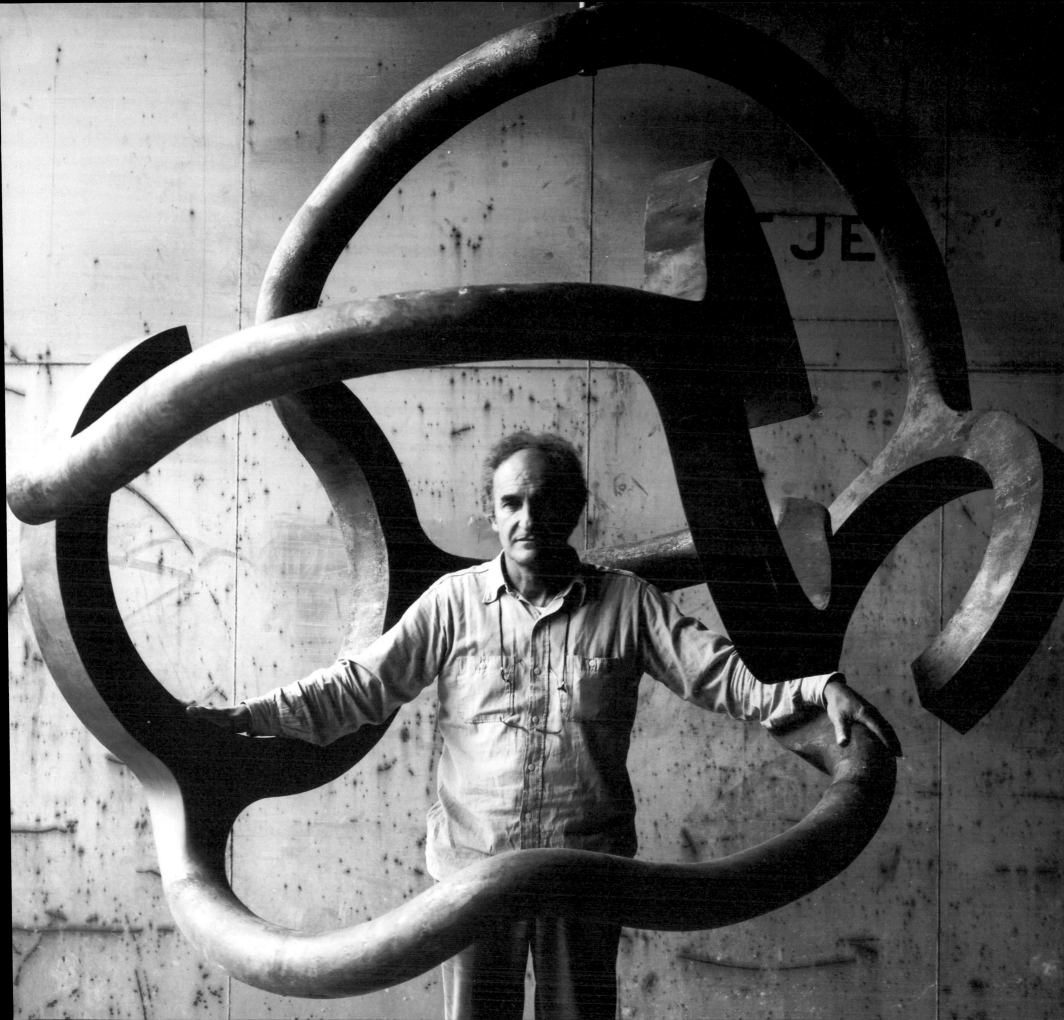

In 1981 the sculptor made a cube of concrete that he dedicated to his friend, the distinguished Spanish poet Jorge Guillén (1894–1984). Chillida had spent a good deal of time with Guillén when he was in residence at Harvard University in 1971, where the poet had been teaching much of the time since his emigration from Spain in 1938 after Franco's rise to power. Guillén's poetry, not unlike Chillida's formal intuition, often deals precisely with physical reality while at the same time taking pleasure in the sensual and emotional. Lines such as

All of space is a wave transfixed...

It buys up the whiteness of the void...

A pure instant of life...

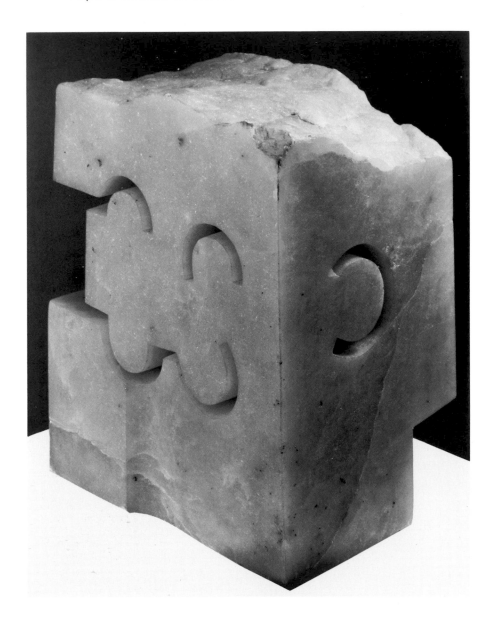

67. *Project for a Monument to Jorge Guillén I.* 1980–81. Alabaster, 15 × 12 × 9 in. (0.38 × 0.30,5 × 0.23 m.). Collection Galerie Maeght Lelong SA, Zurich

opposite: 68. *Homage to Jorge Guillén.* 1981. Concrete, 82 × 41¼ × 60¾ in. (2.08 × 1.05 × 1.54 m.). Collection the artist

overleaf left: 69. *Omar Khayyám's Table I* (detail). 1982–83. Steel, 149 × 58¾ × 19 in. (3.79 × 1.49 × 0.48 m.). Collection Mr. and Mrs. George Segal, East Hampton, New York

overleaf right: 70. *Omar Khayyám's Table I*

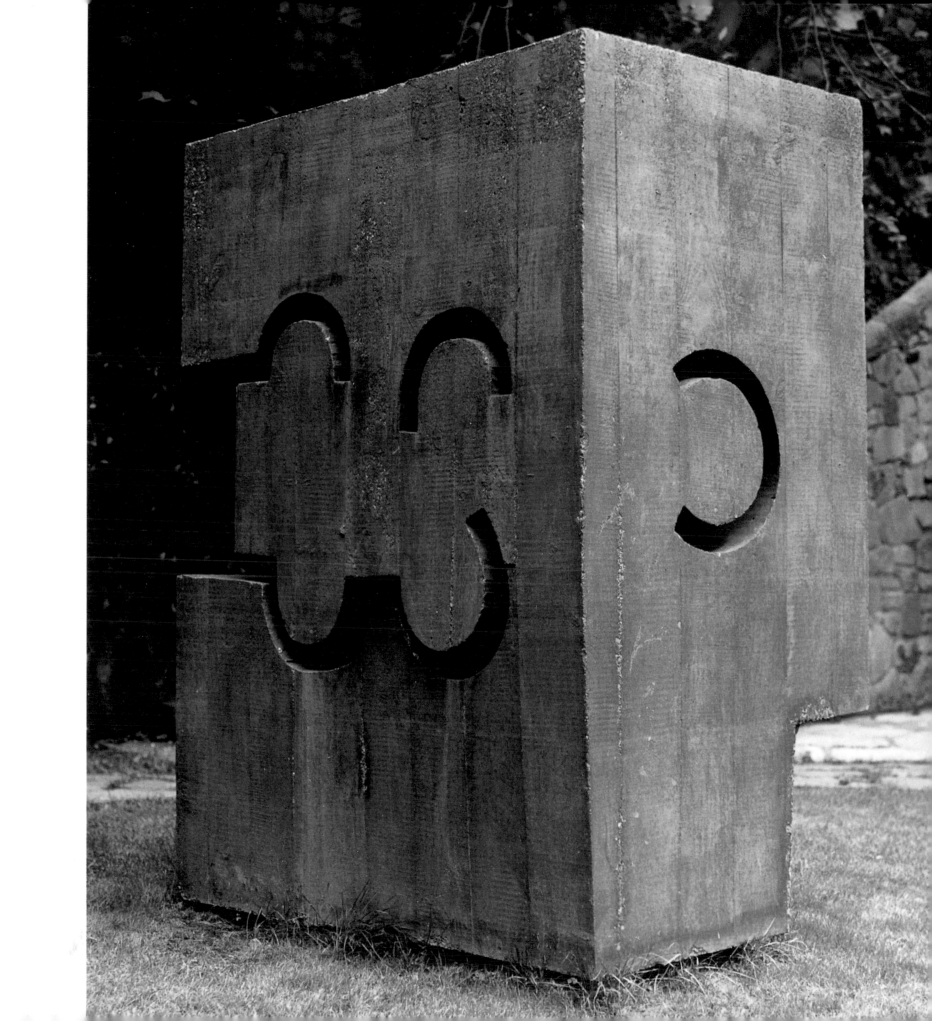

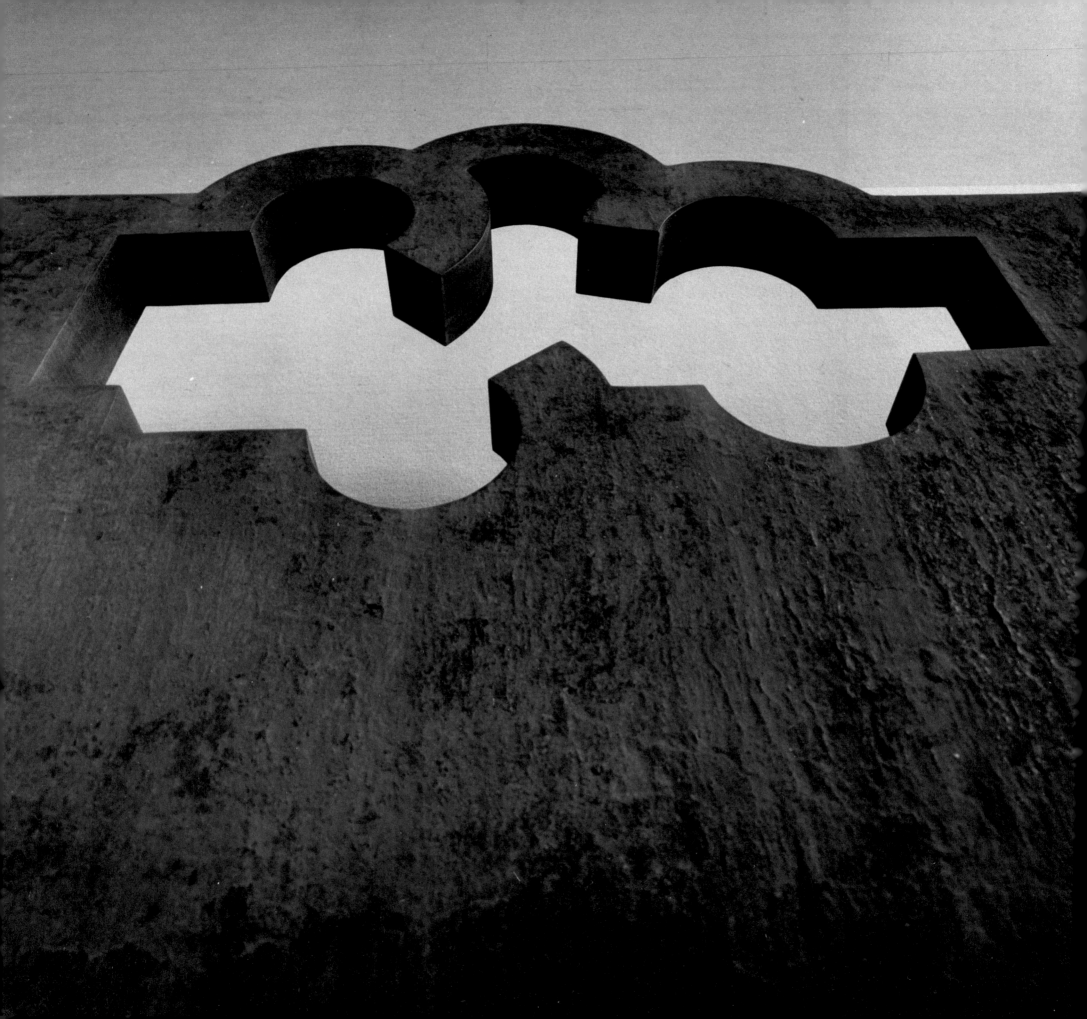

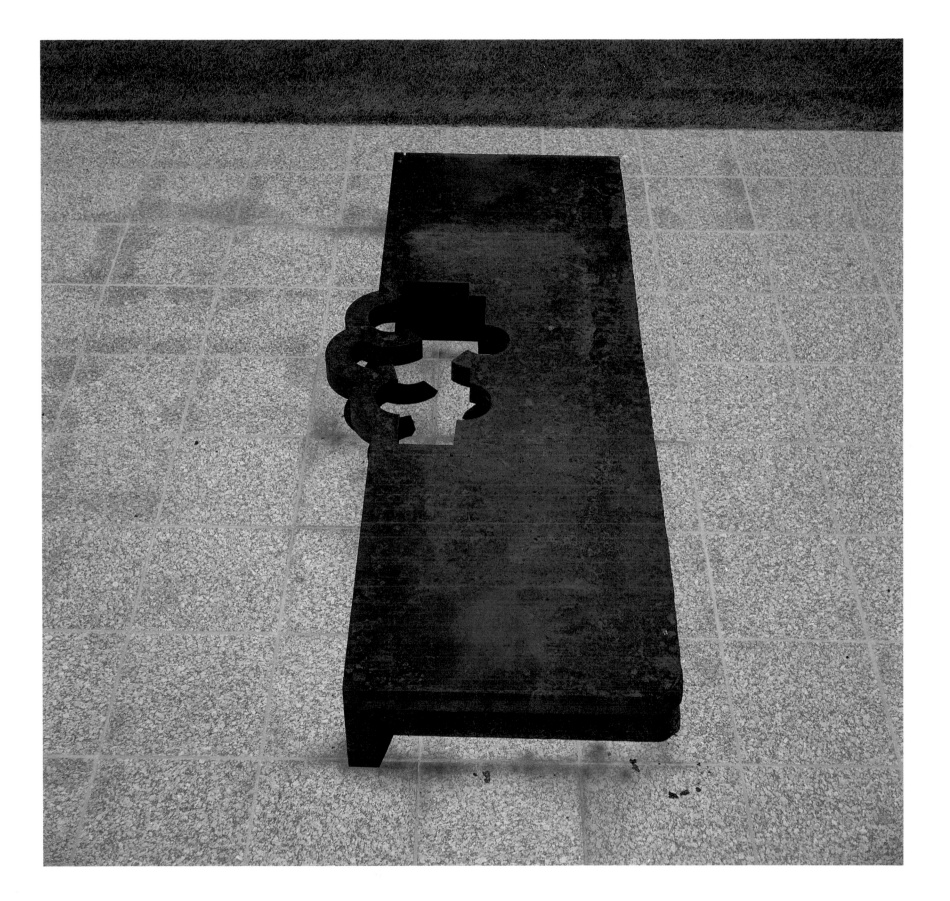

from Guillén's "Flight"[15] would strike a receptive chord in the mind and vision of the sculptor. *Homage to Jorge Guillén* (fig. 68) is a heavy block, almost seven feet high and five feet deep. Cubic in form, it is not a geometric figure but is uneven in its dimensions, and nonuniform in profile. Again, the wooden forms are left visible in the surface. The deep, somewhat irregular semicircular incisions suggest intertwined monograms or simple signs of a secret script.

In place of the heavy vertical block in the *Guillén*, the *Omar Khayyám* series (figs. 69–73) is composed of flat, horizontal steel slabs or tables. Could it be that, looking out at the sea from his house on a hill overlooking the Bay of Biscay, Chillida's mind and eye were impregnated with "water, the queen of the horizontal"?

Chillida continued to be greatly concerned with problems of levitation and gravitation, with the relationship of weight to space. In these horizontal tables, the forms are pushing space against the floor. He experimented for a long time to discover by trial and error the optimal level for the visual impression of apparent levitation, which he found to be fourteen and a half inches from the floor. The low tables rest on three legs, but the viewer, able to see only two from almost any angle of vision, is under the illusion that the table is partly levitated in space. The combination of fantasy and poetry with precise projective calculation made Chillida decide to dedicate this series to Omar Khayyám, the eleventh-century Persian who was a great astronomer and mathematician as well as a fine poet of sensuous quatrains. The number three is of great importance to Chillida; it has qualities both dynamic and mysterious and opens toward new and inaccessible limits. He stated:

> The Number Three does not deal with small solutions. One can resolve everything with Two. One can go to the moon with Two. But you cannot project beyond it. In order to do the impossible, it is necessary to reach for Three.[16]

In *Silent Music II* (1983, figs. 74 and 75) he pushes the juxtaposition of the horizontal and vertical even further. The plane and upright are in a state of equipoise—linked by a rectangular slice of silent space that has been carved with what the Japanese in one of their classical painting manuals refer to as a "stretched iron wire line."

The artist originally designed *The Liberty Door I* (1983, fig. 76) as a monument to Simón Bolívar for Caracas, where the great Liberator was born. The perpendicular slabs are angled in a state of tension, both pulled apart and joined together by angular space.

In contrast to the horizontal and vertical steel sculptures of recent years, Chillida has also done imposing pieces totally open to the embrace of space. In *In Praise of the Void II* (1983, fig. 81) the elliptical form with its jagged serrations is

71. *Omar Khayyám's Table II.* 1983. Steel,
19½ × 151½ × 64½ in. (0.49 × 3.85 ×
1.64 m.). Collection Jacques Hachuel, Madrid

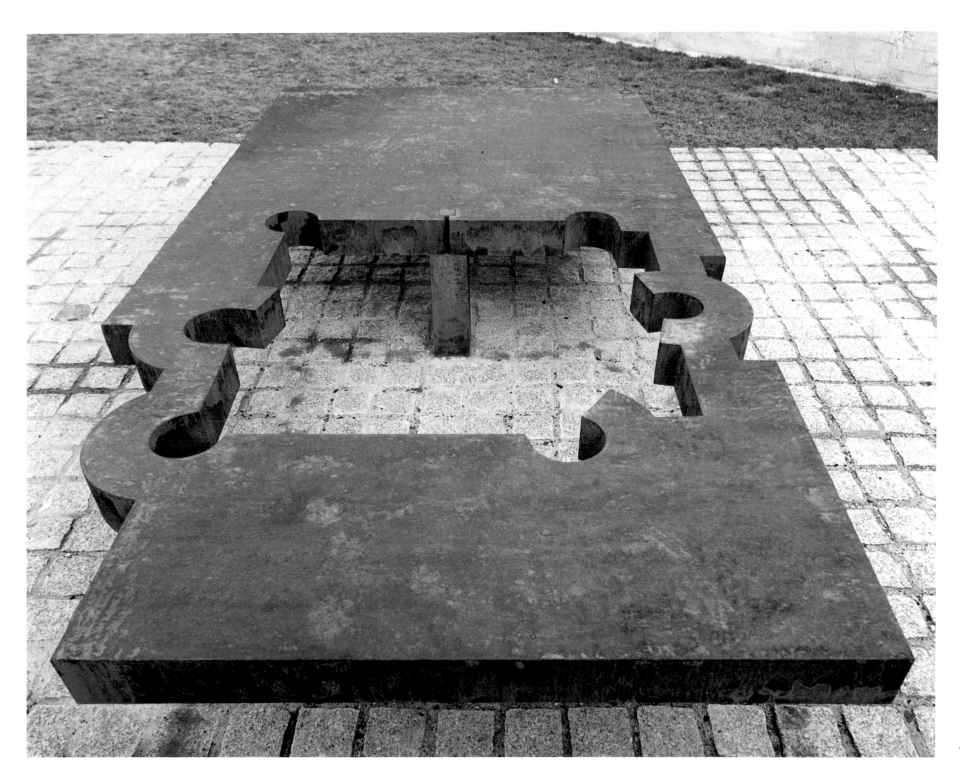

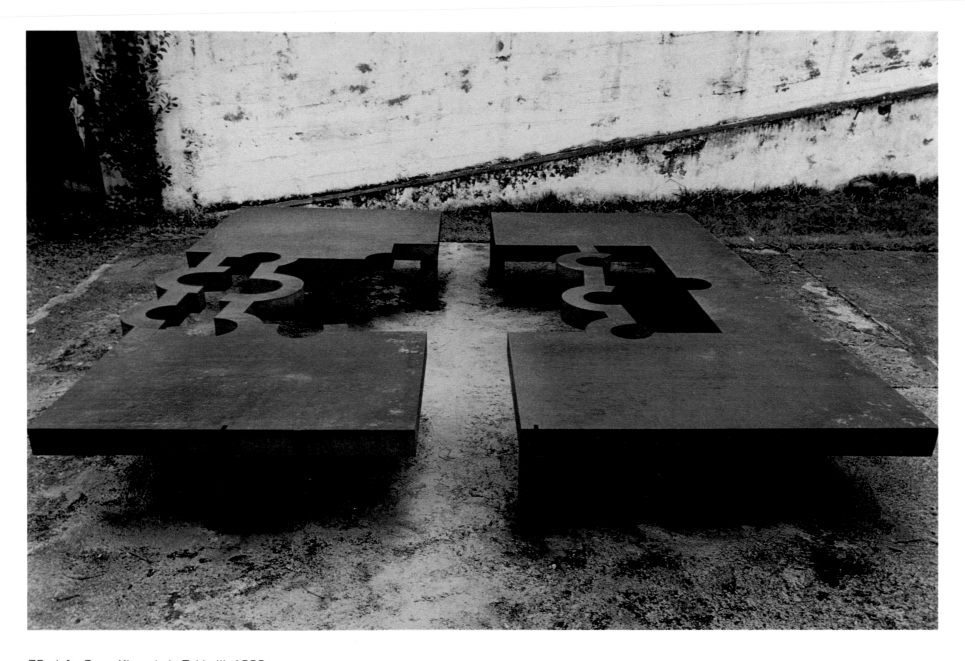

72. left: *Omar Khayyám's Table III.* 1983.
Steel, 19¼ × 151½ × 63½ in. (0.49 ×
3.85 × 1.62 m.).
right: *Omar Khayyám's Table IV.* 1984. Steel,
19¼ × 151½ × 65½ in. (0.49 × 3.85 ×
1.66 m.). Collection the artist

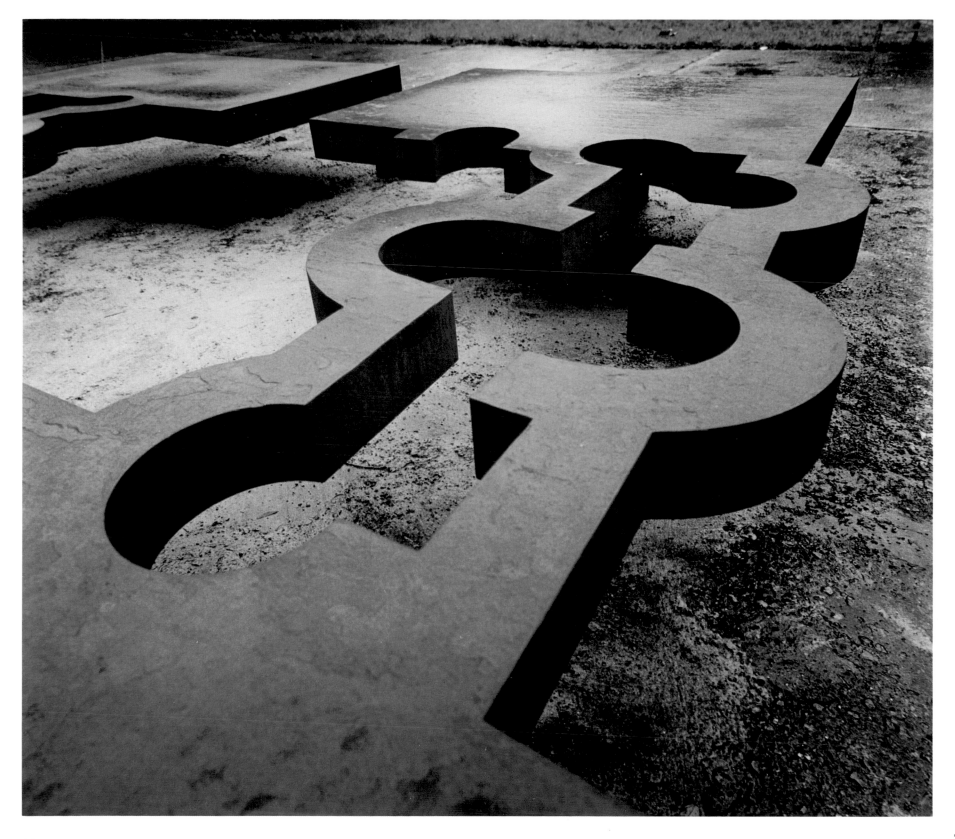

73. *Omar Khayyám's Table III* (detail)

74. *Silent Music II* (detail). 1983. Steel,
31½ × 75⅜ × 41¾ in. (0.80 × 1.91, 5 ×
1.06 m.). Collection Tasende Gallery, La Jolla,
California

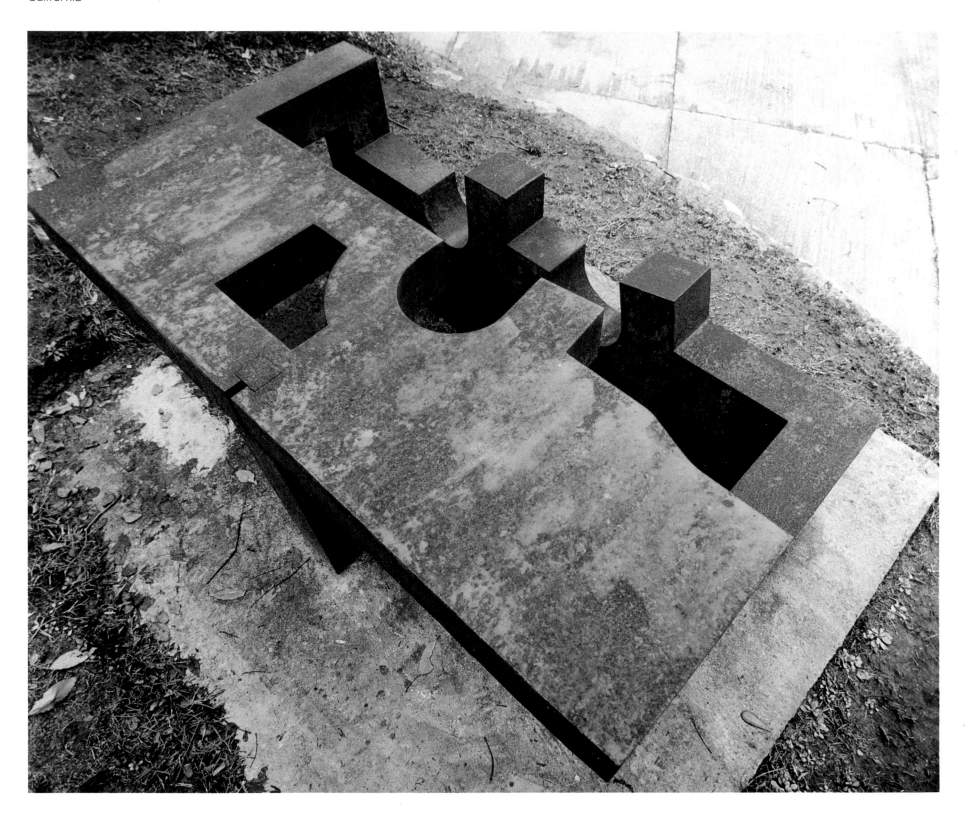

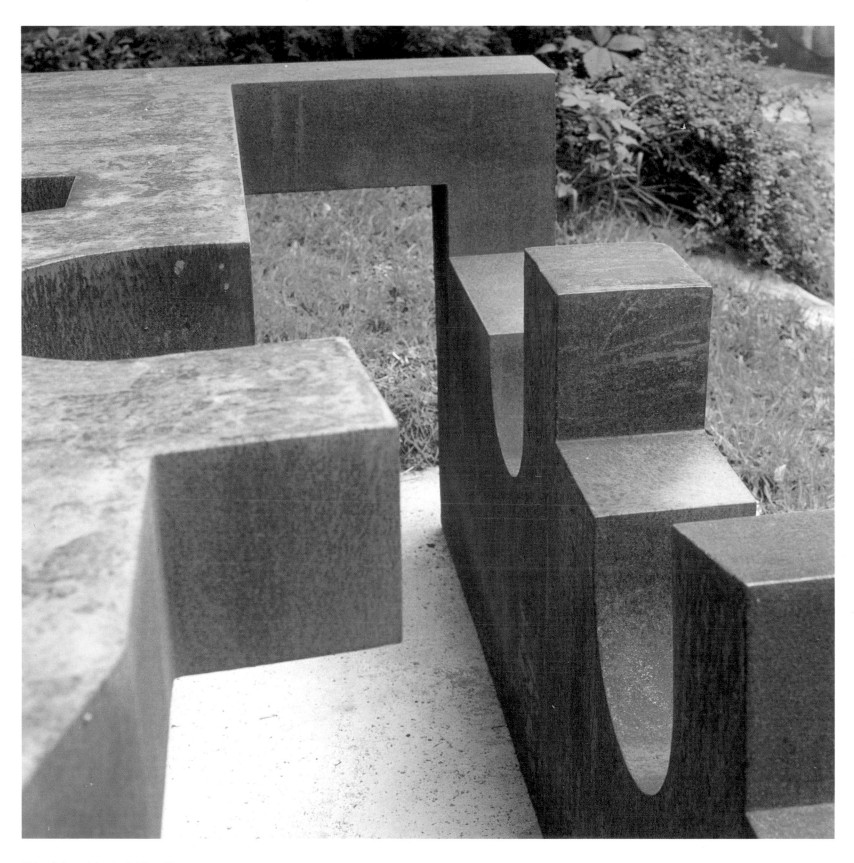

75. *Silent Music II* (detail)

opposite: 78. *The Liberty Door II* (detail)

overleaf left: 79. Chillida with *The Liberty Door II*. Photo, San Sebastián

overleaf right: 80. *The Liberty Door II* (detail)

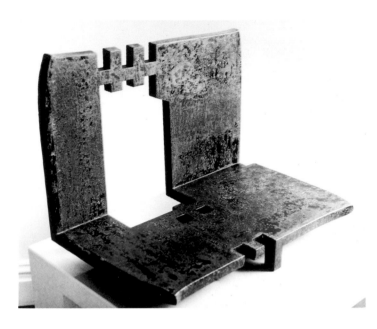

76. *The Liberty Door I.* 1983. Steel, 23½ × 17¾ × 14¼ in. (0.60 × 0.45 × 0.35 m.). Collection Mr. and Mrs. George Segal, East Hampton, New York

right: 77. *The Liberty Door II.* 1984. Steel, 97¼ × 96½ × 48½ in. (2.47 × 2.45 × 1.23 m.). Collection the artist

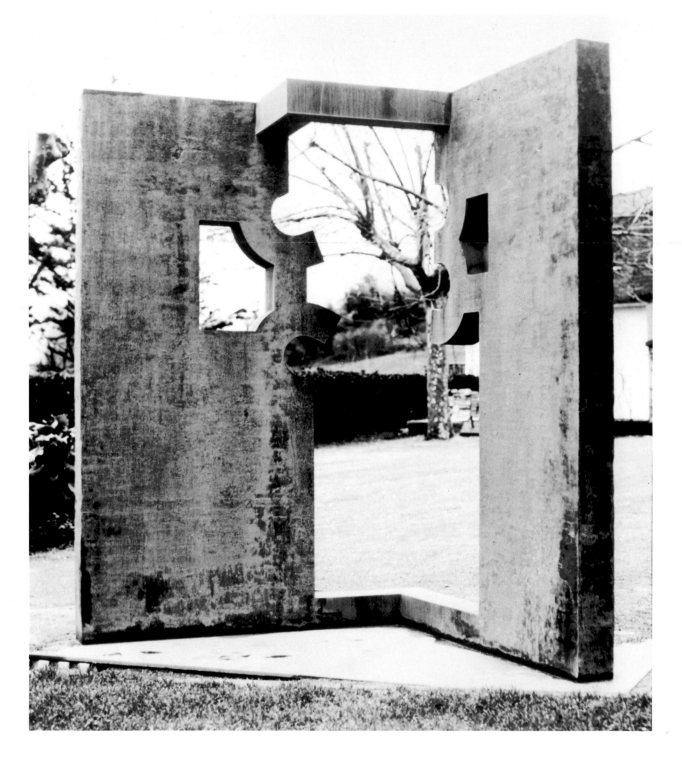

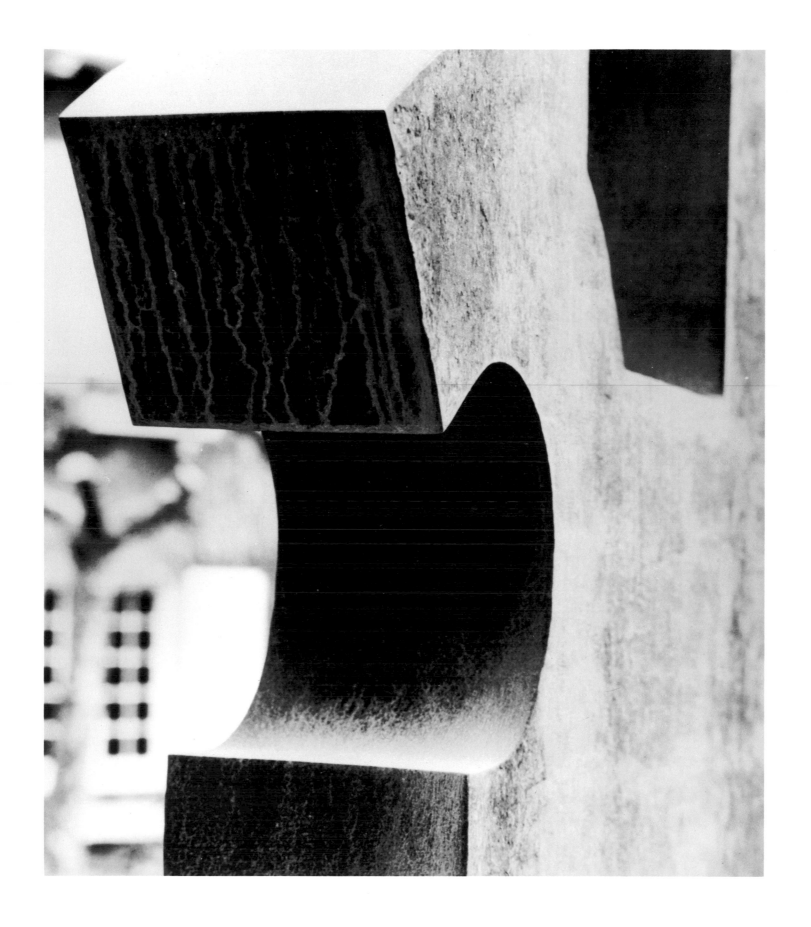

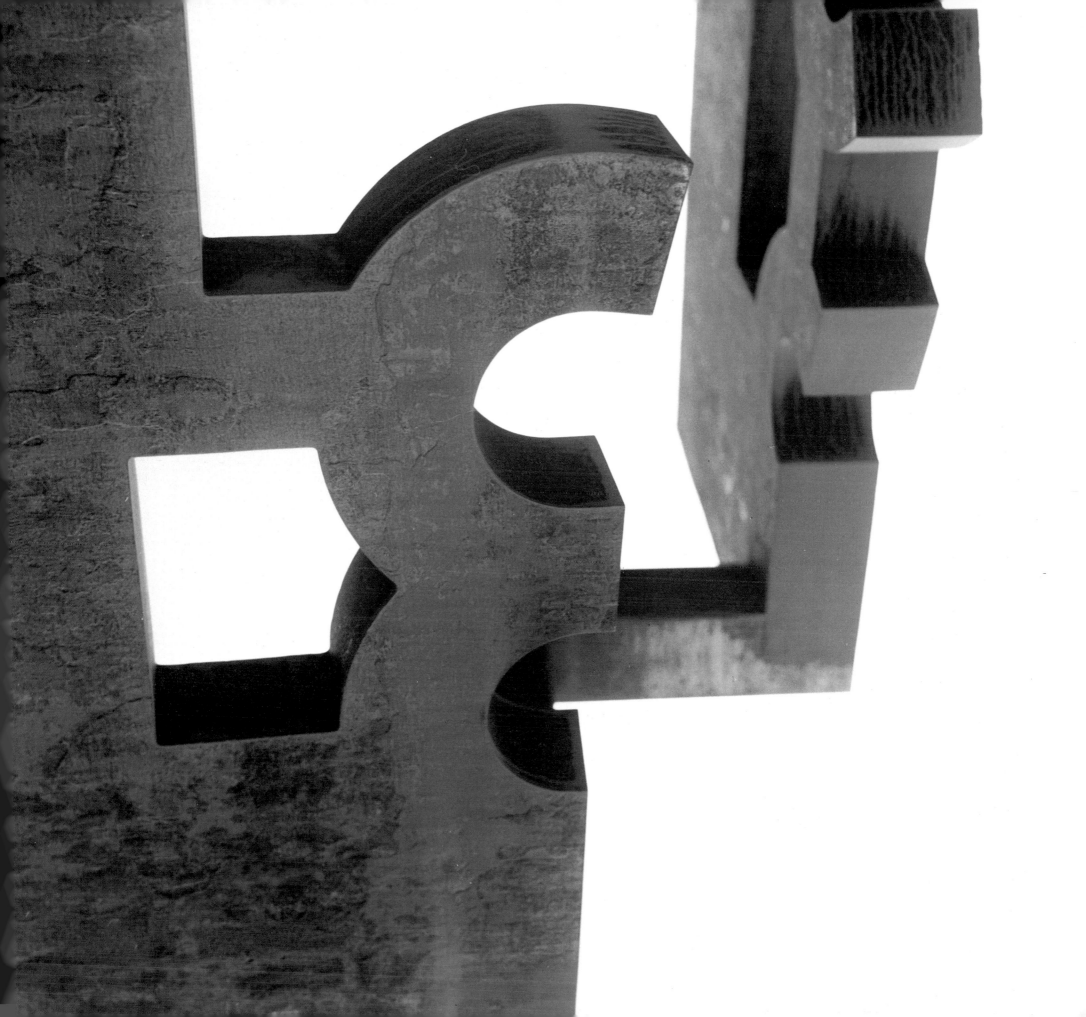

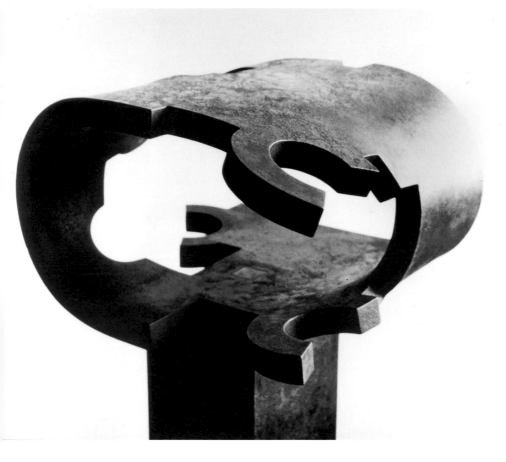

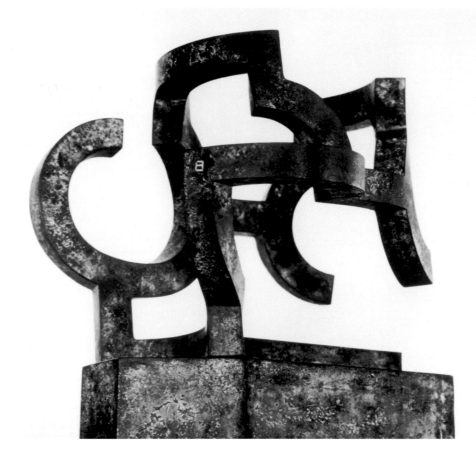

81. *In Praise of the Void II*. 1983. Steel, 24½ × 11¾ × 9¾ in. (0.62 × 0.30 × 0.25 m.). Collection Galerie Beyeler, Basel

82. *In Praise of the Void III*. 1983. Steel, 40¼ × 15¾ × 15¾ in. (1.20 × 0.40 × 0.40 m.). Collection Galerie Maeght Lelong, Zurich

opposite: 83. *In Praise of the Void V*. 1982. Steel, 17 × 11½ × 12½ in. (0.43 × 0.29 × 0.32 m.). Collection Frank Ribelin, Garland, Texas

wrapped around the void interior. The two 1984 *Steles for Agamemnon* (figs. 85 and 86) appear like well-worn ruins from an ancient civilization where the hand of time has eroded a once solid form. Tiny in size, they are monumental in scale.

Chillida deals with the full and the empty; he has used all the materials and processes at his command in a logical sequence toward increasing complexity of geometric relationships. In his open disposition of elements, clarity and precision are fused with inventive imagination and intuitive vigor.

When Guillaume Apollinaire wrote in 1913 that "geometry is to the plastic arts what grammar is to the art of the writer,"[17] he no longer referred to the Renaissance system of measured structure and perspective, but to non-Euclidean systems of ordered infinity and improbability. Similarly Chillida touches upon the ever-present problem of the limit, which, of course, is inaccessible because it cannot be delineated. The limit is the mysterious aspect of space and comes to grips with the ineffable.

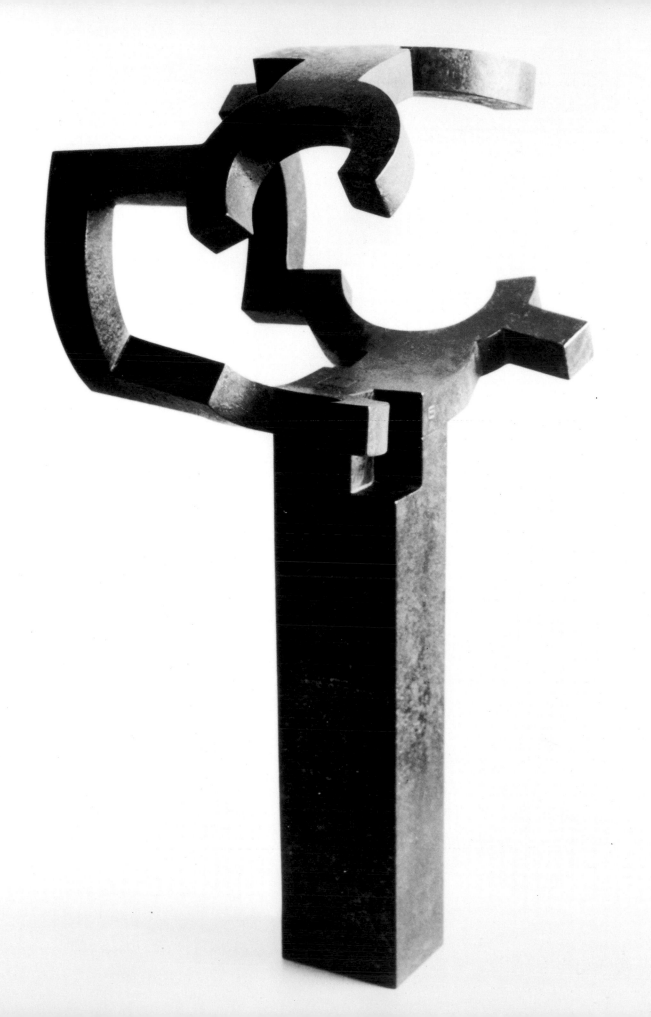

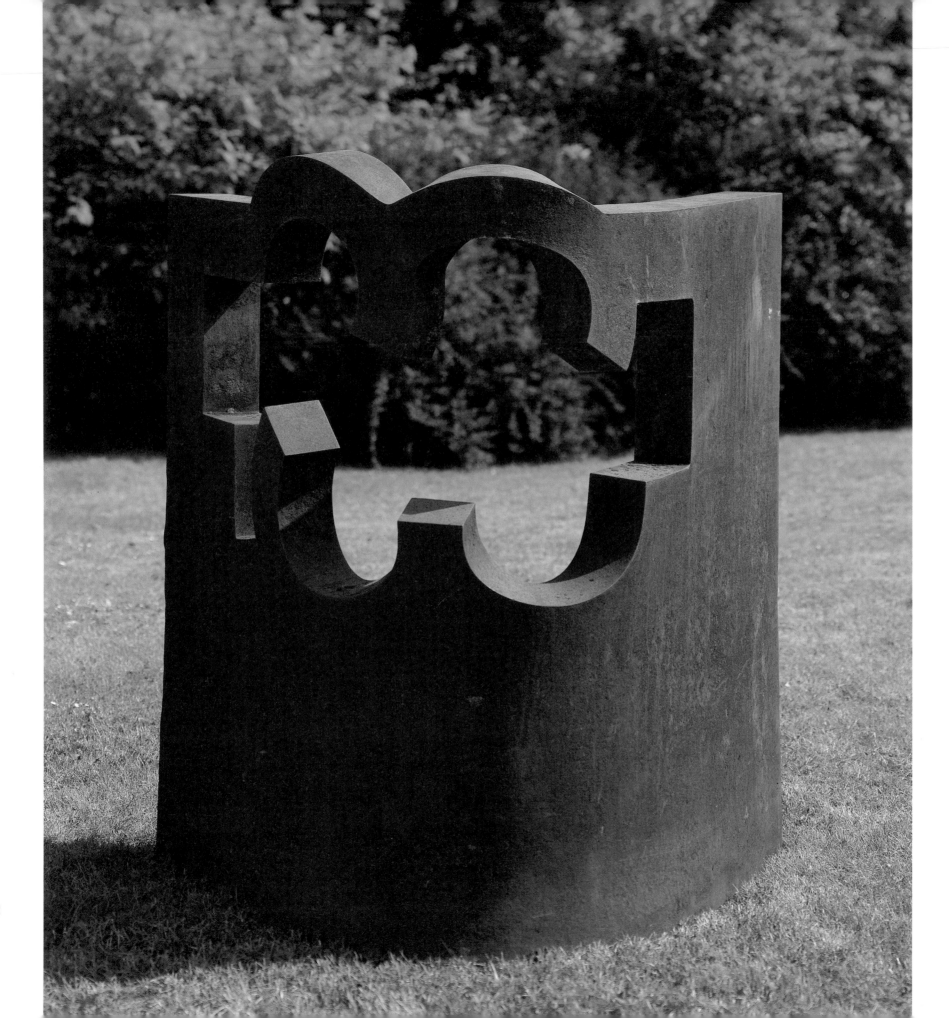

82

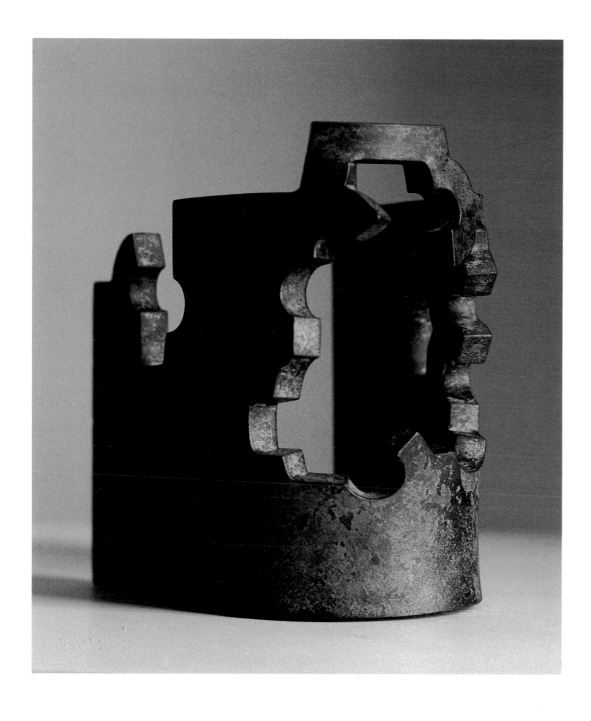

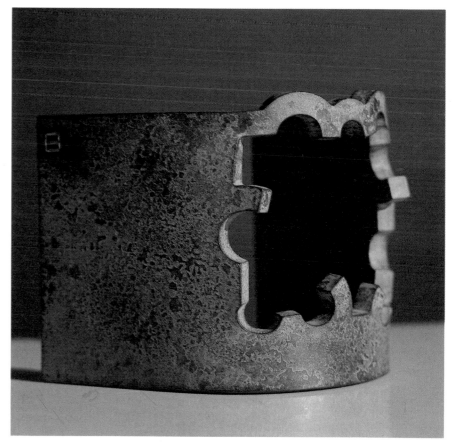

85. *Stele for Agamemnon II.* 1984. Steel,
6¼ × 4¼ × 6 in. (0.16 × 0.10,5 × 0.15
m.). Collection the artist

86. *Stele for Agamemnon III.* 1984. Steel,
5¾ × 7 × 6 in. (0.14,7 × 0.17,5 × 0.15
m.). Collection the artist

opposite: 84. *Stele for Agamemnon I.* 1982.
Steel, 58½ × 49¼ × 37½ in. (1.49 ×
1.25 × 0.95 m.). Collection the artist

Sculpture in the Public Domain

By tradition, sculpture is a public art, which in the past—from Angkor Wat to the Piazza Navona—has created communal experiences, ranging from enchantment to mystical participation. But in the nineteenth century, public sculpture was mostly evidenced in heroic monuments in which rulers of ostentatious pomposity or generals on horseback exalted established social institutions, their privileges and victories, and at least figuratively subdued thoughts of change. The twentieth century, often questioning traditional values, came to find little relevance in such sculptures. Today even such idealistic monuments as the Statue of Liberty or the Triumph of the Republic have become little but tourist attractions, and the multitude of monuments to military victories are no longer capable of rousing the patriotism of the citizenry.

It took a very long time for modern concepts in public sculpture to find acceptance. The Constructivists in particular attempted to create meaningful symbolic sculpture for a dynamic revolutionary society in the twentieth century, but Vladimir Tatlin's materialist design based on the theme of a rotating spiral, the *Monument to the Third International* (1920), remained, ironically, a utopian vision, and it was not until 1957 that a Constructivist sculpture appeared in the public arena, when Naum Gabo was commissioned to make a large work in stainless steel and gilded bronze for the front of a Rotterdam department store.

Brancusi's ensemble of the *Gate of the Kiss*, *Table of Silence*, and *Endless Column* was erected in the 1930s as a sculptural environment both spiritual and secular in meaning, symbolizing the mystery of human existence. But it is in the very remote Romanian village of Tîrgu-Jiu, at the foot of the Carpathian Mountains, almost at the edge of Europe. In fact in 1938, the year this group was

completed, Lewis Mumford wrote: "The notion of a modern monument is veritably a contradiction in terms: if it is a monument, it is not modern, and if it is modern, it cannot be a monument."[18] It is certainly true that most of the finest and most innovative modern sculpture has been highly personal and autonomous, following little but the artist's individual concepts. Largely self-referential, modernism postulates that artists' standards are their own, and the audience is welcome to meet the artists on their own ground. It was not until the post—World War II period that the public gave increasing acceptance and patronage to abstract sculpture. Much of it seemed in accordance with an expanding industrial and technological society, and it appeared with increasing frequency in art dealers' showrooms, museums, private collections, and public spaces. Furthermore the realization grew that sculpture is a concrete, material object rather than a symbol of hieratic values. Very rapidly, however, the very ideas, concepts, and techniques of the pioneers' modern abstract sculpture became sterile as the new academies produced a generation of sculptors who fabricated a plethora of soft biomorphic or hard geometric constructions and plunked them down in public spaces with little thought given to site, scale, or purpose. Corporations as well as government agencies opted for cosmetic artifacts which managed to express a sense of power without offending anyone. Attractive as some of these basically mobile sculptures are, they demonstrate the absence of a sense of place in the works and, indeed, the homelessness of modern society.

Chillida's first public sculptures were placed in preexisting public spaces. In the mid-1960s, after having constructed large wooden pieces, the sculptor wanted once more to carve in stone on a large scale. He expressed this desire to James Johnson Sweeney, who was preparing a retrospective exhibition of the artist's work for The Museum of Fine Arts in Houston. Sweeney arranged for Chillida to be commissioned to create a work for the South Garden of the museum. The sculptor found the right material, rose-colored granite, in an abandoned quarry in Galicia, in northwestern Spain. To launch into this vast project he made a wooden maquette, *Abesti Gogora I* (*Rough Chant I*, see figs. 23 and 24), which was "far from the character of the final realization," he assured the director of the museum, "because of the difference in scale and material."[19] He began carving the granite blocks in the mountains near Budiño, in Galicia. Then after working on it for about a year, he had them trucked to the port of Vigo for shipment to Houston, where the sixty-ton work was assembled by large cranes. Because of illness, he was unable to supervise the final assemblage and installation in 1966 of the fifth and final version of *Abesti Gogora* (see fig. 27). The three huge stones with their semigeometric forms create a striking contrast to the arboreal surrounding. A stone sculpture—itself a piece of nature, quarried from the rock and formed by man—is set in a garden environment, also cultivated by man. *Abesti Gogora V* is set in view of Gunsaulus Hall, Mies van der Rohe's pure, classical addition to the museum. The sculpture itself is very architectural, but instead of the rectangular

symmetry of Mies's glass and steel building, Chillida's stone is rough, irregular, and full of surprises. The positive space of the granite block and the negative space of the void are in a state of tension. In fact, the space itself seems to hold up the heavy granite. There is a powerful interrelationship of balanced discontinuity between the interlocking vertical, horizontal, and diagonal slabs. It invites the visitor to enter, to walk through; each position yields a different spatial experience.

Much as this fifth version was the ultimate work in the *Rough Chant* series, Chillida's serial steel pieces *Around the Void* found their final statement in the fifth piece, *Around the Void V* (1969, fig. 87), installed in front of the World Bank in Washington, D.C. The work consists of stainless-steel cubic forms that appear meticulously formed and finished. The joints, stretched and stressed as they are, show the power of the industrial forge. The squared components, with one arm stretching out in a powerful cantilever, surround an intricate space cell. They appear to have been wrenched apart and to be in the process of reassembling around the central empty space.

In 1971 the Thyssen Company installed a large sculpture by Chillida in front of its corporate headquarters in Düsseldorf. This commissioned piece was made at the Thyssen works in Hattingen under the artist's supervision from large sheets of Cor-ten steel that were supplied by the Thyssen plant in Oberhausen. Here a work of art was fabricated by a huge industrial concern, using highly advanced technological processes in the production of a durable alloy, as a monument to its own success. It was then donated to an industrial and financial urban center and placed in front of a large and impressive, but undistinguished, late International Style high-rise office building on a major traffic artery—not an ideal location for a sculpture by Chillida. In fact, *Monument* (1970–71, figs. 40 and 88) was originally intended for a different place on the site. But it holds its own here with prodigious eloquence. In a way it contradicts rather than passively accepts its site. Its presence sets up a new and unexpected relationship among road, building, and city. It gives life to its site and poses new questions about sculpture and the nature of reality.

Monument is a remarkable three-part work. The central, vertical spine of this anthropomorphic piece is like an articulated backbone with a series of vertebrae bent inward and upward in a steplike succession. This vertical element is a highly complex and active contrapuntal support of a long diagonal bar which stretches far outward until it reaches the ground. This, in turn, is balanced by a heavy square cube, hanging in the air, in fact seemingly held up by the space underneath it. In *Monument* Chillida combines spatial tension with geometric clarity and extraordinary vigor.

Although there is an enormous difference between Bernini's sculpture in which the marble looks like flesh, and Chillida's in which the steel looks only like steel, they share certain formal concerns. Some of Chillida's work, such as *Monu-*

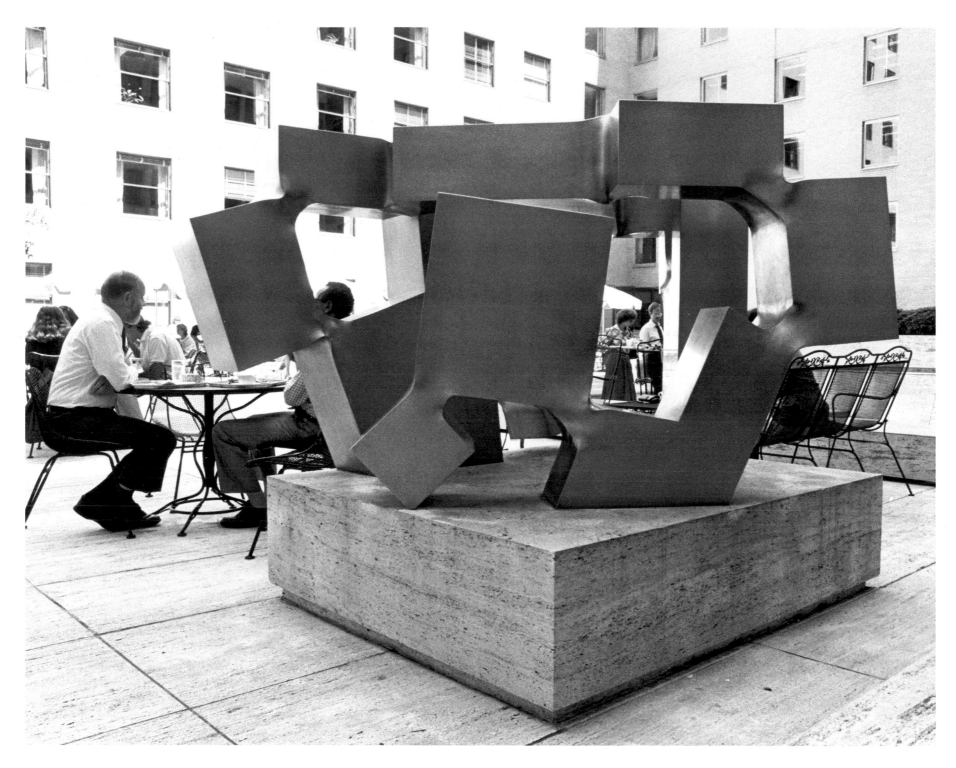

87. *Around the Void V.* 1969. Steel, 52 ×
96 × 36 in. (1.32 × 2.33,5 × 0.91,5 m.).
Collection World Bank, Washington, D.C.

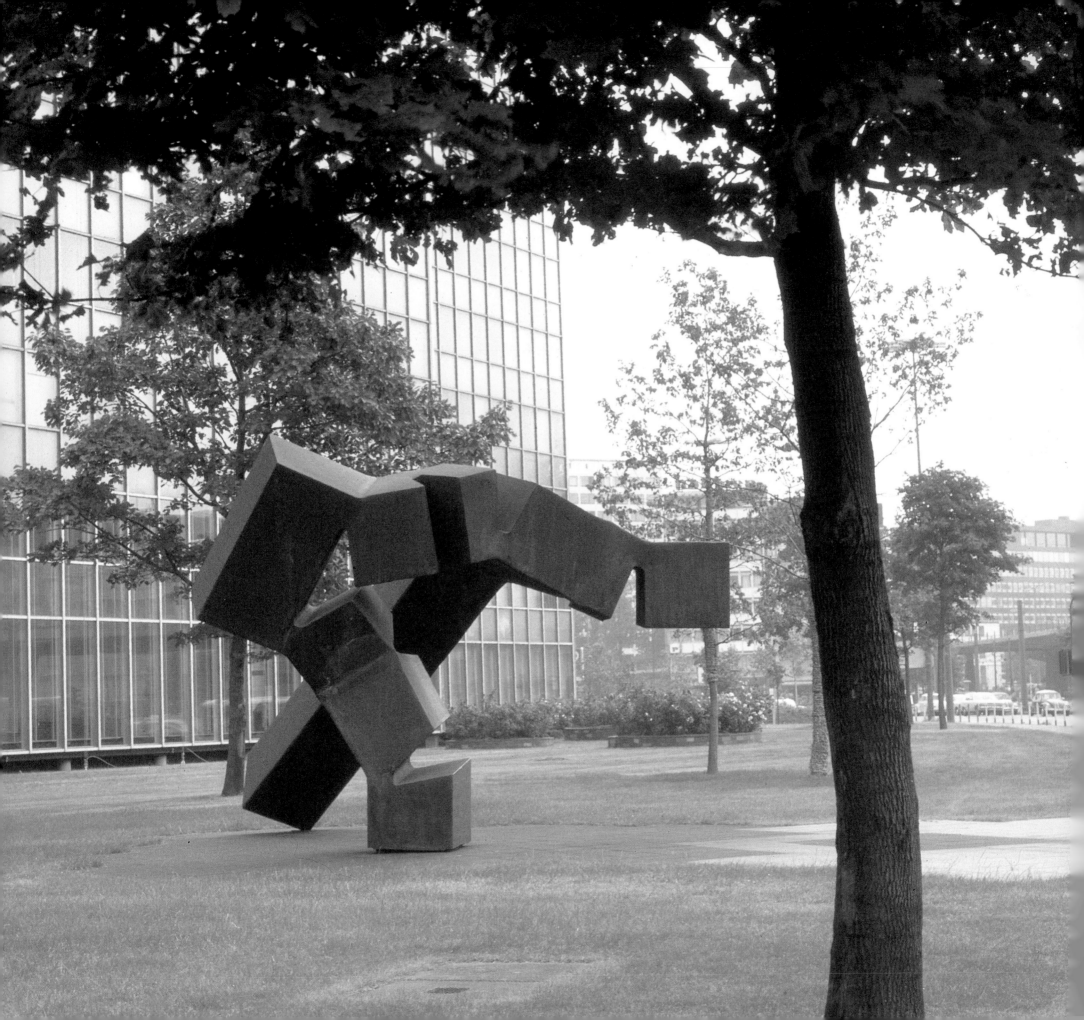

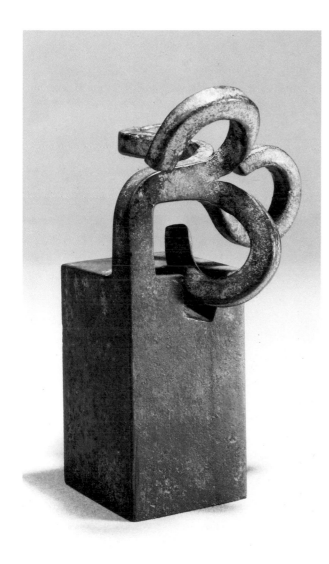

89. *Study for Wind Comb III.* 1974. Steel, 5 × 2½ × 3 in. (0.12,5 × 0.6,5 × 0.7,5 m.). Private collection, Paris

ment, is close to the Baroque master's in its disregard for spatial limitations, its unexpected and precarious asymmetrical composition, its use of twisted forms, and its daring appearance of instability.

Soon after Chillida's return to San Sebastián in 1951 he resolved to create at the end of the city a large environmental sculpture dedicated to the wind and the sea. At the time, however, although he was remembered as the goalkeeper of the San Sebastián soccer team, the authorities did not know Chillida the sculptor. He had begun working on designs for a "comb of the wind" as early as 1952 (see fig. 116), designing three different topologies over the years. In the mid-1960s the city of San Sebastián, in recognition of his increasing fame, suggested an exhibition of his work, but Chillida proposed instead that the municipality commission a permanent work on the western boundary. Ten more years passed before he was requested to proceed with the project. The city paid the cost of the material, and the sculptor contributed his work as a gift to his birthplace. This was his first opportunity to create a meaningful public space, to develop an integrated environmental design.

The actual work was largely done in two years, 1975–77, and was a successful collaboration between the architect, Luis Peña Ganchegui, and the sculptor, working together almost daily as conditions changed on the site. The engineering involved in anchoring the large heavy metal pieces was exceedingly complex. But the work is as permanent as man and the elements can devise: it has been calculated that the steel will lose approximately one centimeter of its substance each hundred years. In this project, the artist was supported by the city in doing exactly as he wished to do, and the result, *Wind Combs* (1977, figs. 91–96), is one of the most magnificent modern sculptures in the public area.

The sculpture is on a natural ledge below the steep palisades at the edge of San Sebastián, an area inaccessible before its construction. Now the space is used as a promenade, as a locale for games, performances, or lectures, as a place for silent meditation or for observing the sea, the sky, and the mountains. Sometimes on a stormy day at high tide, the waves will fill the space with spectacular might and a tempest can even cover the sculptures completely. *Wind Combs* appears like ramparts defending the city against the sea. When the hair of the wind hits, it is combed by the elements of the sculpture on its approach to the town.

Martin Heidegger considered sculpture a thing occupying a place and showing forth in space. *Wind Combs* is in its place—the earth and the rock—and is set against the sky. But it also relates to the sea and its tides. Like the three forces—air, rock, and water—it consists of three pieces. They are like gigantic Jews' harps or pliers, grasping the sky. One comb is set into the cliff with its axis parallel to the ground, stretching three of its claws out into the water, while the fourth one helps anchor it back into the rock. The second sculpture is fastened on a rock in the water and points toward the land. The third comb is farther out in

89

the sea, silhouetted against the horizon and oriented vertically, opening its arms to the sky. The three are engaged in a conversation which may be silent or highly animated, depending on the forces of nature. The two horizontal wind combs, the sculptor feels, relate to the past, the vertical comb opens to the future, which is unknown. The water is an essential part of the sculpture, filling the void when the element decides to do so. The noise of the waves is part of this *Gesamt-kunstwerk*, as are the sea gulls overhead and the people below.

To give release to the often turbulent power of the sea below the espla-nade, the sculptor drilled holes into the granite paving stones of the platform. The seven different designs of these water holes (see fig. 95) have been named by the people after the seven Basque provinces, a response that pleases the artist, who did not have it in mind when he designed the work. But he declared in 1980:

> Just as the piece of land with its sculpture fights the waves and air to sur-vive and attempts to communicate with the other two pieces nearby, the Basque people are struggling to survive as a distinct culture within Spain.[20]

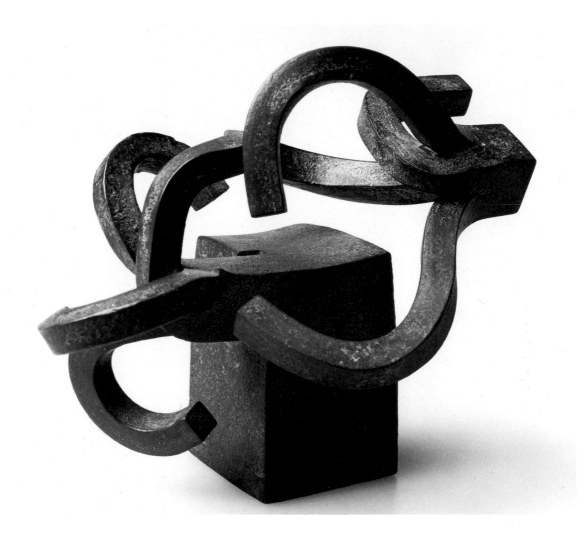

90. *Study for Wind Comb VI*. 1976. Steel, 5½ × 6 × 4 in. (0.14 × 0.15 × 0.10 m.). Private collection, Switzerland

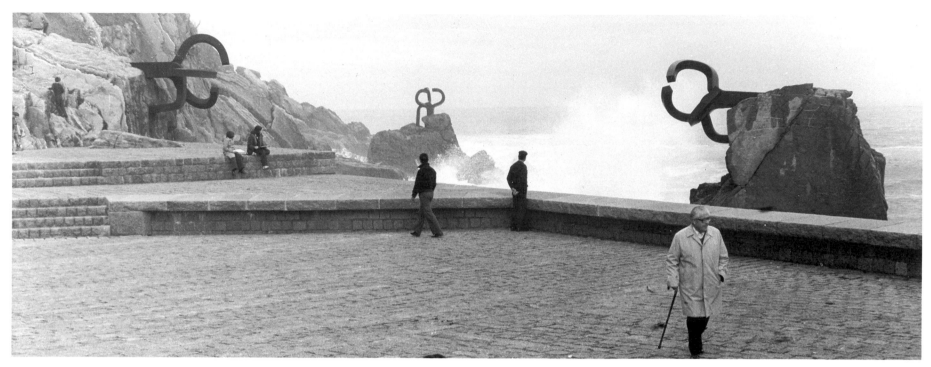

91.

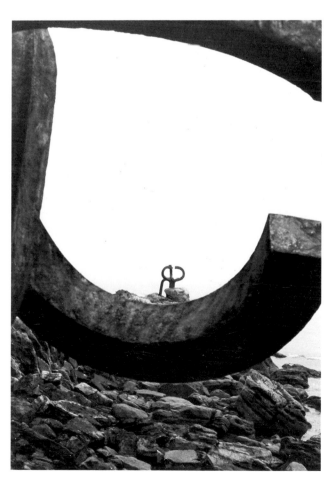

92.

91.—96. *Wind Combs*. 1977. Donostia Bay, San Sebastián

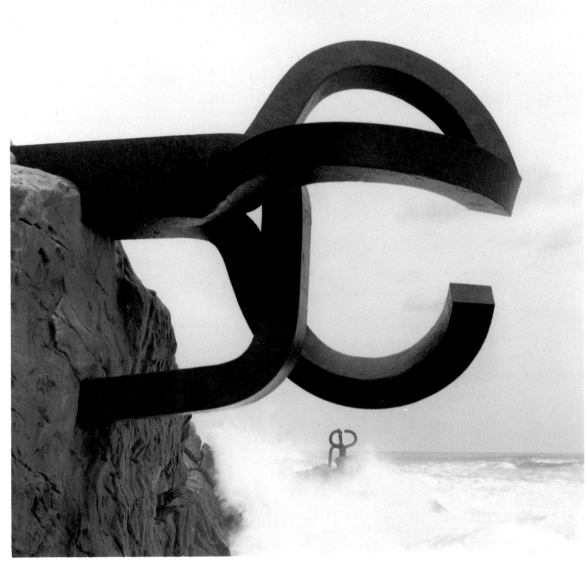

93.

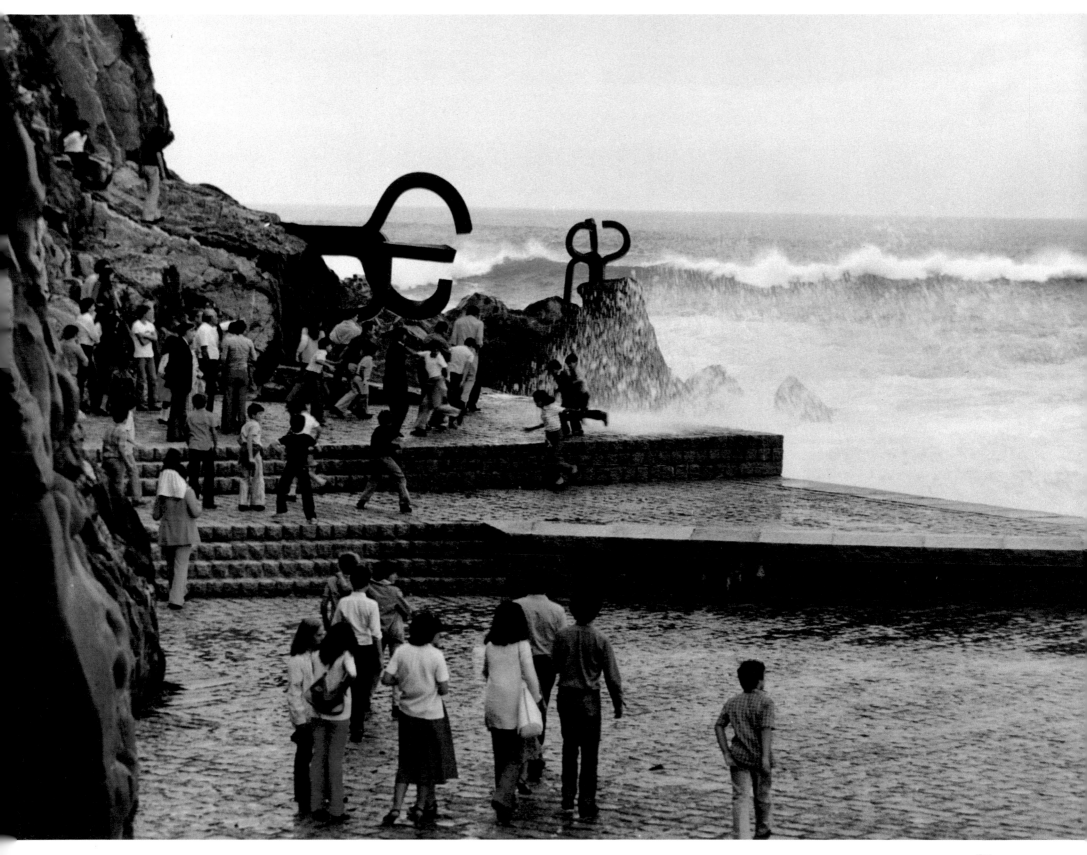

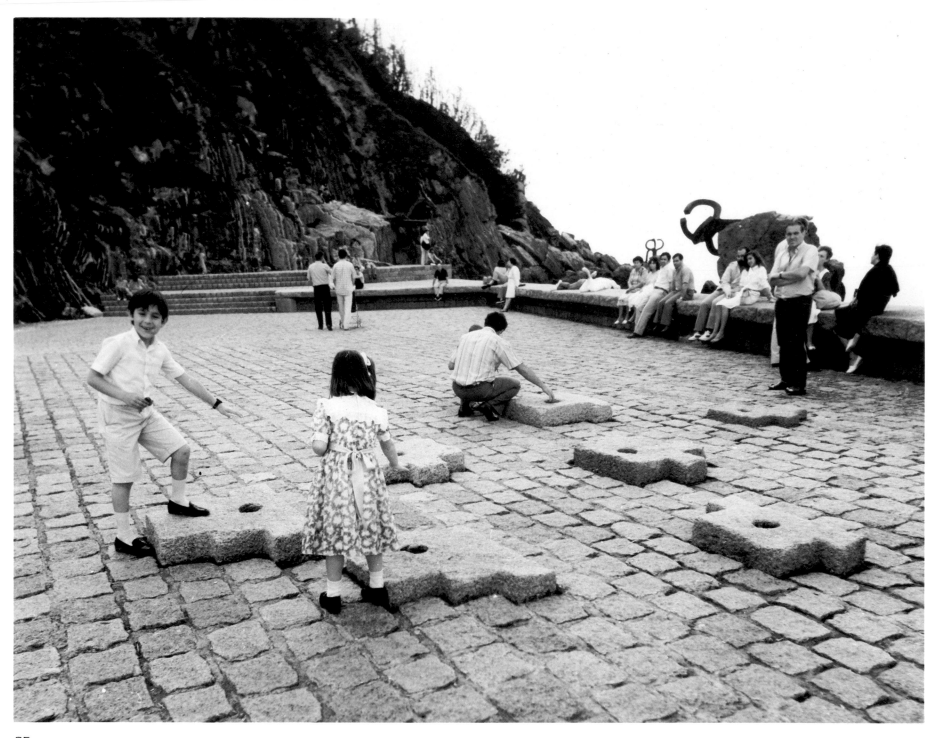

95.

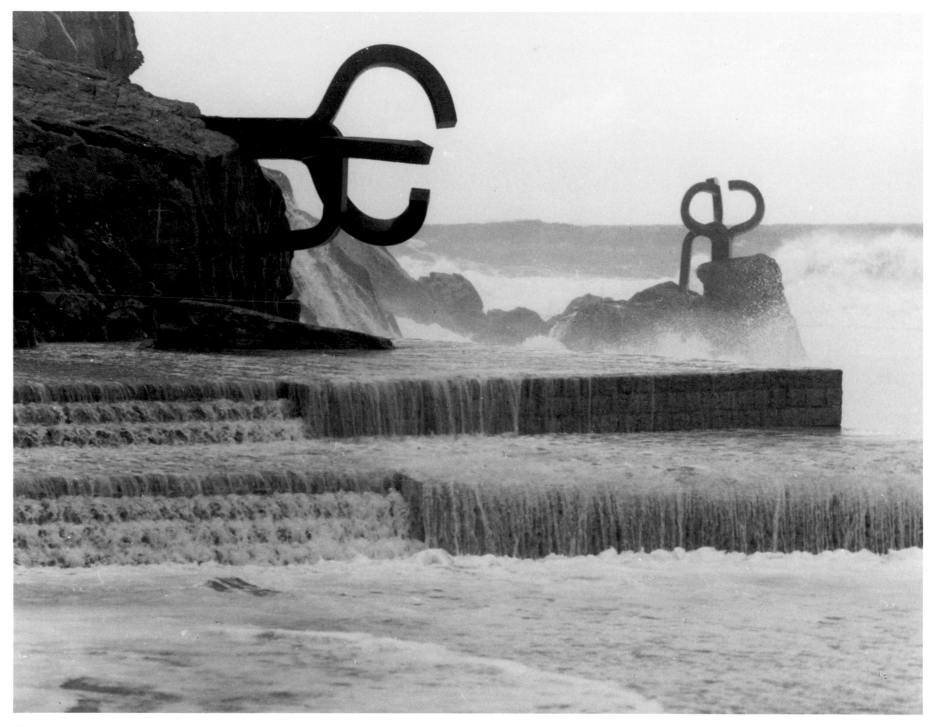

96.

97. *Wind Comb No. 8.* 1984. Steel, 5¼ ×
4⅛ × 2½ in. (0.13,5 × 0.10,3 × 0.6,5 m.).
Collection the artist

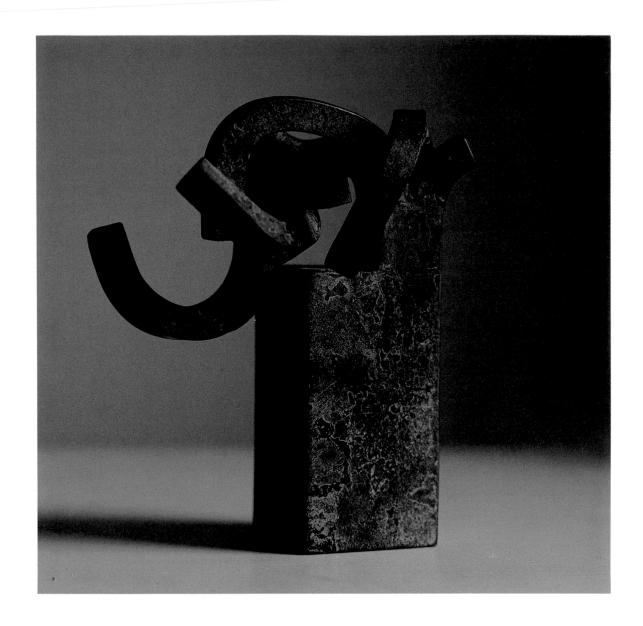

The location itself is a site of remarkable rock formations. The layers of the stratification, which actually are perpendicular to the sea, are powerful visible reminders of the tremendous forces that formed the Pyrenees, which at this very spot rise from the ocean. The wind combs, reaching for each other, try symbolically to bring together again what was once united in remote geological times. The work deals with, among other things, the condition of separating and connecting. *Wind Combs* is a great metaphor of man's connection to nature. Rainer Maria Rilke wrote in 1902:

> People . . . , unwilling to leave the Nature they have lost, go in pursuit of her and try now, consciously or by the use of their concentrated will, to come as near to her again as they were in their childhood without knowing it. It

will be understood that the latter are artists: poets or painters, composers or architects, fundamentally lonely spirits, who, in turning to Nature, put the eternal above the transitory, that which is most profoundly based on law above that which is fundamentally ephemeral, and, who, since they cannot persuade Nature to concern herself with them, see their task to be the understanding of Nature, so that they may take their place somewhere in her great design. And the whole of humanity comes nearer to Nature in these isolated and lonely ones. It is not the least and is, perhaps, the peculiar value of art, that it is the medium in which man and landscape, form and world, meet and find one another.[21]

Although a work like *Wind Combs* seems to have become a perdurable part of the land and seascape, not all of Chillida's site sculptures are necessarily permanent installations. He recently placed his *Architect's Table* (1984, fig. 98) in front of his *caserío* in Zabalaga near San Sebastián. (A *caserío* is one of the old Basque farmhouses still to be found around the Pyrenees.) Chillida and his family acquired it as the permanent locale of the Fundación Chillida to house the artist's archives. The seventeenth-century farmhouse, made of timber with masonry facing, has a heavy, solid character and a quality of endurance and simplicity characteristic of much indigenous architecture. It is surrounded by a fine orchard which has grown appropriately wild. Set on fieldstones and facing the wide house is the low steel table. It appears to be a perfect echo: the house itself is almost square in plan; so is the *Table*. The angular apertures of the *Table* seem to respond to the doors and windows of the half-timber facade, while the *Table*'s eroded edge and the rusted patina acknowledge the worn state of the *caserío*. The modern abstract sculpture has found its perfect location and connotes its connection to its own tradition.

Wind Combs is a prodigious sculptural ensemble set into the forces of nature. A few years later (1975–80) Chillida focused on site-specific work in urban space, redesigning the business center of the lively commercial and manufacturing city of Vitoria-Gasteiz, the capital of the Basque province of Álava. Here the artist became an active social designer shaping a participatory space. This work actually preceded much of the most interesting expanded sculpture to be done in the United States in the 1980s. Originally Chillida had been commissioned by the county council of Álava simply to erect a sculpture in the marketplace of Vitoria as a monument to Los Fueros—the ancient laws guaranteeing the privileges and liberties of the Basque people. On reflection, he decided to persuade the authorities to consider a whole new architectural complex for the old Plaza de Abastos (Marketplace; figs. 99–106). Much of the basic design for the new Plaza de los Fueros was based on the earlier and much smaller Plaza de la Trinidad (Trinity Square), which was a project for games and activities by Peña Ganchegui in the old section of San Sebastián. The square in Vitoria was again a collaborative proj-

overleaf: 98. *Architect's Table.* 1984. At the Fundación Chillida in Zabala, Basque country. Steel, 19¼ × 63 × 62¾ in. (0.49 × 1.60 × 1.59 m.). Collection the artist

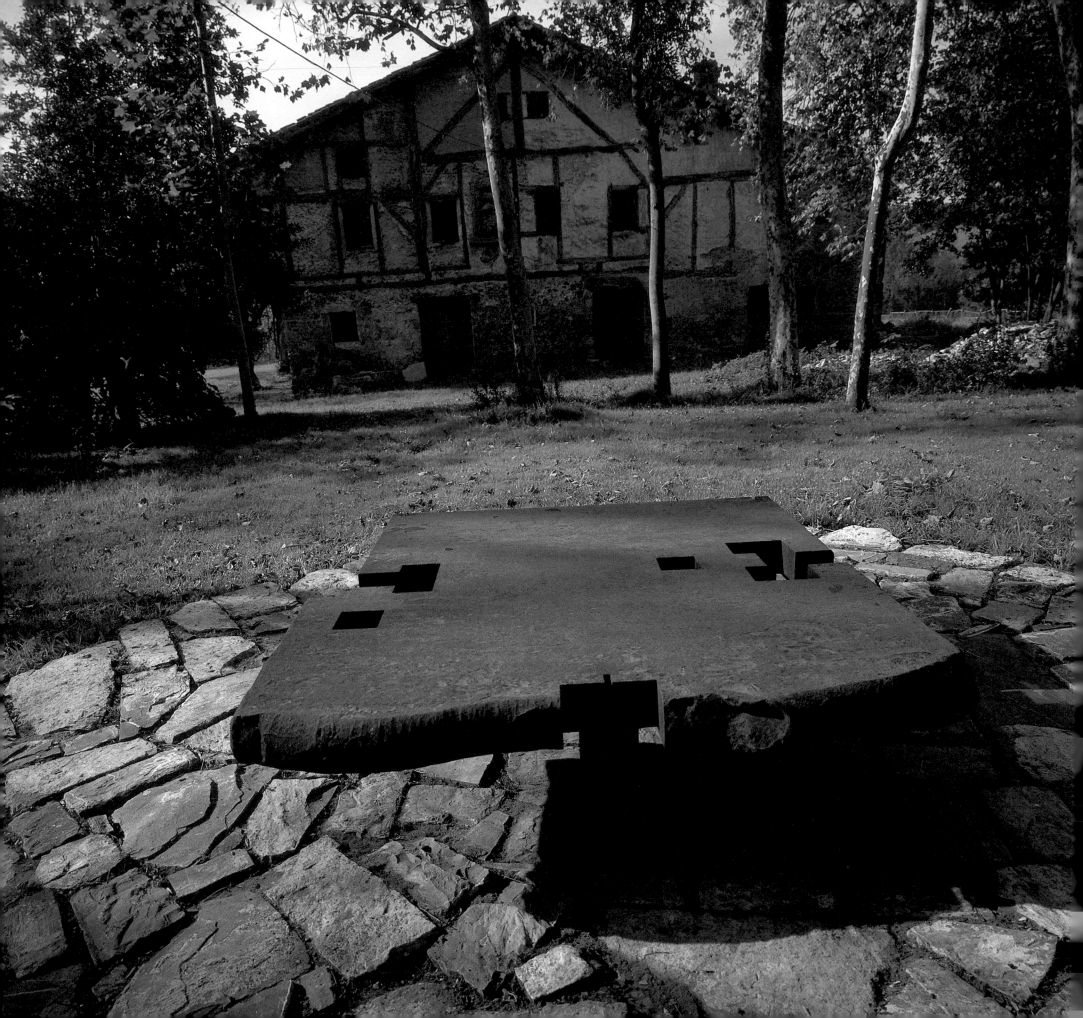

99.—106. In collaboration
with Luis Peña Ganchegui.
*Plaza de los Fueros (Plaza of
Basque Liberties).* 1980.
Vitoria-Gasteiz, Basque
country

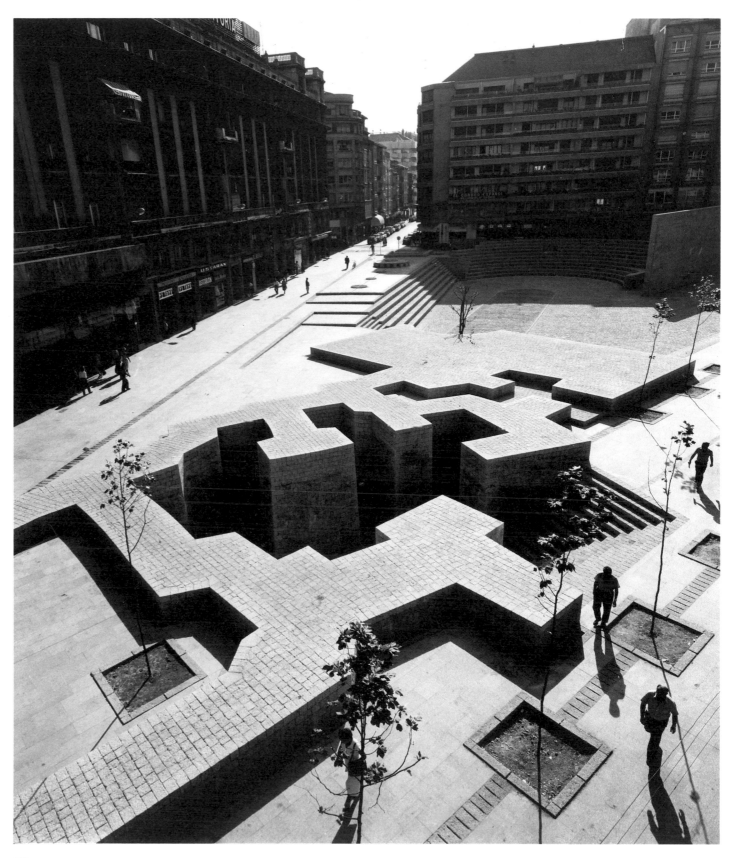

99.

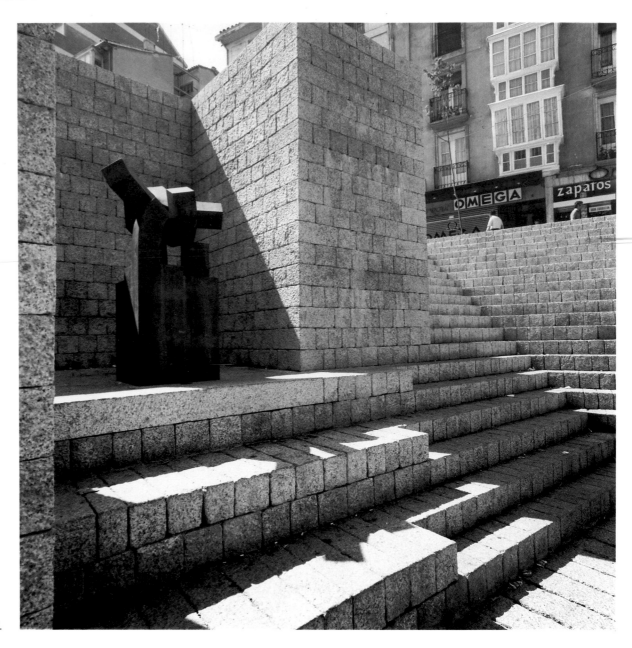

100.

ect between Chillida and Peña Ganchegui. The latter designed most of the public areas, consisting of the large planar *frontón* wall for jai alai, which itself resembles a rectangular architectural fragment, a court for the *bolatoki*, the ancient Basque ox races, a subterranean bowling alley, a small amphitheater, and a labyrinthine area that leads downward to Chillida's steel sculpture, the monument to the defense of Los Fueros. It was during the working process that Chillida, who did not like the site surrounded with inelegant new buildings, decided to change his original design from a raised labyrinth and pelota court and to dig partly beneath the ground to create a new and distinct identity for the plaza. The whole square is

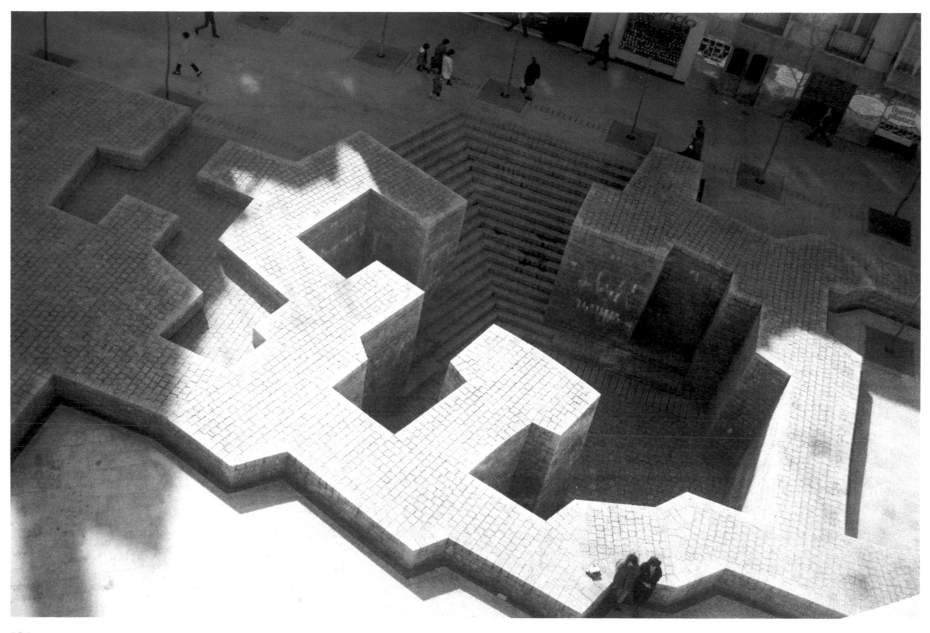

101.

made of pink Galician granite, the same stone the artist had selected for the *Abesti Gogora* in Houston (see fig. 27).

The space in the Vitoria city square (eighty-six thousand square feet) is not in the classical mode of many of its counterparts in which broad vistas are addressed to imposing facades. It is rather in the Baroque tradition, full of involutions, mazes, tangles, and surprises. Like the *plaza mayor* (main square) in many Spanish towns, it is not in the very center of the city, but set apart from major traffic arteries. Also in keeping with Baroque urban design, and in significant contradistinction to the International Style planning promoted by CIAM (Congrès In-

CALLE DE LOS FUEROS

- 0,80

F
- 2,80

- 4,40

- 1,20

- 0,00

- 2,80

- 2,80

A

+R

- 2,80

- 0,80

- 0,20

- 4,60

E

- 2,50

± 0,00

B

- 0,20 - 0,40 - 0,60 - 0,80

• M

± 0,00

- 0,80

14,30 32,20

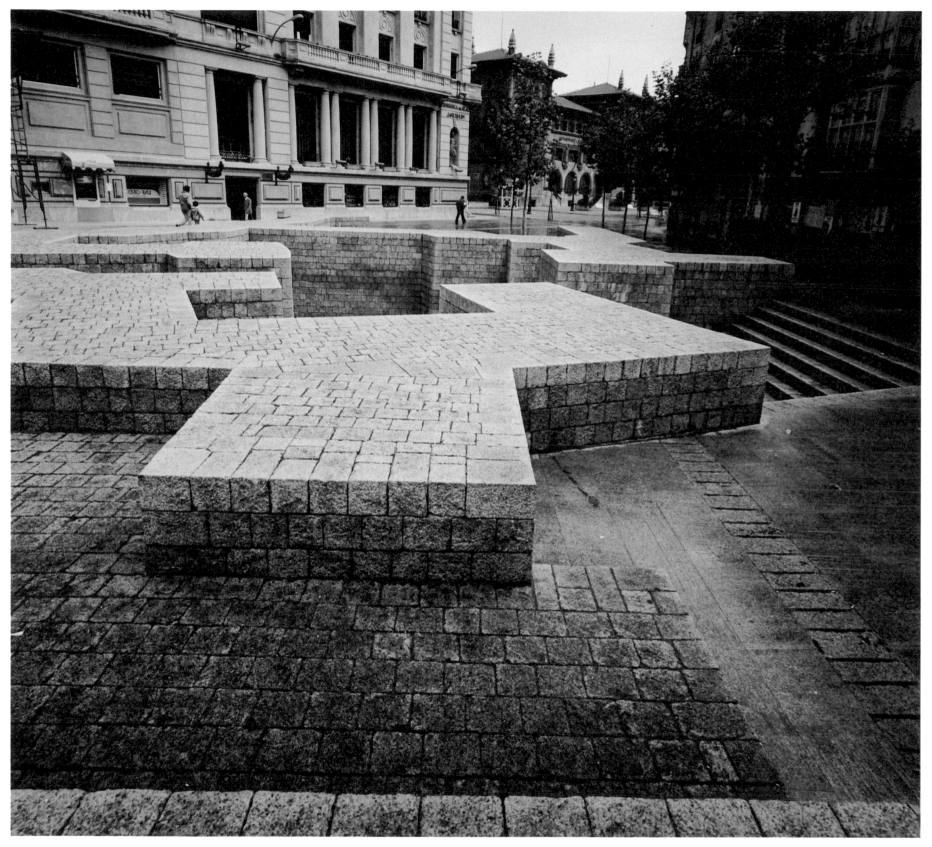

103.

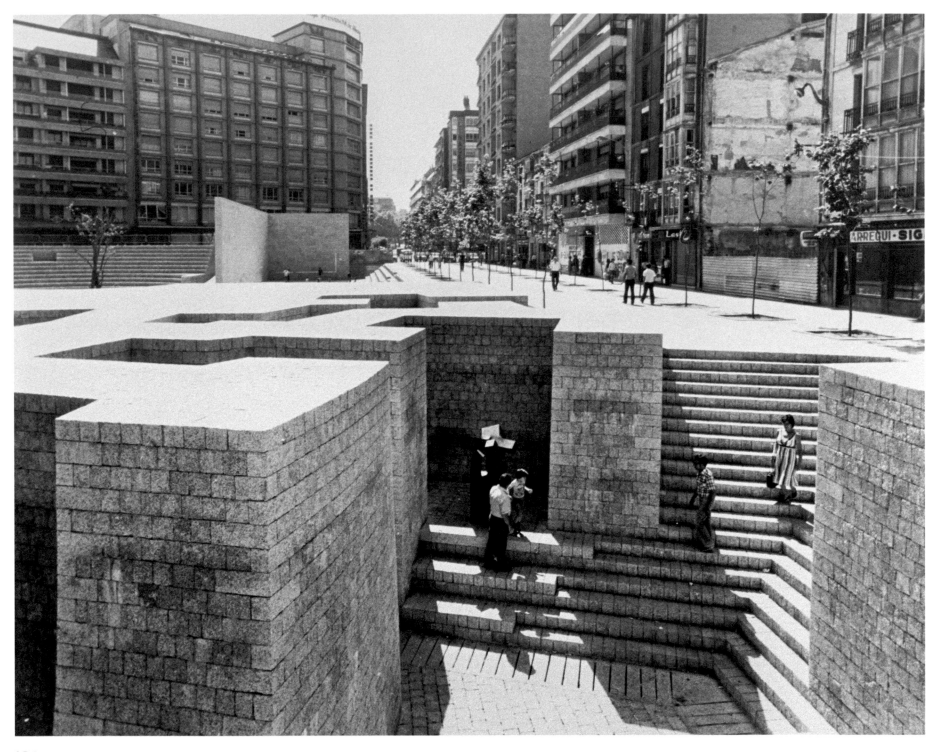

104.

104

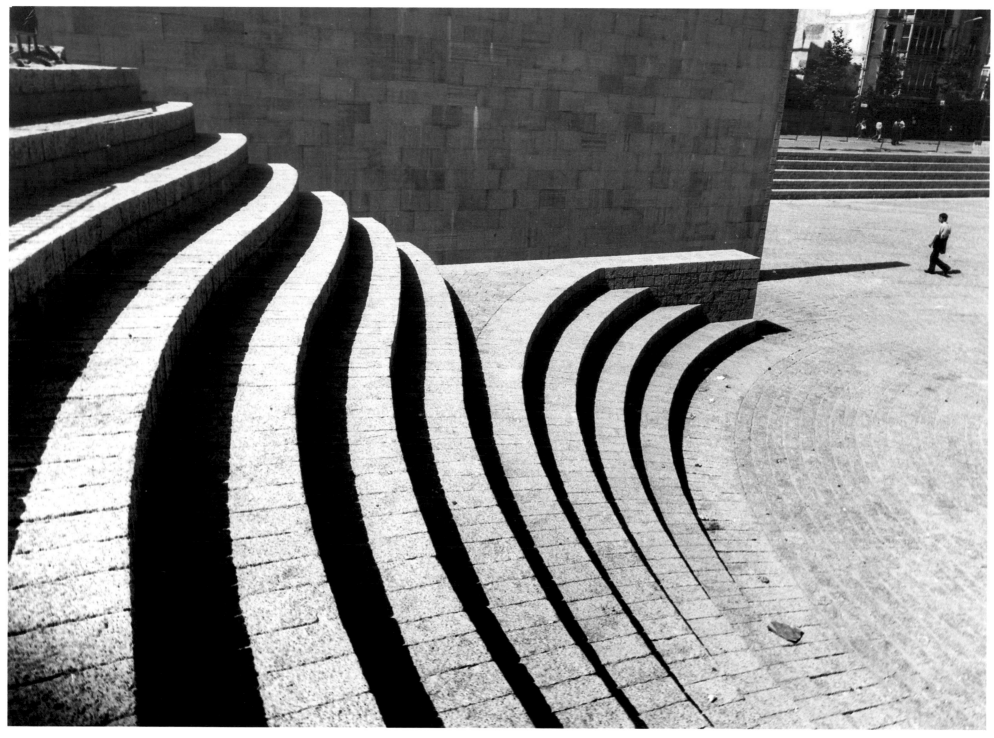

105.

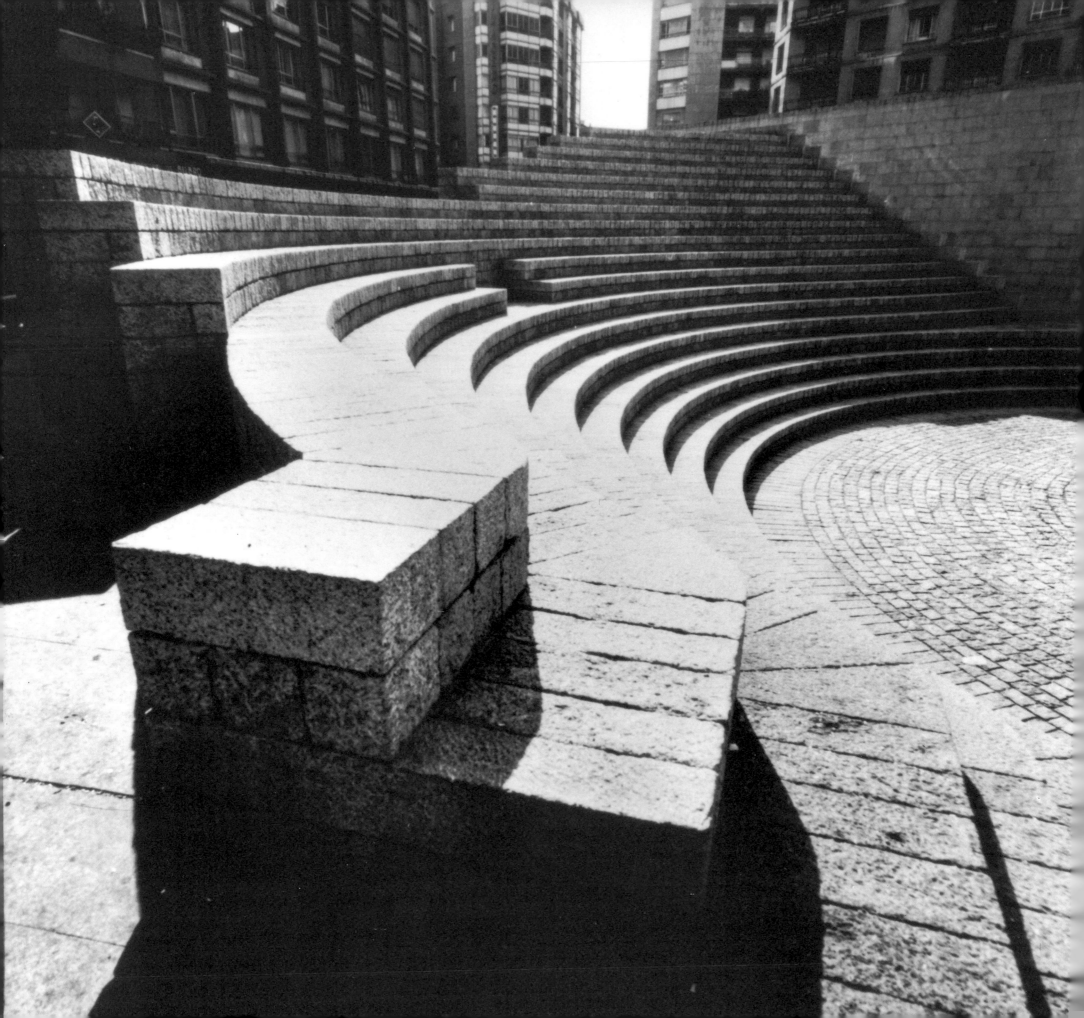

ternationaux d'Architecture Moderne), which postulates large open landscape spaces surrounding slab buildings, Chillida and Peña Ganchegui preferred to have the buildings surround the open space.

When viewed from above, the deep angular maze resembles the design of Kufic arabesques, but it undoubtedly originated in the articulation of clandestine passages in the sculptor's earlier drawings, etchings, and alabasters. Stairs lead downward between stone pylons to a depth of thirteen feet, to a chamber open to the sky, the core of the whole complex. There in the sacred niche the viewer confronts a steel stele that could be a metaphor for both a tree and a fist, and that is meant to stand for the ancient oak tree in Guernica (fig. 107). Guernica, symbol to the world of the horror of aerial bombing and memorialized in Picasso's great painting, has also since medieval times been the site of the venerable oak under which the lords of Biscay came to swear their loyalty to Basque law. The tree remains the symbol of liberty for the Basque people. Chillida's sculpture is housed on the bottom of a deep well, surrounded by tall, protecting walls. Its intertwined arms branch in different directions from its heavy squared base. It stands in a guarded hub of the Basque capital city and signifies the Basque spirit of independence, metaphorically radiating to all the Basque territories in the defense of an ancient culture and its rights.

Chillida continues working on proposals for sculptures in the public arena. He has submitted several versions of a powerful monument for Nashville, Tennessee (figs. 108 and 109), which bears a strong semicircular form, a broken circle with all its implications of unfolding and reaching toward closure. A similar shape occurs in the *Project for Hamburg* (1979–80, fig. 110), where a dynamic configuration of several such U-shaped forms surmounts an angular horizontal platform. In 1982 he created his very primal *Monument to Tolerance* (fig. 111), earmarked for the city of Seville, where it was meant to be placed on the banks of the Guadalquivir River near the Torre del Oro. Sixteen feet high and almost forty feet long, it is again based on the variations of the theme of giant semicircular curves, oriented horizontally and vertically at right angles to each other. Its powerful apselike space is meant to receive people who would enter the concrete sculpture near the center of the city. The monument, meant as a totemic sign for freedom, was rejected by the city, because, Chillida suspects, of his Basque nationality.

For the city of Frankfurt, Chillida has designed the *House of Goethe* (1981, fig. 113), a highly ambitious work in which solid slabs of steel alternate with juxtaposed cutouts of voids. The large steel sculpture, stressing the poet's monumental intellectual powers, deals with different aspects of his genius than does the alabaster *Homage to Goethe* series (see figs. 38 and 39), with its involuted passages of light. In 1985 the city of Frankfurt commissioned Chillida to construct the *House of Goethe* full-scale, in concrete, to be placed close to his birthplace, in the center of the old city near the Main River.

In his works and projects for public spaces, Chillida sets out to shape a

107. The ancient oak of Guernica, symbol of Basque liberty

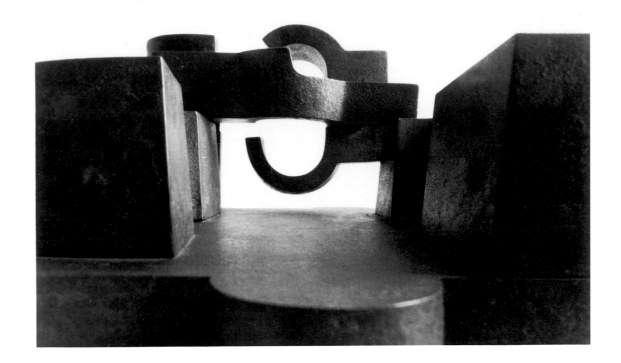

108. *Project for Nashville* (detail). 1977.
Steel, 8½ × 9 × 10 in. (0.21,5 × 0.23 ×
0.25,5 m.). Collection the artist

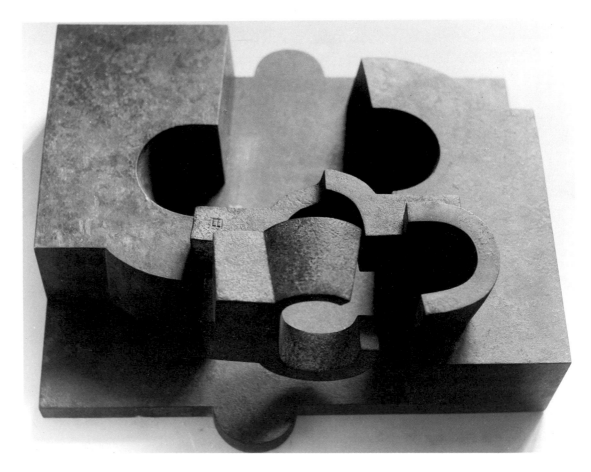

109. *Project for Nashville*

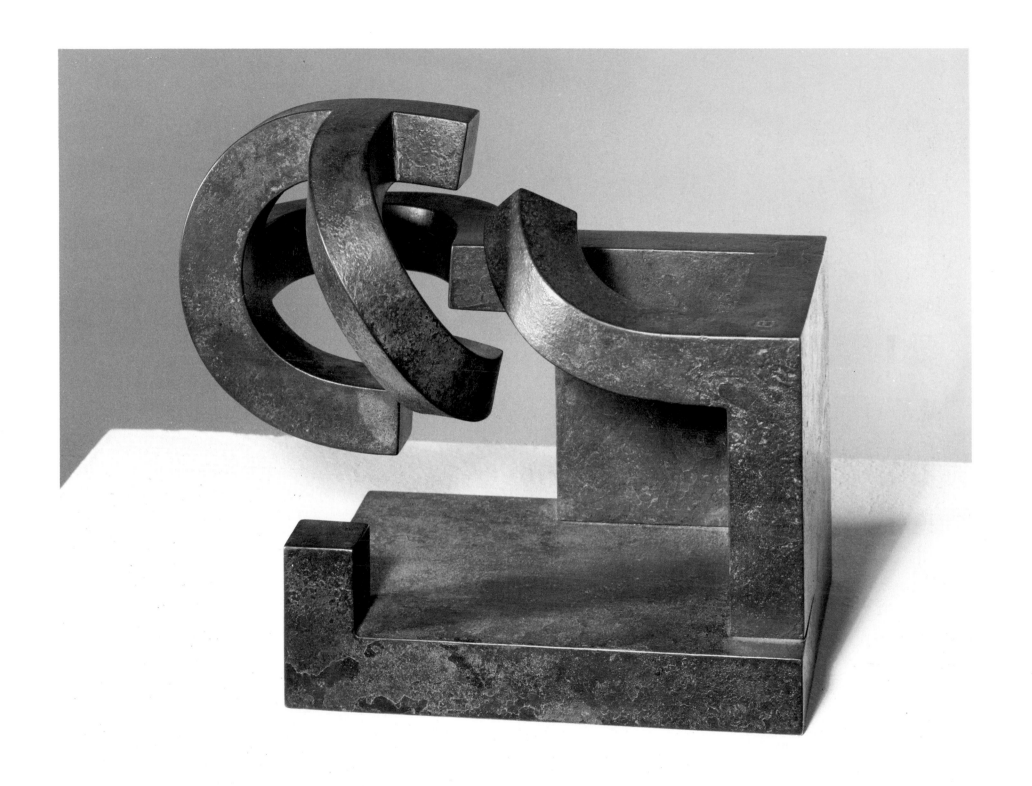

110. *Project for Hamburg.* 1979—80. Steel,
8 × 10 × 8½ in. (0.20 × 0.25,5 × 0.21,5
m.). Private collection, Switzerland

111. *Monument to Tolerance.* 1982. Steel, 5 × 12 × 10½ in. (0.12,5 × 0.30,5 × 0.26 m.). Collection the artist

opposite: 112. *Tolerance.* 1985. Steel, 37 × 104 × 86½ in. (0.94 × 2.64 × 2.19 m.). Collection the artist

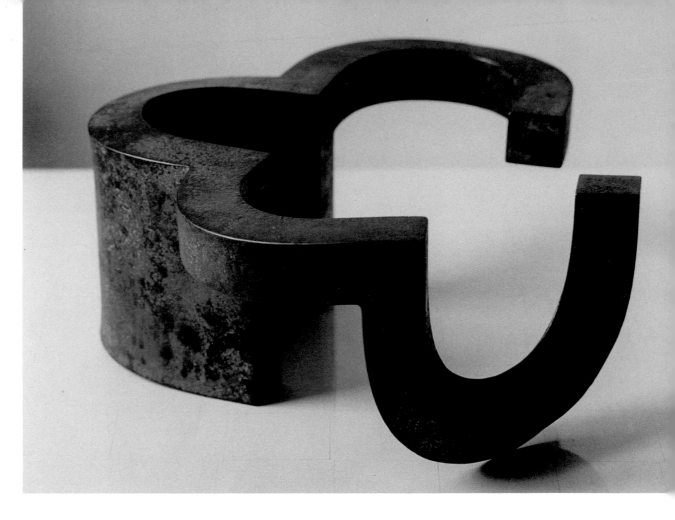

specific part of man's environment. Among the depressing mediocrity of most public sculpture in our time, only a small number of works attain real distinction. Those that come to mind are Brancusi's ensemble at Tîrgu-Jiu, Alberto Giacometti's and Joan Miró's groupings at the Fondation Maeght, Dubuffet's *Four Trees* at Chase Manhattan Plaza and Noguchi's garden beneath it, in New York, or Dubuffet's *Closerie Falbala*, in Périgny-sur-Yerres, France, and Noguchi's garden at Costa Mesa, California. There have also been a few memorable temporary installations such as David Smith's at Spoleto and Christo's in Marin and Sonoma counties, California, and elsewhere. Eduardo Chillida's two large public works in his Basque home territory are outstanding examples of this small group. In these distinguished works the sculptor has scrutinized and calculated the nature and the quality of the space, space, which, Immanuel Kant had noted, infiltrates through each of our senses. While retaining the essentially private autonomy of modernist sculpture, these works relate to the life of the people, providing an opportunity for reflection in a communal situation.

Public sculpture has become an increasingly important aspect of Chillida's *oeuvre*. His public works relate to landscape or city and transform their sites into aesthetically valid environments. Although in the tradition of abstract sculpture, they have become meaningful place markers. The master sculptor assumes a social role, giving aesthetic definition to places of human interaction.

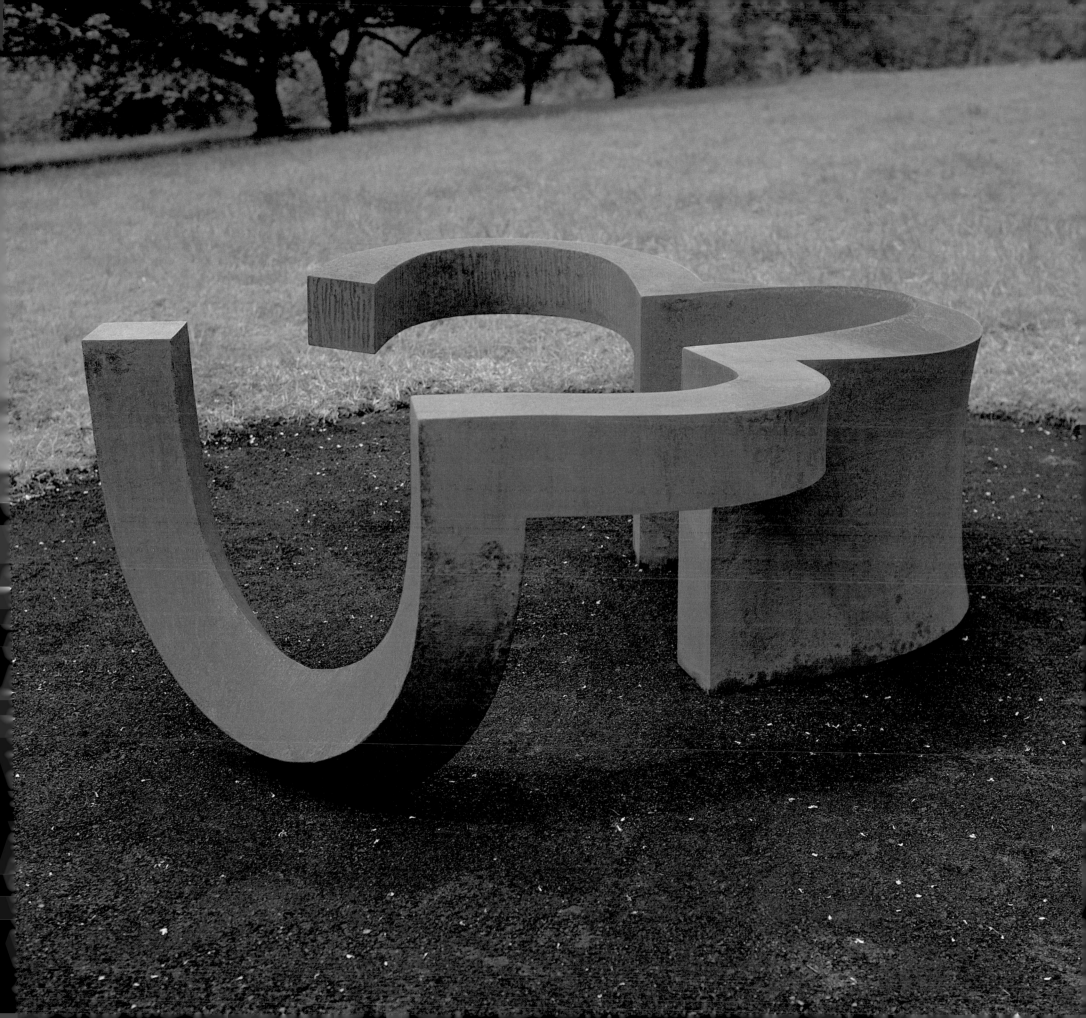

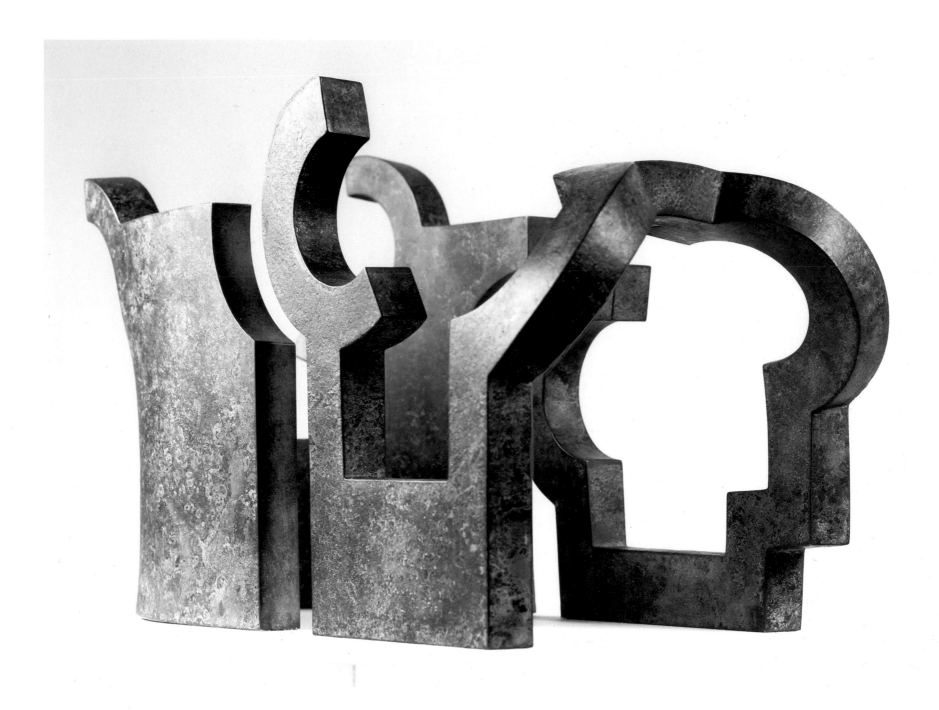

113. *House of Goethe*. 1981. Steel, 11¾ ×
9¾ × 16½ in. (0.30 × 0.25 × 0.42 m.).
Collection the artist

mires, such as Medardo Rosso, Gonzalez, and Giacometti, he is quick to point out that his own prime concern focuses on interior forces, and on space, gravitation, and the void, rather than on surface appearances.

Although abstract, Chillida's work is altogether distinct from the geometric forms of artists like Max Bill, who belongs in a mathematical Constructivist tradition. And if there is any similarity between the austere precision of certain of Chillida's steel sculptures and the work of American Minimalists, this is a purely surface resemblance. Minimalist sculptors are concerned with objects, their shape, volume, and color, and are careful to deny any personal expression. Chillida's sculptures, on the other hand, seem subjective, mysterious, and filled with spiritual energy. Whereas the Minimalists' work is predetermined, Chillida's is open-ended. Much like Zen painting or Hermann Hesse's *Glass Bead Game*, Chillida's sculptures fuse the rational with the immutable. The Minimalists stress the importance of the depersonalized industrial fabrication of their work, Chillida that of personal intervention. Minimalist sculpture extols the machine and its industrial technologies; Chillida will use engineering methods merely as means to his end. Above all, Minimalists create specific objects whose "thingness" is a self-contained solidity. It is a denial of the void, which had been the principal consideration in much of the sculpture of this century.

Eduardo Chillida was never in any stylistic mainstream and chose to live away from international art centers and the gyrations of fashions that they engender. Nevertheless his work is central to the modernist tradition in sculpture, which is based on the dialectic of solid and void, of inside and out. His work would not have been feasible without the Cubist articulation of space, but whereas the Cubists in sculpture as well as painting proceeded from the background to the frontal plane, Chillida, especially in his alabasters and clays, begins with the surface and then cuts spatial elements into the form. Or he bends and curves the steel to embrace the void.

When beginning his career, he had turned to iron and its forging precisely because of his need to penetrate the void. As time went on, he dealt with the void as the nucleus and core of his work. Titles such as *In Praise of Air* (see fig. 7), *Modulation of Space* (see fig. 22), *Around the Void* (see figs. 28–30 and 87), appear among his nomenclatures. In 1983 he created *In Praise of the Void II* (see fig. 81), a work in which an elliptical shape is placed on top of a rectangular column. It seems that the main purpose of the work is the display of the void, which is much more enclosed than in earlier pieces. Jagged and rounded forms cut from a sheet of steel circumscribe the interior, and the two forwardmost prongs again reach toward each other for completion. The solid form protects the vacant space. For Chillida the void is not an abstract entity but, like volume, it has physical attributes. It is the void which animates matter and enlivens space (fig. 82).

The deep interest in the nature of space is one of the prime concerns of twentieth-century thought. It is an essential element of modernist architecture. It

entered the world of poetry as early as Mallarmé and is central to the music of John Cage. Nothingness or Void was one of the principal considerations of modern philosophers such as Husserl, Sartre, Bachelard, and above all, Martin Heidegger.

Heidegger explored the phenomenological relationship of bodies in space and analyzed space as part of our physical being as early as the 1920s.[24] Similarly Merleau-Ponty insisted that the modern concept of space can no longer follow the mechanical and tangible Cartesian model, but that space is relative and can be experienced only by the human being from the inside. He submits that "the shell of space must be shattered."[25]

In 1968 Heidegger and Chillida, having become very much interested in each other's work, met in Saint-Gall. Heidegger published his essay *Die Kunst und der Raum (Art and Space)* specifically in relation to the work of the much younger Chillida.[26] Chillida illustrated the philosopher's tract with seven austere collage lithographs—prints in which the center is void, similar to his alabasters of the same time. Heidegger describes sculpture as "not taking possession of space" and stipulates that works of sculpture not set outer limits, that "what we call volume must lose its name, the significance of which is only as old as modern technical science. . . . And then what will happen to the emptiness of space? Often enough it appears only as absence. Emptiness is considered as a lack of fullness, of hollow spaces and interstices. . . . Emptiness is not nothing. It is also not a matter of absence. In plastic embodiment the void acts like the searching and projecting establishment of place."[27]

Heidegger defines space not as objective reality, but in relation to man, as our living space. Sculpture is not merely placed in a given area, but reveals the specific character of the space. Art for Heidegger, moreover, is not a reflection of something already in existence, but a new beginning, independent of causality. It is "truth-setting-itself-to-work."

Similarly, Chillida has pointed out that "Sculpture should always face and be attentive to everything around it which moves and enlivens it."[28] Space acquires a tangible reality in his thinking and is the armature of his work. Contrasting his concept of space to that of traditional thought, he says: "Philosophers teach us that space is unified, but I have the feeling that space is always different, its density depending on the projection of forms." For both Chillida and Heidegger truth in art—much as creation itself—originates in the void.

The void is also the element which acts as the catalyst for the imagination. Space itself is denoted by its boundary, which is the edge and not a limit. Heidegger argued that "A boundary is not that at which something stops, but as the Greeks recognized, the boundary is that from which something begins its presencing."[29] Similarly Chillida explained that "Limit is the true protagonist of space, just as the present, another limit, is the true protagonist of time."[30]

In painting, a similar feeling for ineffable space prevails in some of the work of Mark Rothko, Ad Reinhardt, and Yves Klein. It has always been central to

**Postscript by
James Johnson
Sweeney**

Postscript:
The Wind Combs
—An Explication

James Johnson Sweeney

115. *Study of Space with Hand.* 1972. Pen
and ink, 6¾ × 9½ in. (0.17 × 0.23,5 m.).
Collection the artist

Eduardo Chillida is a sculptor who can be primarily and finally respected for
the individuality and integrity of his art; this, one comes to see, is rooted
in his respect for nature.

As a young man he developed a great facility for drawing, and
amazed his contemporaries with his representational ability. But he soon tired of
what he regarded as shallowness in representation and duplication and began to
look for deeper meaning in his drawing. Still his facility frustrated him with a ten-
dency to overdraw, and with the result that he lost the "sensibility of the lines,
the value and the weight." Even though everyone was enthusiastic about the re-
sults, he said, "I understood very quickly that was not the way to do things; I de-
cided to draw with my left hand." This discipline imposed severe limitations on his
expression but allowed him to focus on the value and weight of each line, to con-
centrate on achieving the maximum effect with the minimum number of lines.

In the 1940s Chillida studied architecture in Madrid, and to his self-disci-
pline was added an external discipline, a training in use and strength of materials,
in the importance of planning spatial relationships, and in the organization of scal-
ing elements. These features, which were to reassert themselves emphatically in
his later work, seemed too restrictive at this time and, leaving architectural
school, he began to develop his sculptural interests more freely. His architectural
training had made its impact, however, and his *oeuvre* continues to display an un-
derlying sense of structure and organization, and a sensitivity to the integrity of
materials which had been encouraged by his studies in Madrid. He uses drawings
to study the potential features of a sculpture which he is considering, just as an
architect uses sketches to study details of a building. As he uses them, "They

119

The quotations from Chillida were tape recorded in January 1984 during a visit by the author to Chi-
llida's home in San Sebastián.

give a certain approach to the spirit of the work, but not the full quality. It is like a preparation; the attack of the work is direct, has to be with the material." His drawing is extremely three-dimensional, owing to the economy of line and quality of line weight. But Chillida insists that his subtle volumetrics are an illusion of the beholder: "The lines of a drawing can develop the idea of three-dimensionality. In your mind you [can] make a connection between these lines [and a hand] and then you see three-dimensionally—but it is not in the drawing, it is in your mind" (fig. 115, and see fig. 21). The greater the intensity in the line relationships, the more convincing is the communication of three-dimensionality in his two-dimensional drawings.

His sensitivity to different materials results in very different expressions of recurring themes using different materials. Stone has great compressive strength, no tensile strength, so he chips it, cuts it, and makes impressions on its surfaces. Steel has great tensile strength, and its shape can be altered by applying intense heat. He takes full advantage of this quality, and the resultant forms, tense and disciplined, display a peculiar agony as if the material had suffered during its metamorphosis from iron ore to steel sculpture. From 1947 on, Chillida honed these talents, and in his sculpture and graphics we see the physical expression of his philosophical integrity. He does not confuse or take license with the inherent character of the materials with which he works.

In 1952, Chillida first conceived the idea of a *Wind Comb,* "of doing homage to his town of San Sebastián and the wind at the same time" (fig. 116). The most westerly promontory of the Bay of San Sebastián was the farthermost boundary, the extent of the town, the local horizon, and the first point of land which the prevailing wind struck on its way to the town. "In a certain way this is like a *finis terrae*, not exactly like Santiago de Compostela, which is the limit of Europe, but for us, for our grandfathers, this place is the limit of our known"—and the beginning of the unknown.

Between 1952 and 1977, when he completed the work, Chillida approached the problem from many directions, as he said, "because this work is like an equation that I have to solve. In an equation in mathematics you have only numbers, but here you have people, you have the horizon, the rain, the sea, the birds, the rocks, and the mountains."

The result is a sculpture that stands alone in nature, enhancing the wild beauty that surrounds it, and its three earth-brown tortured steel forms complement the battered sandstone cliffs and the boulders rounded by the waves (see figs. 91—96). Chillida placed one of the pieces of the *Wind Combs* just on the edge of the town line, "the farthest bound of the town." The other two are juxtaposed in the sea, "as if in colonization of the horizon." They strain toward each other in a symbolic representation of the past: "It was a unity broken by nature." The Bay of San Sebastián was formed by the incessant action of the waves against the sandstone cliffs, gradually rending the promontory from its neighbor-

opposite: 116. *Wind Comb I.* 1952—53. Iron, 52 × 19 × 24 in. (1.32 × 0.48 × 0.61 m.). Collection Museo Español de Arte Contemporáneo, Madrid

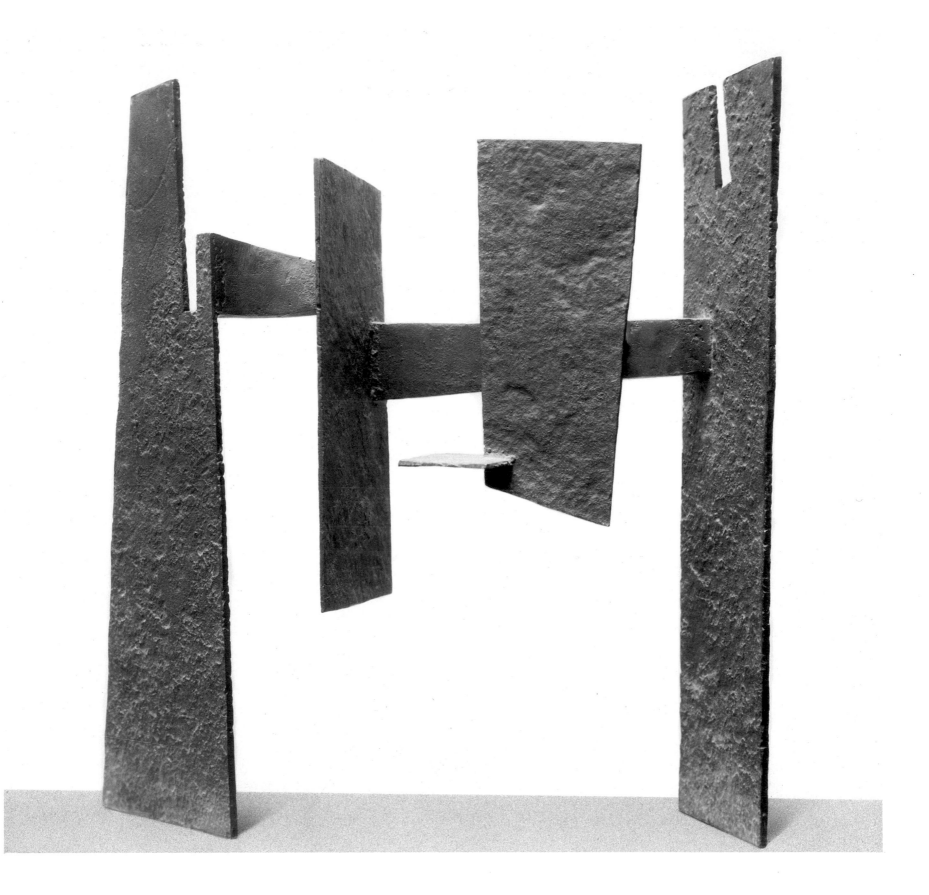

ing island. Chillida said, "What I liked to do was put together a symbolism of the past, and also a vertical affirmation of the future. The future (for one) is the Horizon—the unknown. They are the symbolism of the future."

The approach to the *Wind Combs* is by a very carefully designed extension of the promenade that circles the Bay of San Sebastián. Chillida chose paving stones cut from a granite that comes from Santiago de Compostela—"where it has withstood the waves and wind for years." The size of the stones is carefully scaled to the size of man and is clearly man's domain even though on the edge of overwhelming nature. Sandstone cliffs stand fissured and vertical on one side, the Bay of Biscay in its many moods boils on the other. The parapet of the promenade, built with the same granite stones, is low and has scuppers like the deck of a ship. It does not pretend to resist the sea, but accepts the waves when they are overwhelming and extends out into an unforgiving environment in an easy equilibrium with nature. "This path between the wall there and the steps is a place that, when the sea is very strong, the waves pass over; then you control the waves, because it is open on the side to drain the water."

Chillida carefully organized the approach to the *Wind Combs* so that "you see [the sculpture] appearing as you arrive." As one approaches, one can see one piece, then two, and finally one sees three elements: "I wanted to control the three elements and the sea inside [them]. Everything in this triangle is a part of the work, a part of the sea." In the result we see the marriage between Chillida's respect for architectural discipline and the freedom of his sculptural vision.

During the development of his ideas for the construction of the *Wind Combs*, he realized that he must give vent to the energy of the waves below sea level as well as above. Otherwise his construction would be no more permanent than the preceding sandstone cliffs. To meet this condition, he drilled seven holes down through the granite promenade into submarine caves so that the fury of the storm would be released in seven vertical columns of water which serve as a visual announcement of the *Wind Combs* which stand behind them (fig. 95).

Initially he placed an organ pipe in each hole, "but the waves were more powerful organists than Bach and the townsfolk objected." He removed the pipes and now there is a hiss and a geyser from each hole, and the effect is very exciting when the sea is disturbed. "The sculpture absolutely disappears, both there and here, when the sea is high. And the holes breathe heavily when the sea is up—like a whale surfacing."

It is this last playful touch that draws people of all ages out to enjoy the *Wind Combs*, all fascinated by its affirmation of the eternal movement of the sea, of its rising and falling but never-failing presence, of its patient but uncompromising strength. The *Wind Combs* is the triumph of a sensitive, respectful man doing homage to both man and nature in the same sculpture.

Notes

1. Gaston Bachelard, "Le Cosmos du fer," *Derrière le Miroir*, nos. 90–91, October/November 1956, n.p.

2. Meyer Schapiro, "Recent Abstract Painting" (1957), in *Modern Art—19th and 20th Centuries: Selected Papers* (New York, 1978), p. 217.

3. Heinrich Wolfgang Petzel, *Auf einen Stern zugegen: Begegnungen mit Martin Heidegger 1929–1976* (Frankfurt, 1983), pp. 164ff.

4. Eduardo Chillida, quoted in Pierre Volboudt, *Chillida* (London, 1967), p. xi.

5. Ibid., p. vii.

6. Bachelard, op. cit.

7. Octavio Paz, "Chillida: From iron to light," trans. Rachel Phillips, in The Solomon R. Guggenheim Museum, *Chillida* (New York, 1979), p. 17.

8. James Johnson Sweeney, *Eduardo Chillida* (Houston, 1966), p. 21.

9. This fact is often overlooked when it is stated that Robert Rauschenberg, in 1964, when awarded the prize of the President of the Council of Ministers, was the first American artist to be honored with a major award at Venice. In fact not only Tobey, but also Alexander Calder and James McNeill Whistler had received principal prizes at the Biennale.

10. Chillida, quoted in Claude Esteban, *Chillida* (Paris, 1971), p. 159.

11. Paz, op. cit., p. 18.

12. The material Chillida employed for his large metal pieces is Reco-Especial, an alloy manufactured in Spain that is similar to the American Cor-ten.

13. Novalis, "Aesthetische Fragmente," in *Werke* (Berlin and Leipzig, n.d.), p. 205.

14. Chillida, quoted in Galerie Beyeler, *Eduardo Chillida* (Basel, 1982), n.p.

15. Jorge Guillén, "Flight," in *Guillén on Guillén* (Princeton, N.J., 1979), pp. 86–87.

16. Chillida, quoted in Esteban, op. cit., p. 167.

17. Guillaume Apollinaire, *The Cubist Painters* (1913; trans. New York, 1962), p. 13.

18. Lewis Mumford, *The Culture of Cities* (New York, 1938), p. 438.

19. Sweeney, op. cit., p. 21.

20. Chillida, quoted in Ellen Schwartz, "Chillida's Silent Music, de Kooning's Eloquent Ambivalence," *Art News*, March 1980, p. 71.

21. Rainer Maria Rilke, "Worpswede," in *Where Silence Reigns* (New York, 1978), p. 9.

22. Naum Gabo, "The Realist Manifesto," in Herschel Chipp, Peter Selz, and Joshua C. Taylor, *Theories of Modern Art* (Berkeley, 1968), p. 329.

23. Julio Gonzalez, in Andrew C. Ritchie, *Julio Gonzalez* (New York, 1956), p. 42.

24. Martin Heidegger, *Being and Time* (1929; trans. New York, 1962), passim.

25. Maurice Merleau-Ponty, "Eye and Mind," in *The Primacy of Perception* (Evanston, Ill., 1964), p. 180.

26. Martin Heidegger, *Die Kunst und der Raum*, with seven lithographs by Eduardo Chillida (Saint-Gall, 1969).

27. Ibid., pp. 11–13.

28. Chillida, quoted in Guggenheim Museum, *Chillida*, p. 21.

29. Martin Heidegger, "Building, Dwelling, Thinking" (1954; trans. in *Poetry, Language and Thought*, New York, 1971), p. 154.

30. Chillida, quoted in Galerie Beyeler, *Eduardo Chillida*, n.p.

Plates

117. *Spirit of the Birds I.* 1952. Iron and shingle, 23 × 36 × 15 in. (0.58,5 × 0.91,5 × 0.38 m.). Collection Museo Español de Arte Contemporáneo, Madrid

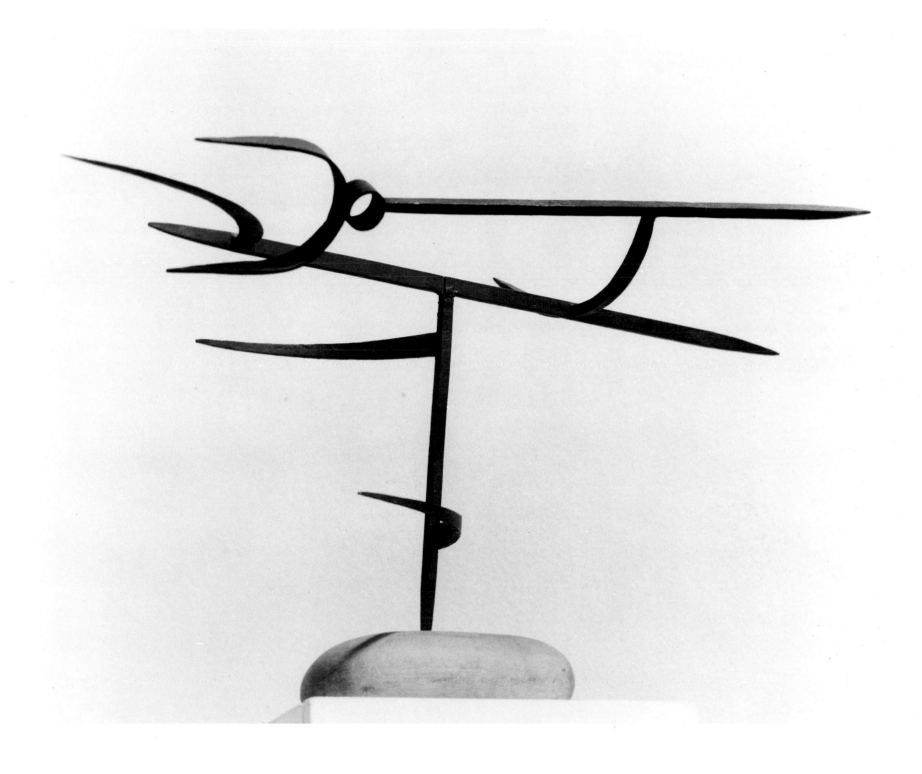

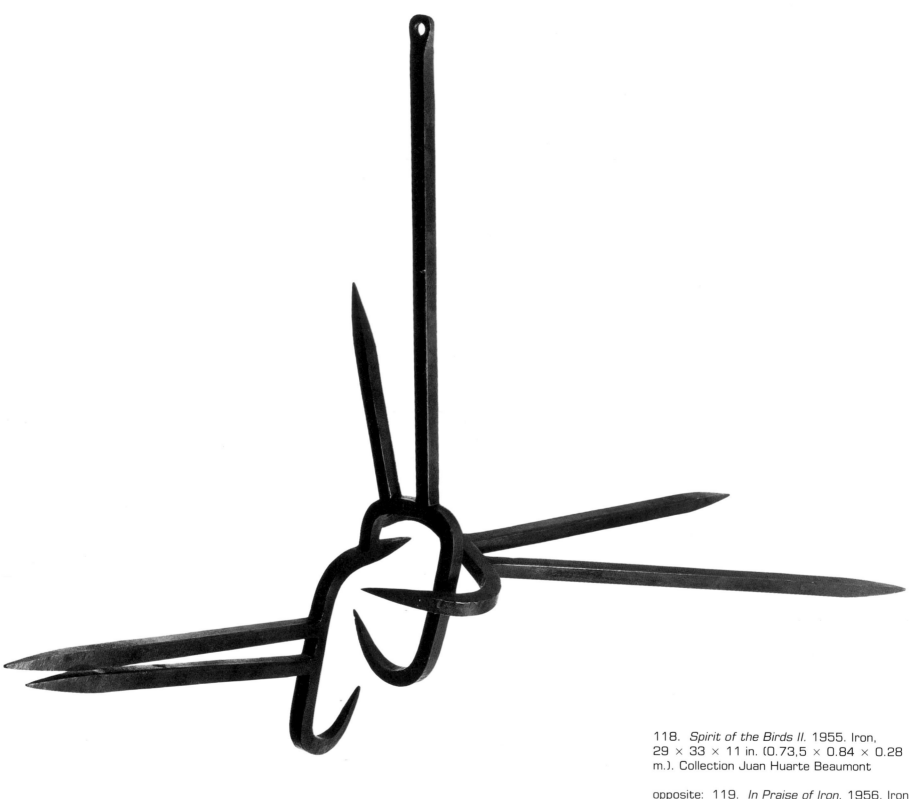

118. *Spirit of the Birds II*. 1955. Iron,
29 × 33 × 11 in. (0.73,5 × 0.84 × 0.28
m.). Collection Juan Huarte Beaumont

opposite: 119. *In Praise of Iron*. 1956. Iron,
27 × 20 × 15 in. (0.68,5 × 0.51 × 0.38
m.). Collection Amalia de Schultess,
Los Angeles

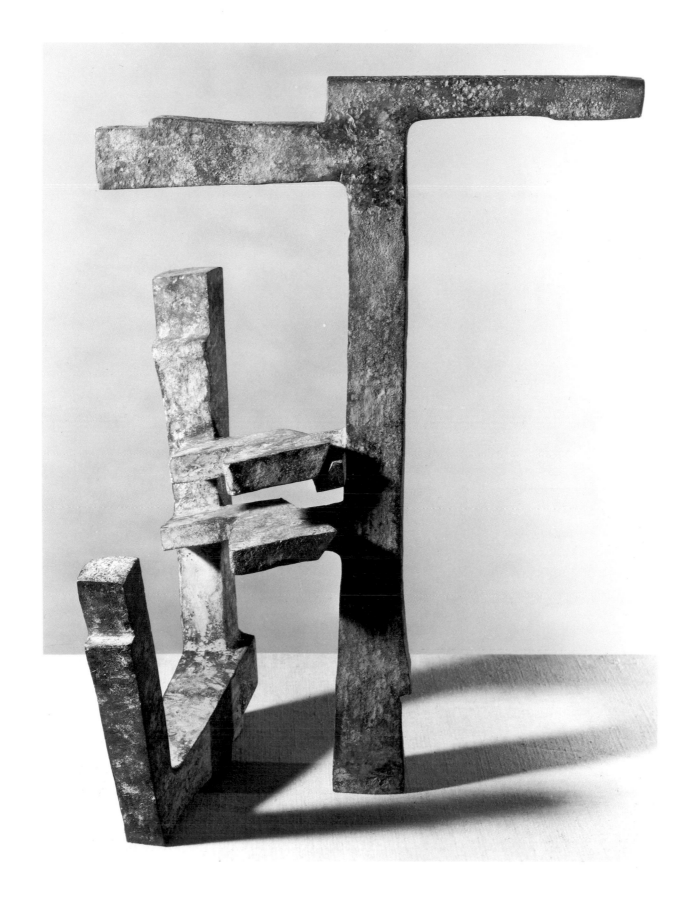

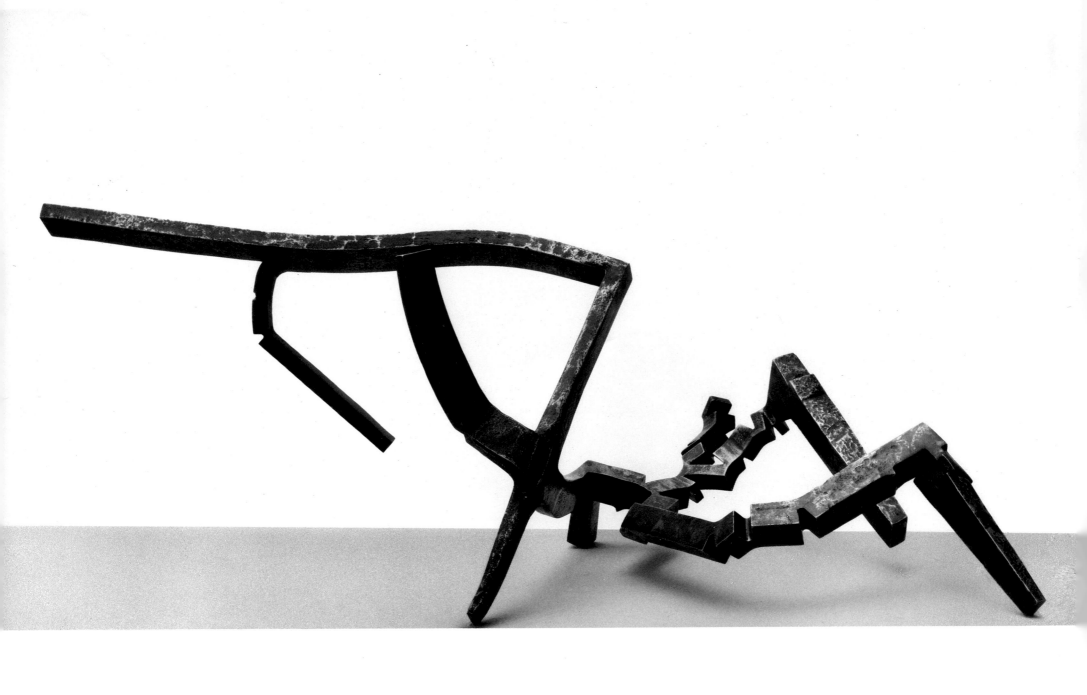

120. *From the Edge.* 1957. Iron, 22 × 59 ×
31½ in. (0.56 × 1.50 × 0.80 m.). Collection
Kunsthaus, Zurich

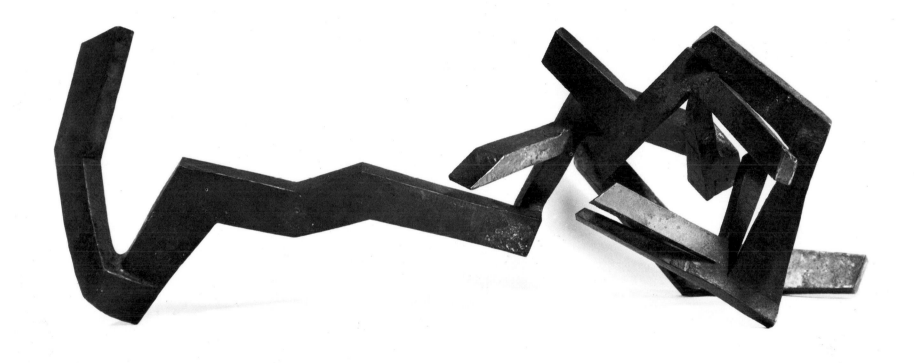

121. *Tximista (Lightning)*: 1957. Iron, 31 × 15 × 12 in. (0.78,5 × 0.38 × 0.30,5 m.). Collection Hirshhorn Museum and Sculpture Garden, Smithsonian Institution, Washington, D.C.

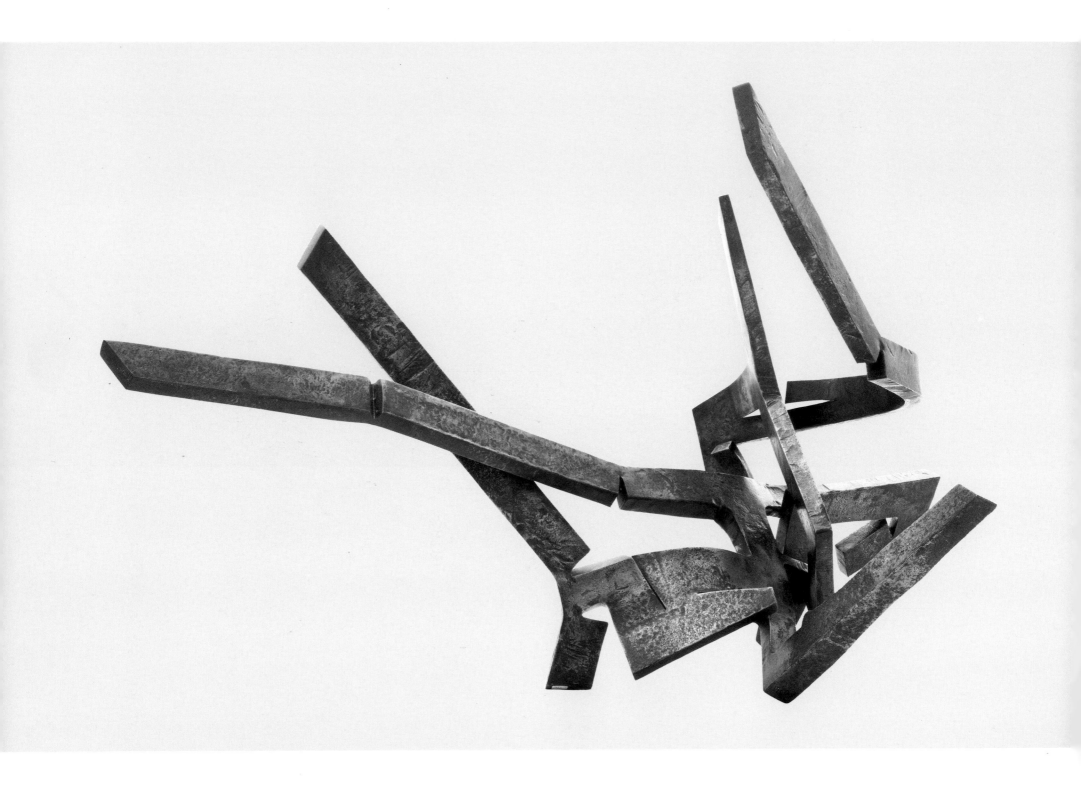

122. *Aizian (In the Wind)*. 1958. Iron,
28 × 55 × 41 in. (0.71 × 1.40 × 1.04 m.).
Collection Museum of Art, Carnegie Institute,
Pittsburgh. Museum purchase: Howard Heinz
Endowment Purchase Fund, 1958

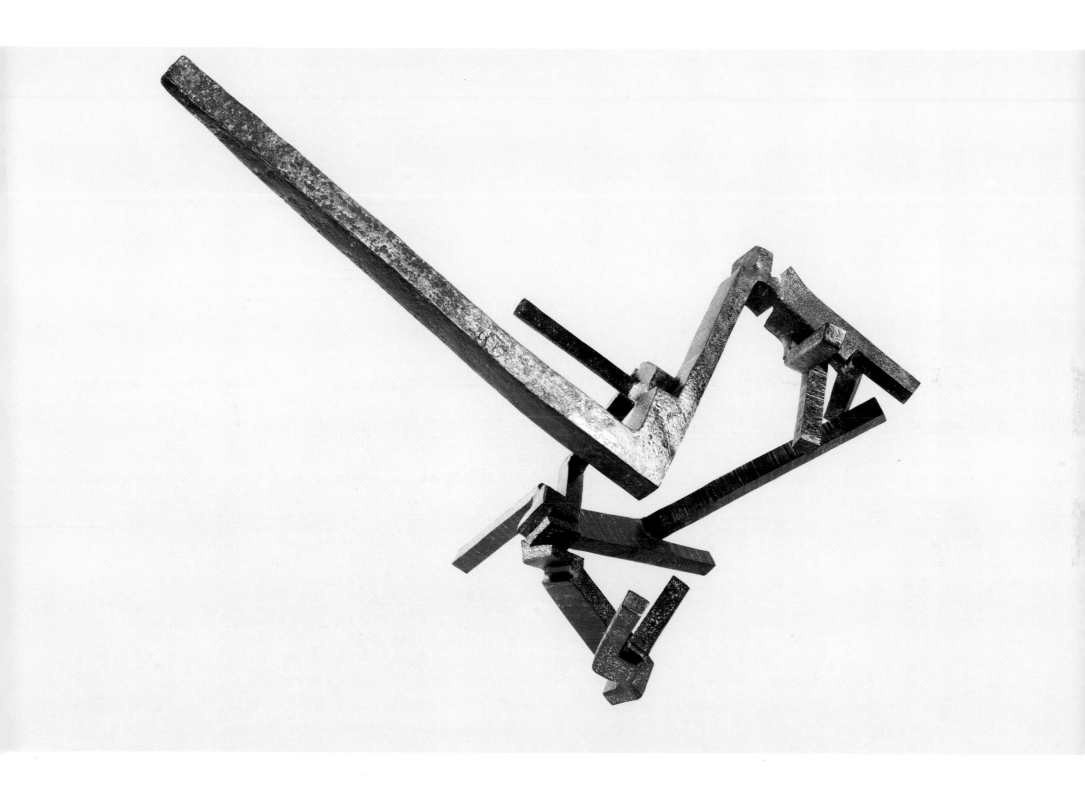

123. *Place of Silences*. 1958. Iron,
16 × 17 × 9 in. (0.40,5 × 0.43 × 0.23 m.).
Private collection, Houston, Texas

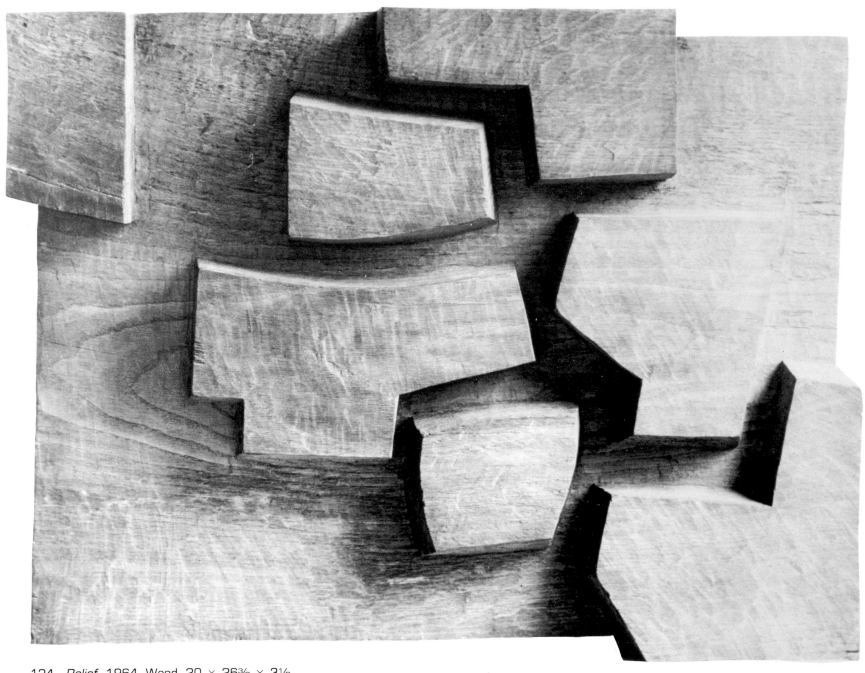

124. *Relief*. 1964. Wood, 20 × 26⅜ × 3⅛
in. (0.51 × 0.67 × 0.08 m.). Collection the
artist

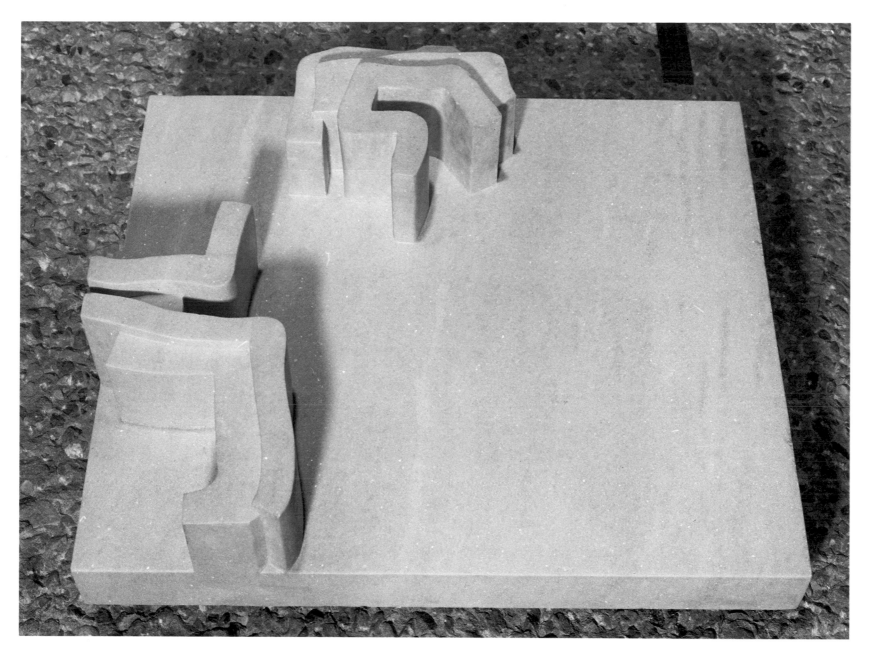

125. *Relief*. 1965–70. Marble,
27½ × 31 × 8 in. (0.70 × 0.79 × 0.20 m.).
Collection Sonja Henies og Niels Onstads Stif-
telser, Høvikodden, Norway

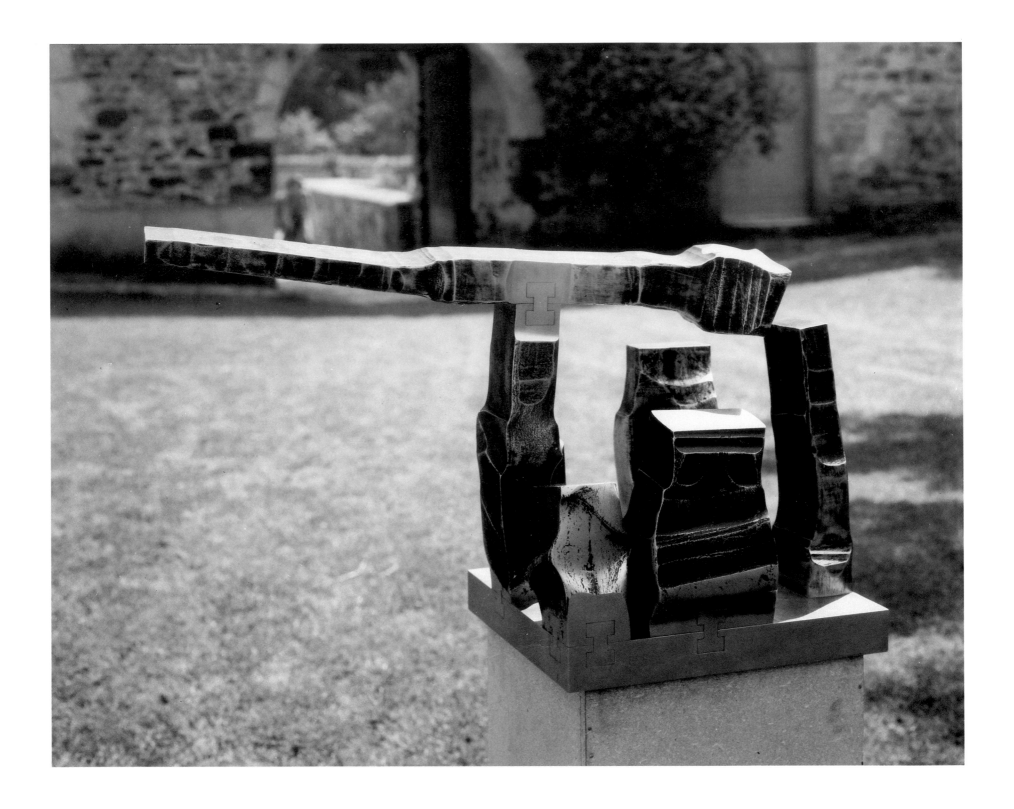

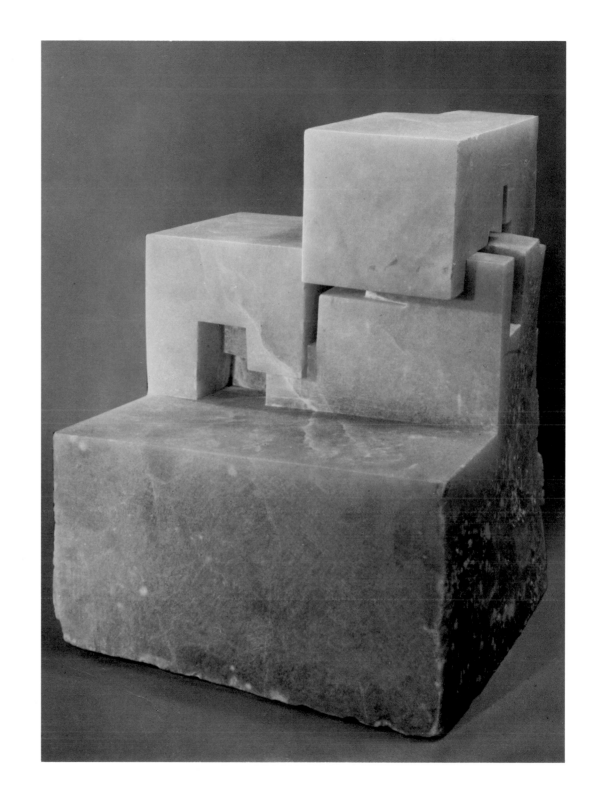

opposite: 126. *Leku I (Place I)*. 1968. Steel,
25 × 39 × 19 in. (0.63,5 × 0.99 × 0.48
m.). Collection H. C. Bechtler, Zurich

right: 127. *Bakuntza (Union)*. 1968. Alabas-
ter, 21 × 16 × 17 in. (0.53,5 × 0.40,5 ×
0.43 m.). Collection Adrien Maeght, Paris

128. *In Praise of Light XI.* 1969. Alabaster, 16 × 20½ × 6 in. (0.40,5 × 0.52 × 0.15 m.). Private collection, West Germany

129. *In Praise of Architecture I.*
1968. Alabaster, 12 × 12 × 12 in.
(0.30,5 × 0.30,5 × 0.30,5 m.).
Collection Galerie Maeght Lelong,
Zurich

130. *In Praise of Architecture III*. 1972.
Steel, 60 × 38 × 29 in. (1.52,5 × 0.96,5 ×
0.73,5 m.). Collection Städtische Kunsthalle,
Mannheim, West Germany

opposite: 131. *Homage to Architecture I*.
1973. Alabaster, 10½ × 6 × 7½ in.
(0.26,5 × 0.15 × 0.19 m.). Private collection,
Madrid

139

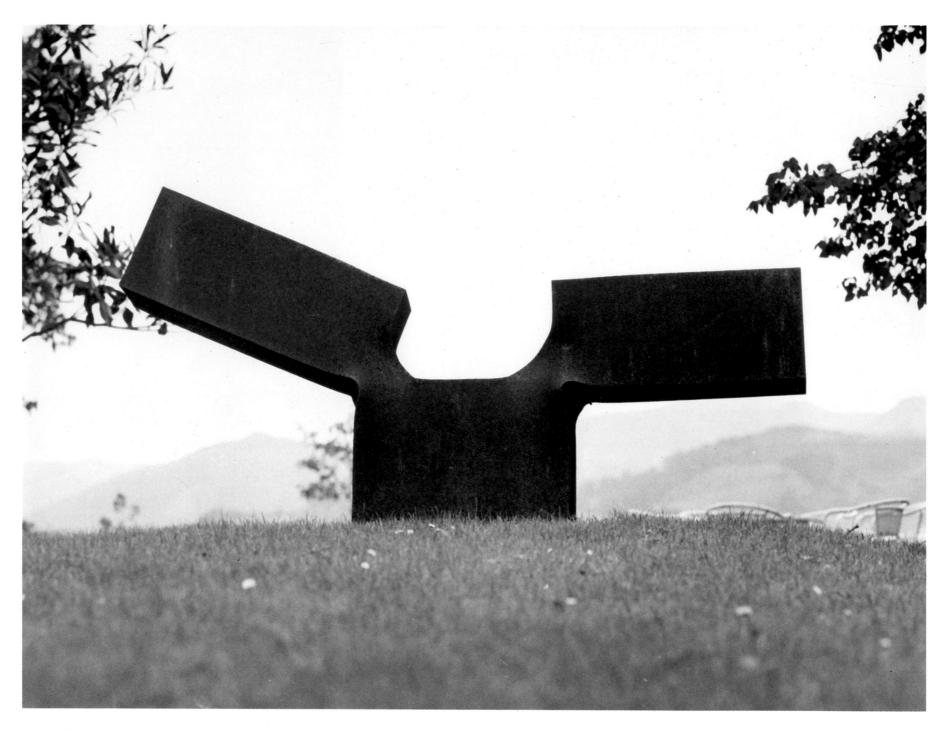

132. *Homage to Rafael Elosegui*. 1970. Steel,
38 × 74 × 13 in. (0.96,5 × 1.88 × 0.33
m.). Collection Jaizkibel Golf Club, Hondarrabia,
Gipuzkoa, Basque country

opposite: 133. *Bas-Relief*. 1972. Alabaster,
10½ × 6 × 3 in. (0.26,5 × 0.15 × 0.7,5
m.). Collection Mr. and Mrs. Jan Boon, Holland

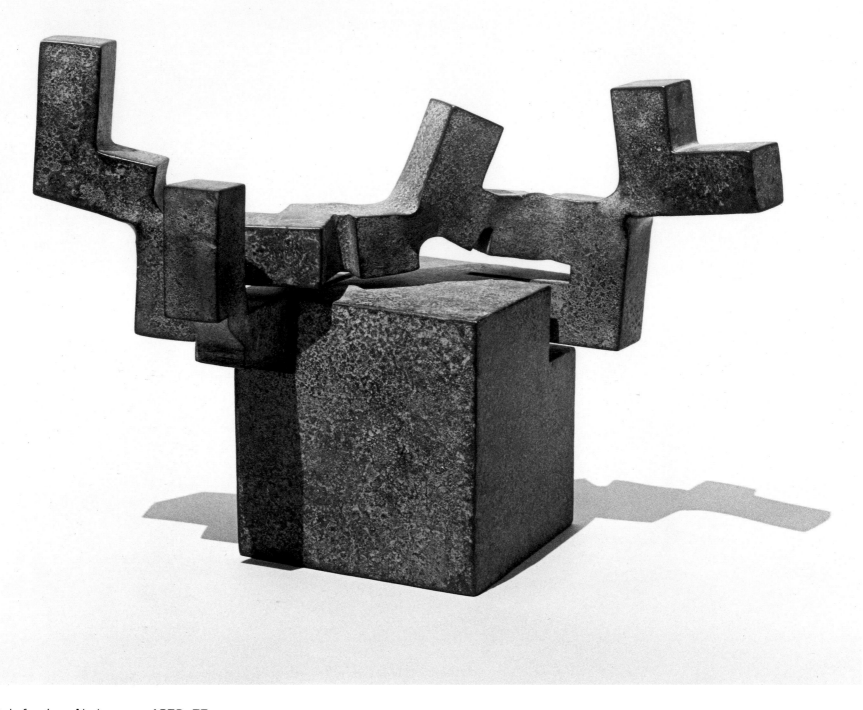

134. *Stele for Juan Ajuriaguerra.* 1972–77.
Iron, 8¾ in. (0.22 m.). Collection Mr. and Mrs.
George Segal, East Hampton, New York

142

opposite: 135. *Iru Zulo (Three Holes).*
1973–74. Steel, 15½ × 31¾ × 19¾ in.
(0.40 × 0.78 × 0.50 m.). Collection Kunstmuseum and Hermann und Margrit Rupf-Stiftung,
Bern

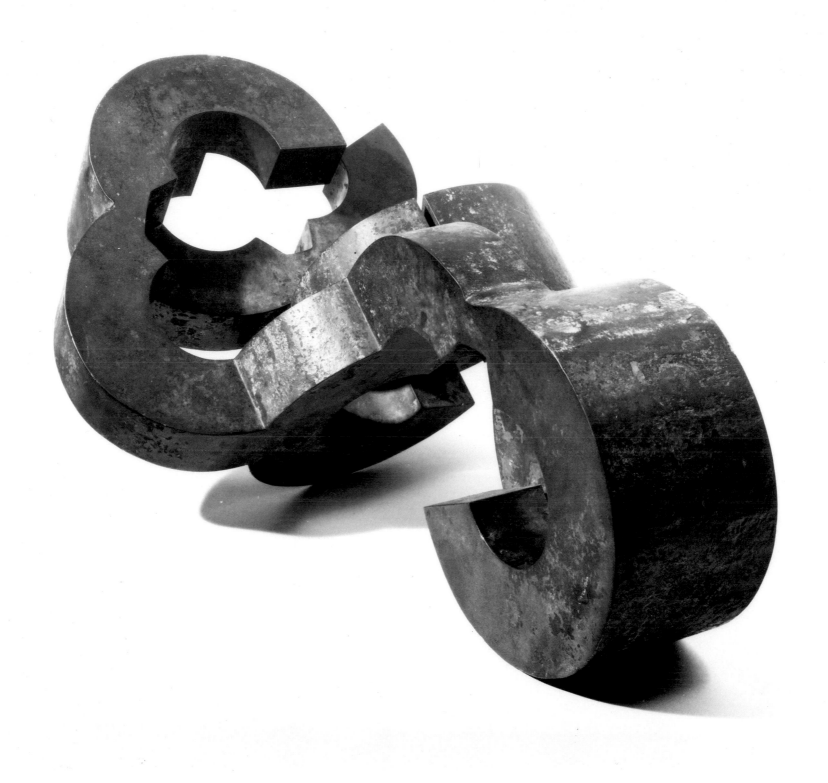

143

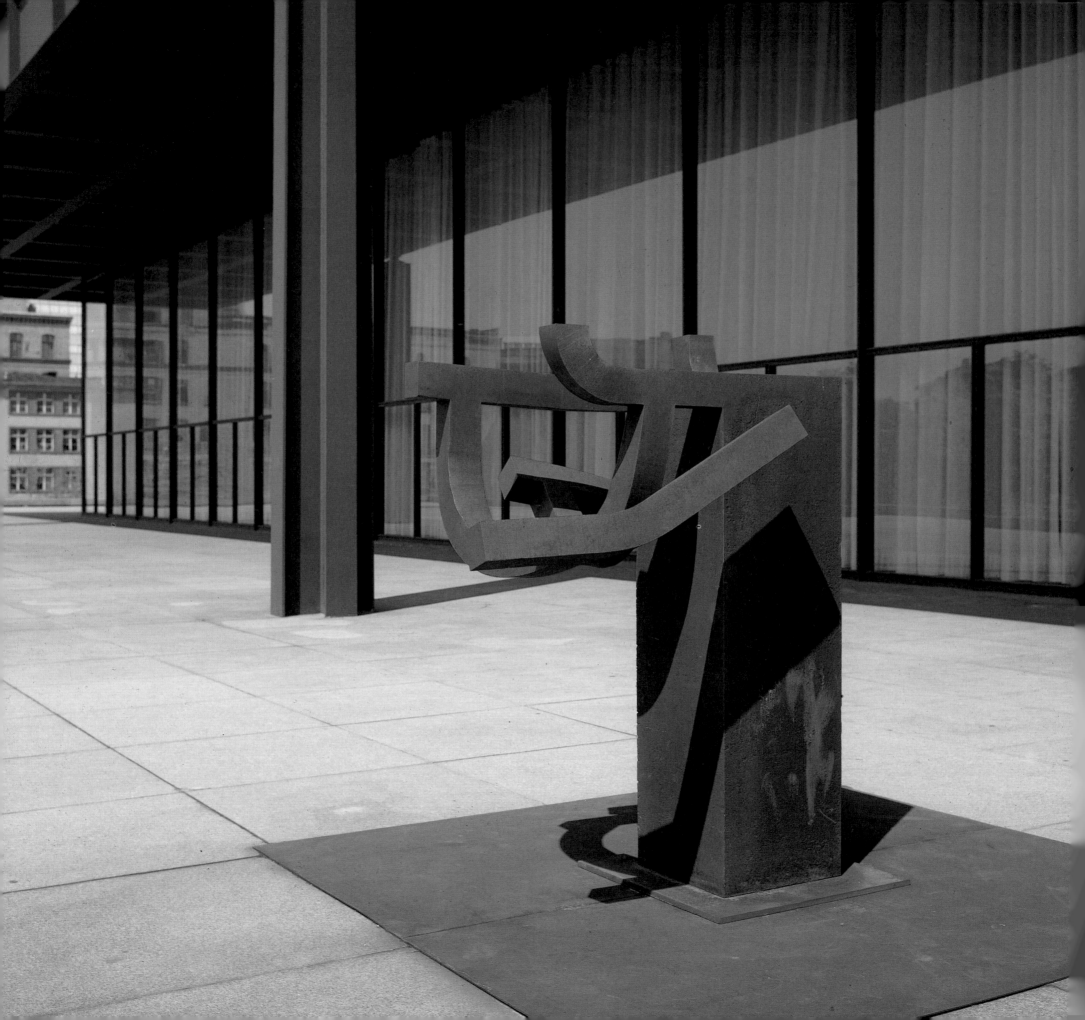

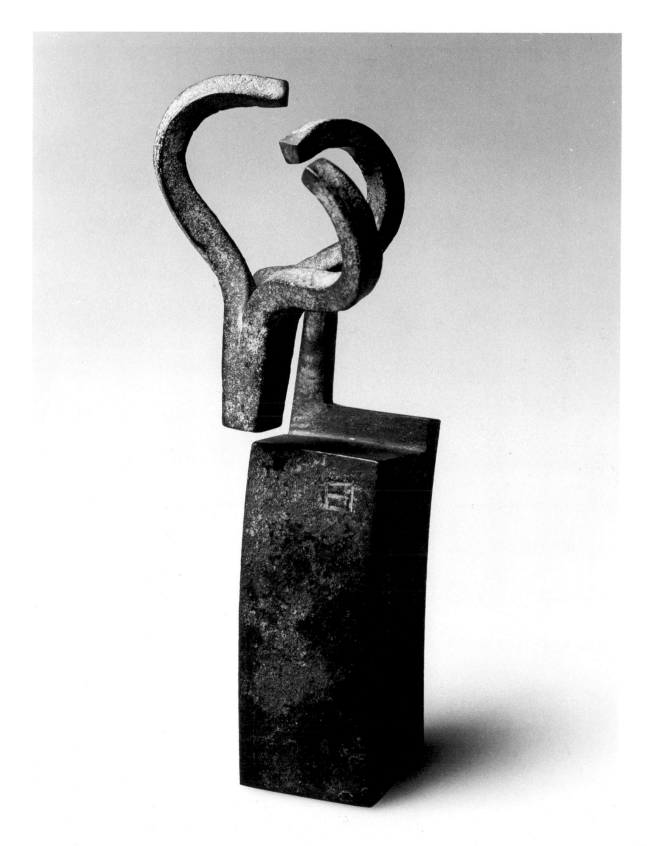

opposite: 136. *Gudari (Warrior)*. 1974–75.
Steel, 73 × 57½ × 42 in. (1.85 × 1.46 ×
1.06,5 m.). Collection Nationalgalerie, West
Berlin

right: 137. *Stele for Picasso*. 1975. Steel,
7½ × 3½ × 3 in. (0.19 × 0.9 × 0.8 m.).
Collection Galerie Beyeler, Basel

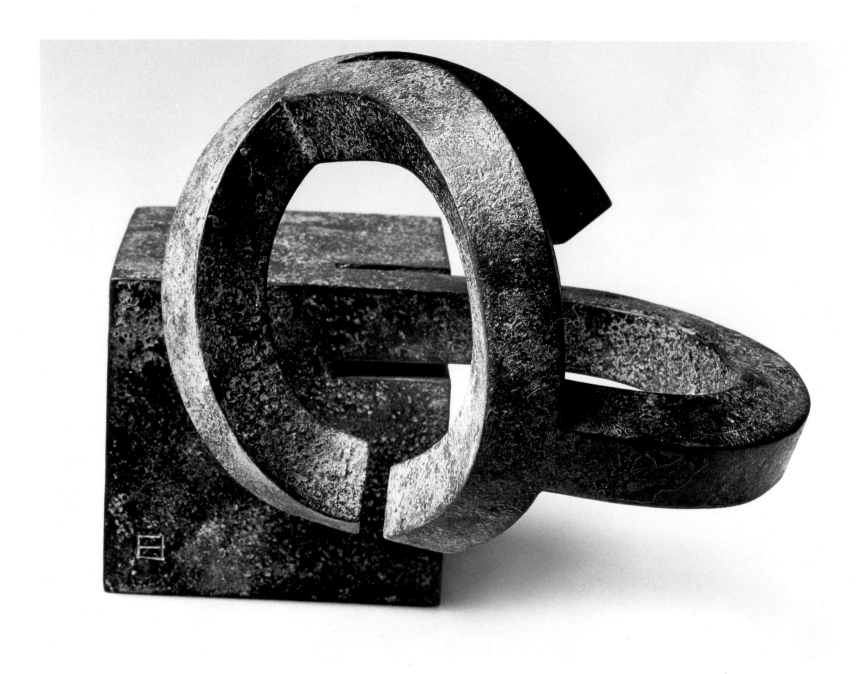

138. *Stele for Borromini.* 1976. Steel,
7 × 8½ × 8 in. (0.18 × 0.21,5 × 0.20 m.).
Private collection, West Germany

opposite: 139. *Stele for José Antonio de
Aguirre.* 1978. Steel, 36 × 27 × 7½ in.
(0.91,5 × 0.68,5 × 0.19 m.). Collection
Galerie Maeght Lelong, Paris

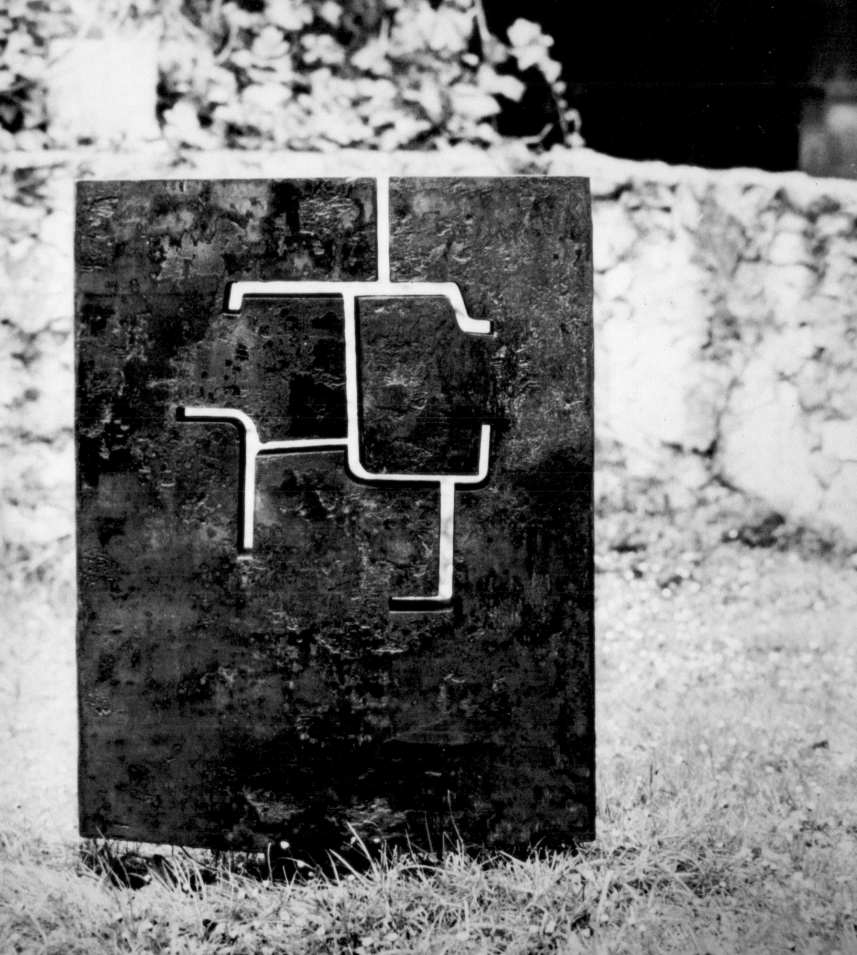

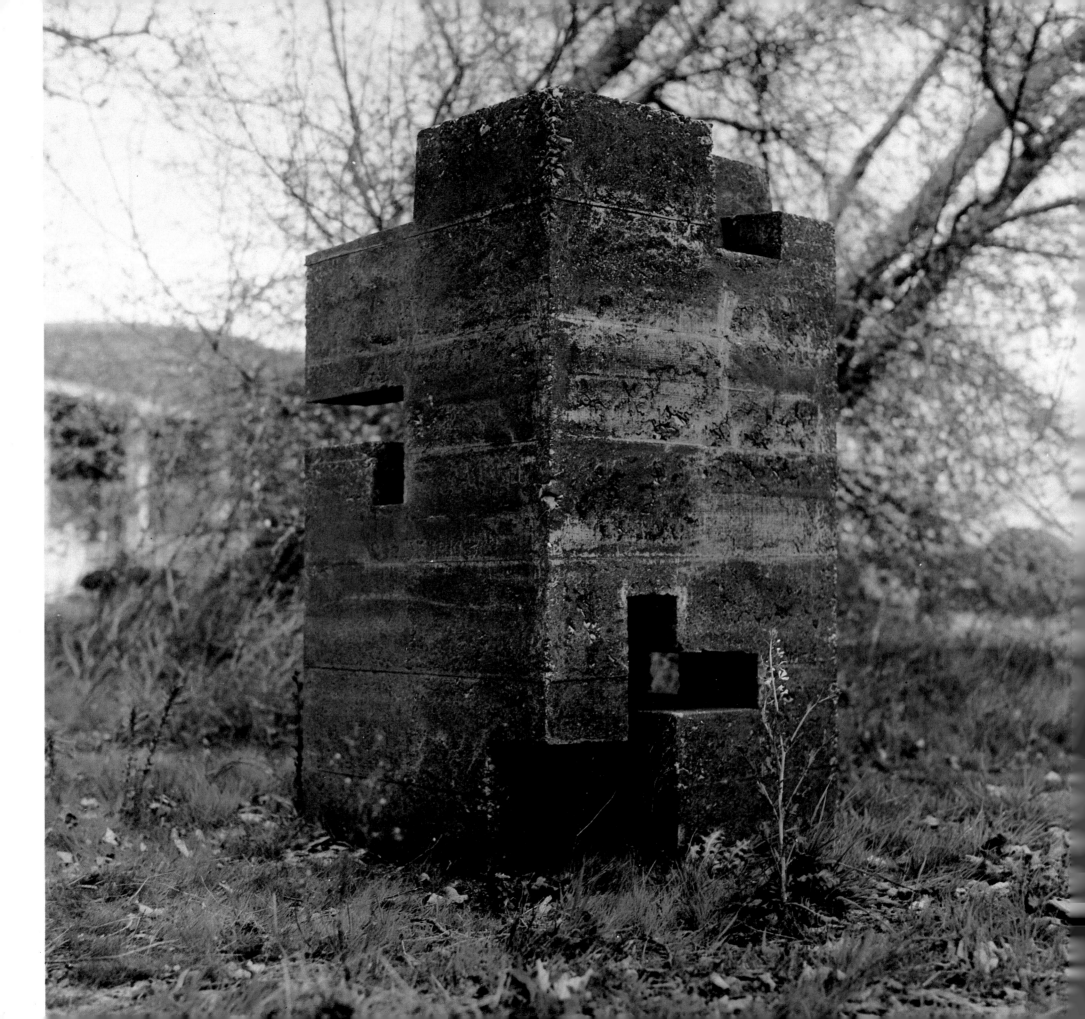

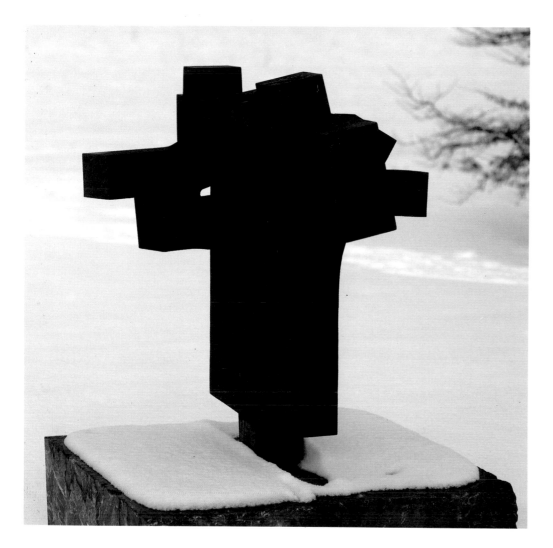

opposite: 140. *Heterodox Architecture I.*
1978. Reinforced concrete, 55 × 31½ ×
31½ in. (1.90,5 × 0.80 × 0.80 m.). Collec-
tion Galería Maeght, Barcelona

above and right: 141.—142. *Homage to
Johann Sebastian Bach.* 1978. Steel, 44 ×
34½ × 58 in. (1.12 × 0.87,5 × 1.47,5 m.).
Collection Edith Hafter, Switzerland

opposite: 145. *Refuge for Man.* 1980.
Alabaster, 16 × 14 × 18½ in. (0.40,5 ×
0.35,5 × 0.47 m.). Private collection, Spain

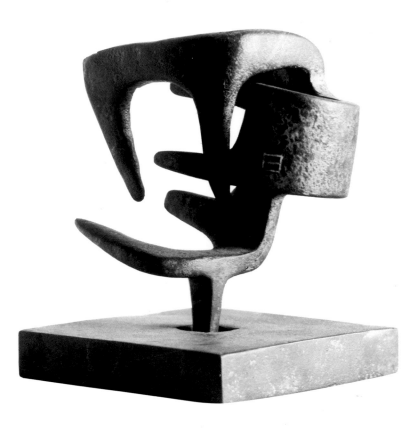

143. *Zuhaitz IV (Tree IV).* 1954–78. Iron,
5⁵⁄₁₆ × 4⁵⁄₁₆ × 4 in. (0.13,5 × 0.11 × 0.10
m.). Collection Museo de Bellas Artes, Bilbao

right: 144. *Stele VIII.* 1980. Steel,
12 × 10½ × 7 in. (0.30,5 × 0.27 × 0.18
m.). Collection Arango, Madrid

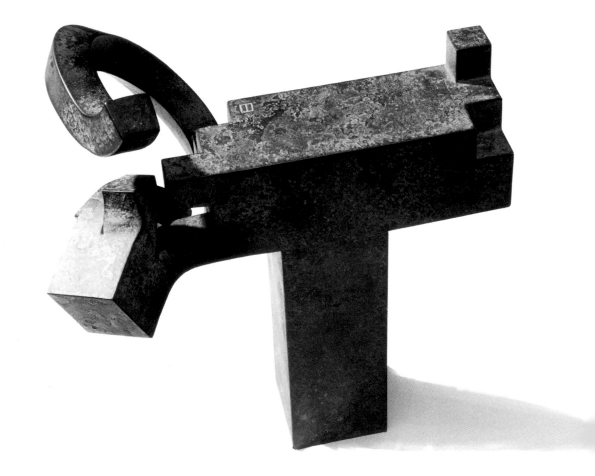

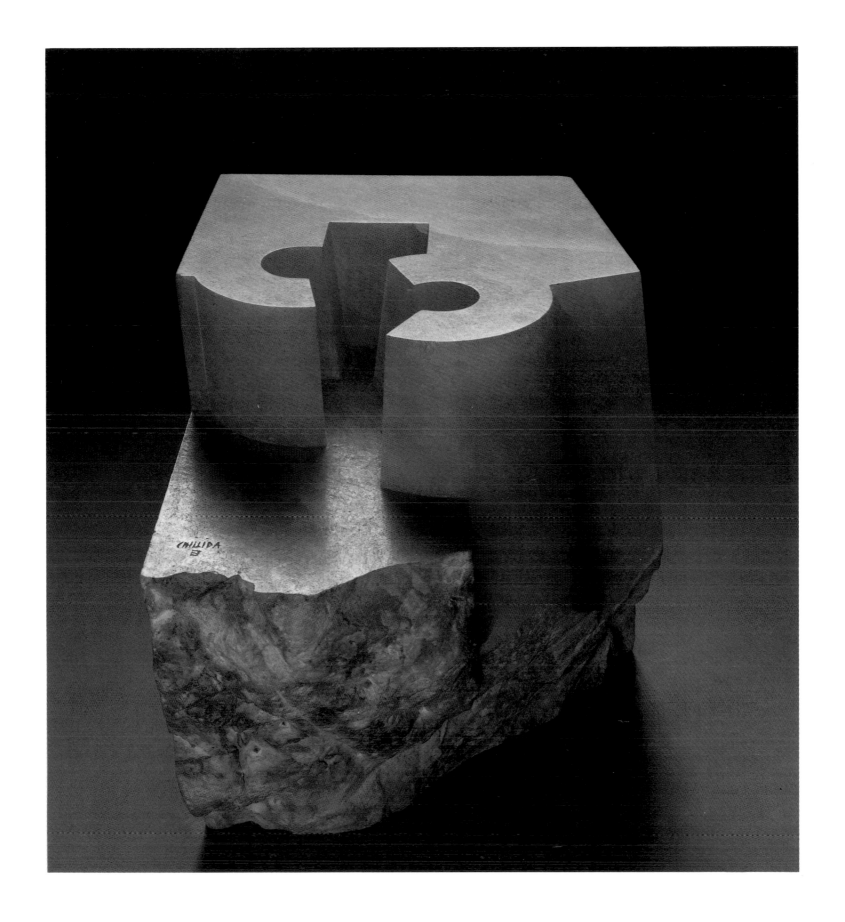

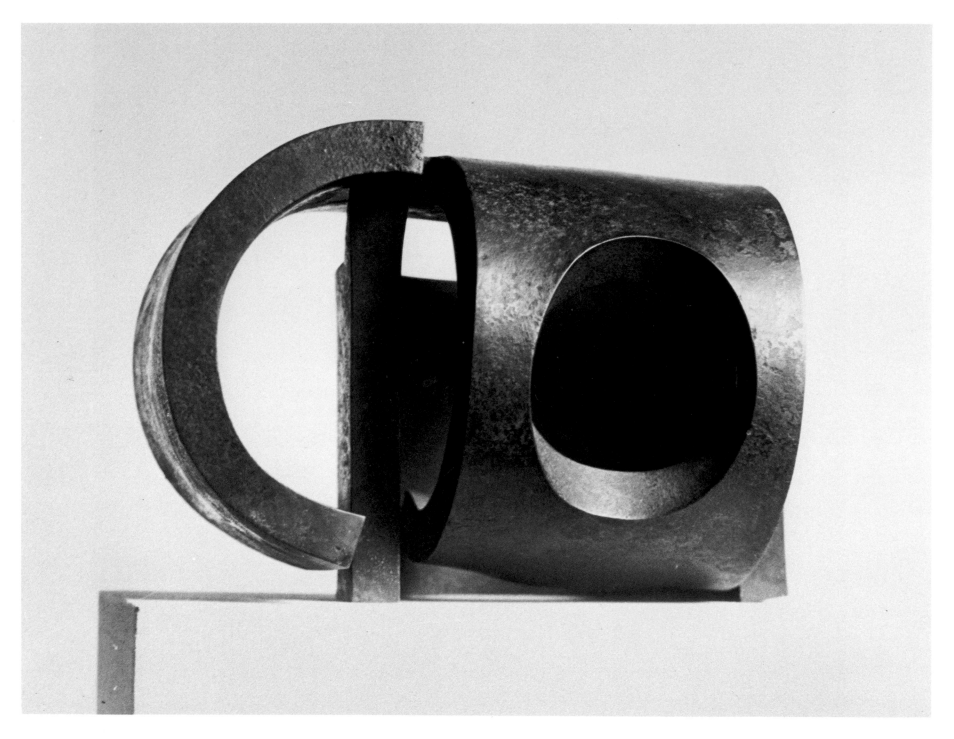

146. *The Poet's House.* 1980–81. Iron,
8¼ × 13 × 9⅞ in. (0.21 × 0.33 × 0.25
m.). Collection Museo de Bellas Artes, Bilbao

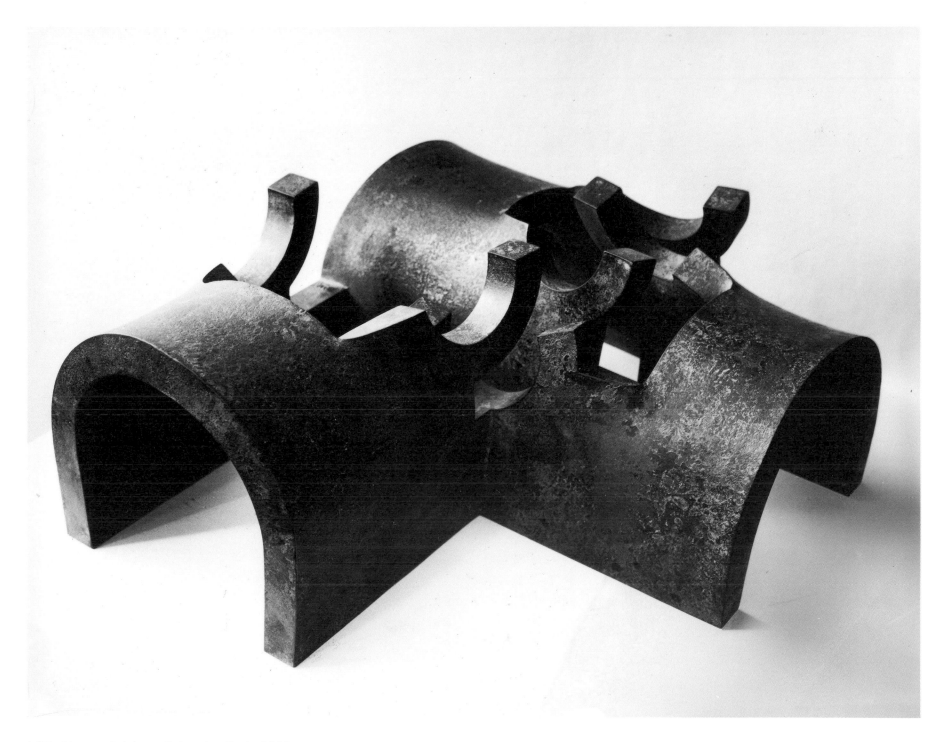

147. *House of Johann Sebastian Bach.* 1981
Steel, 9 × 18 × 22 in. (0.23 × 0.45,5 ×
0.56 m.). Private collection

148. *House of Hokusai.* 1981. Steel, 12 ×
12½ × 16 in. (0.30,5 × 0.32 × 0.40,5 m.).
Private collection

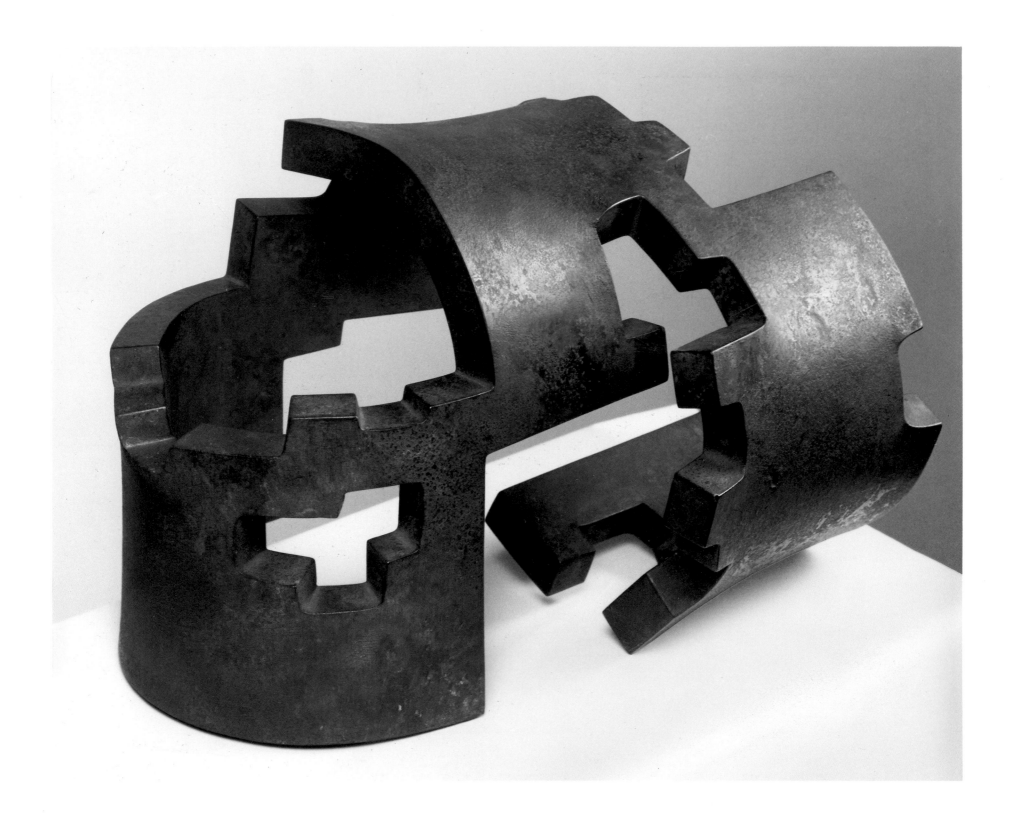

149. *Project for a Monument.* 1982. Steel, 15½ in. (0.40 m.). Collection Mr. and Mrs. Allen D. Kohl, Milwaukee

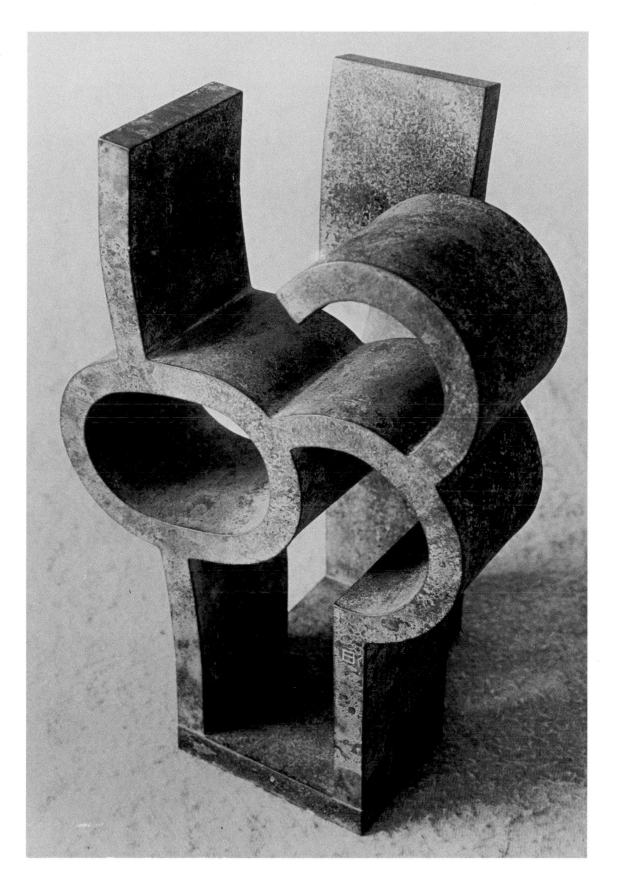

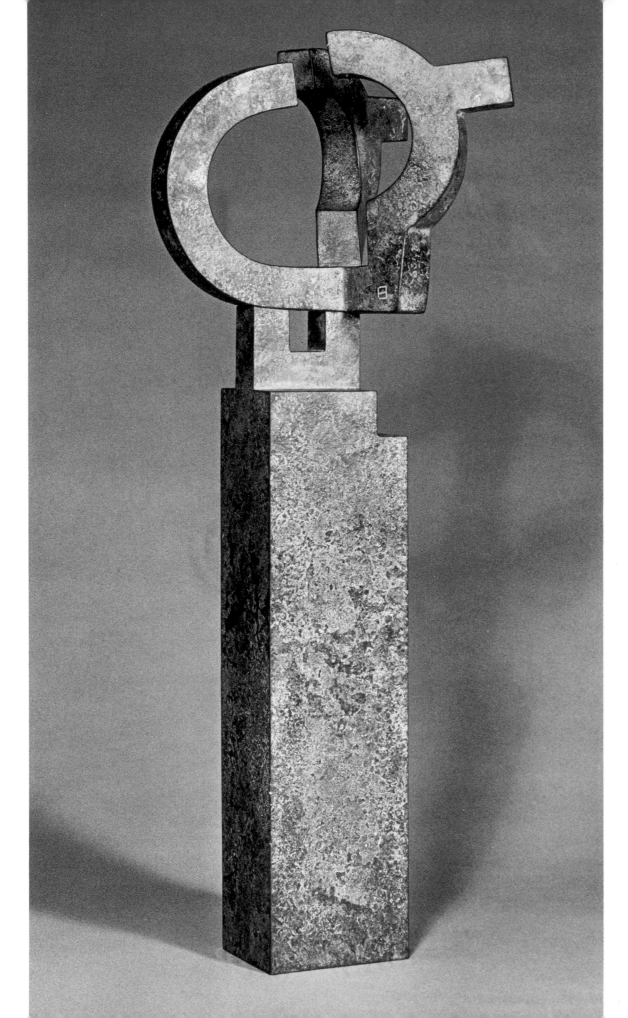

150. *In Praise of Space.* 1983. Steel, 23½ in. (0.59,5 m.). Private collection

opposite: 151. *Deep Is the Air* (detail). 1983. Steel, 45¼ × 8½ × 8½ in. (1.15 × 0.21,5 × 0.21,5 m.). Collection the artist

152. *Gurutz (Cross).*
1983. Steel, 17¼ in.
(0.44 m.). Collection
Tasende Gallery, La Jolla

opposite: 153. *Gnomon
III.* 1984. Steel, 7 ×
9 × 10¼ in. (0.17,5 ×
0.23 × 0.26 m.). Collec-
tion the artist

154. *Tau.* 1984. Steel, 37 ×
18½ × 11¾ in. (0.94 × 0.47 ×
0.29,5 m.). Collection the artist

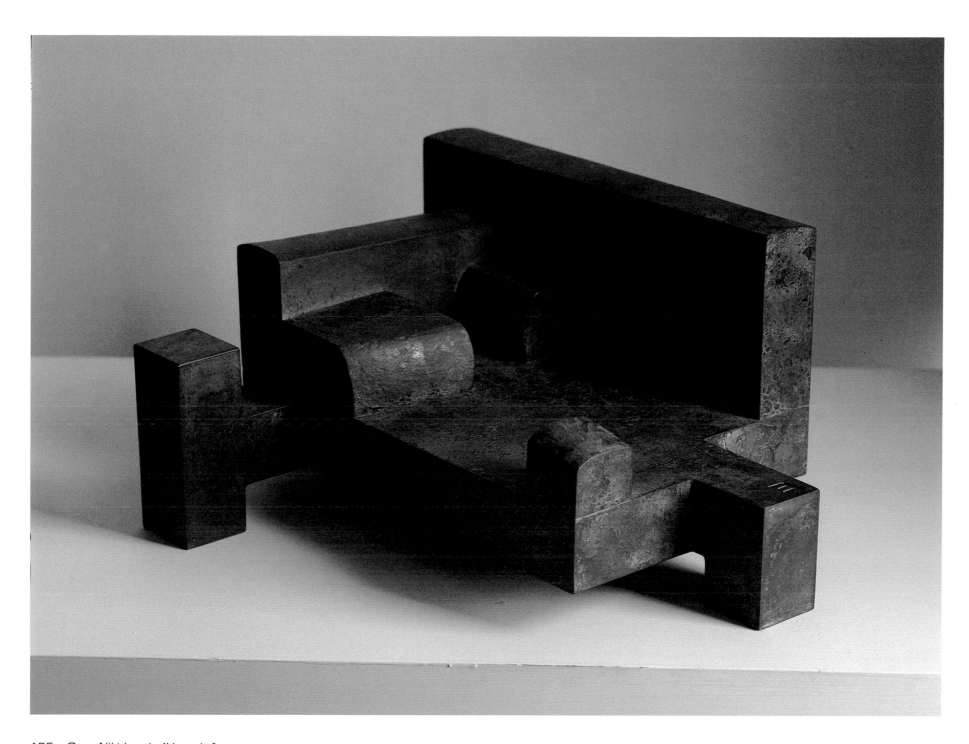

155. *Gora Niki Lauda (Hurrah for Niki Lauda)*. 1984. Steel, 6⅛ × 14¼ × 13¾ in. (0.15,6 × 0.36 × 0.35 m.). Collection the artist

overleaf left: 156. *In Praise of Architecture*. 1984. Steel, 30½ × 27 × 22½ in. (0.77,5 × 0.68,5 × 0.57 m.). Collection Tasende Gallery, La Jolla

overleaf right: 157. *Zuhaitz (Tree)*. 1984. Steel, 48 × 30¾ × 15½ in. (1.22 × 0.78 × 0.39,5 m.). Collection Tasende Gallery, La Jolla

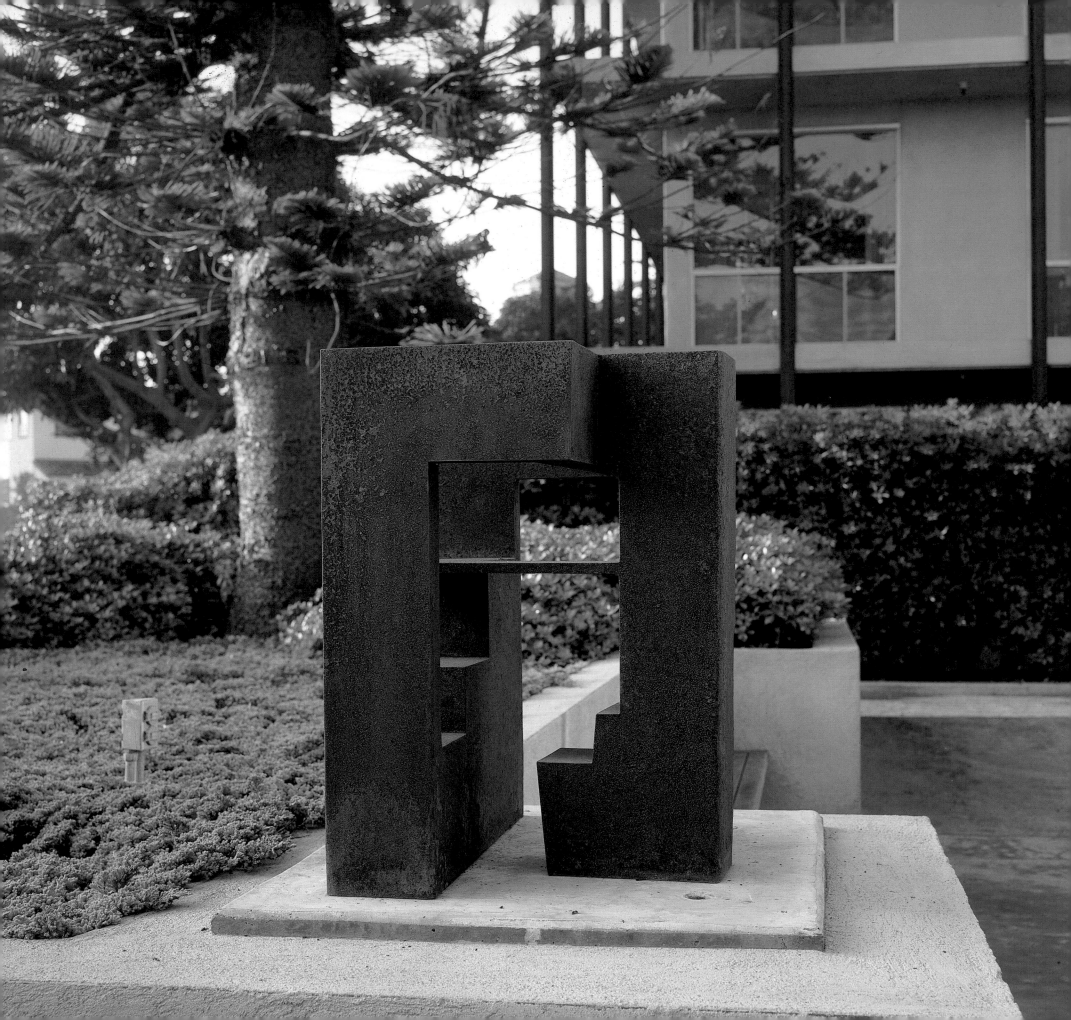

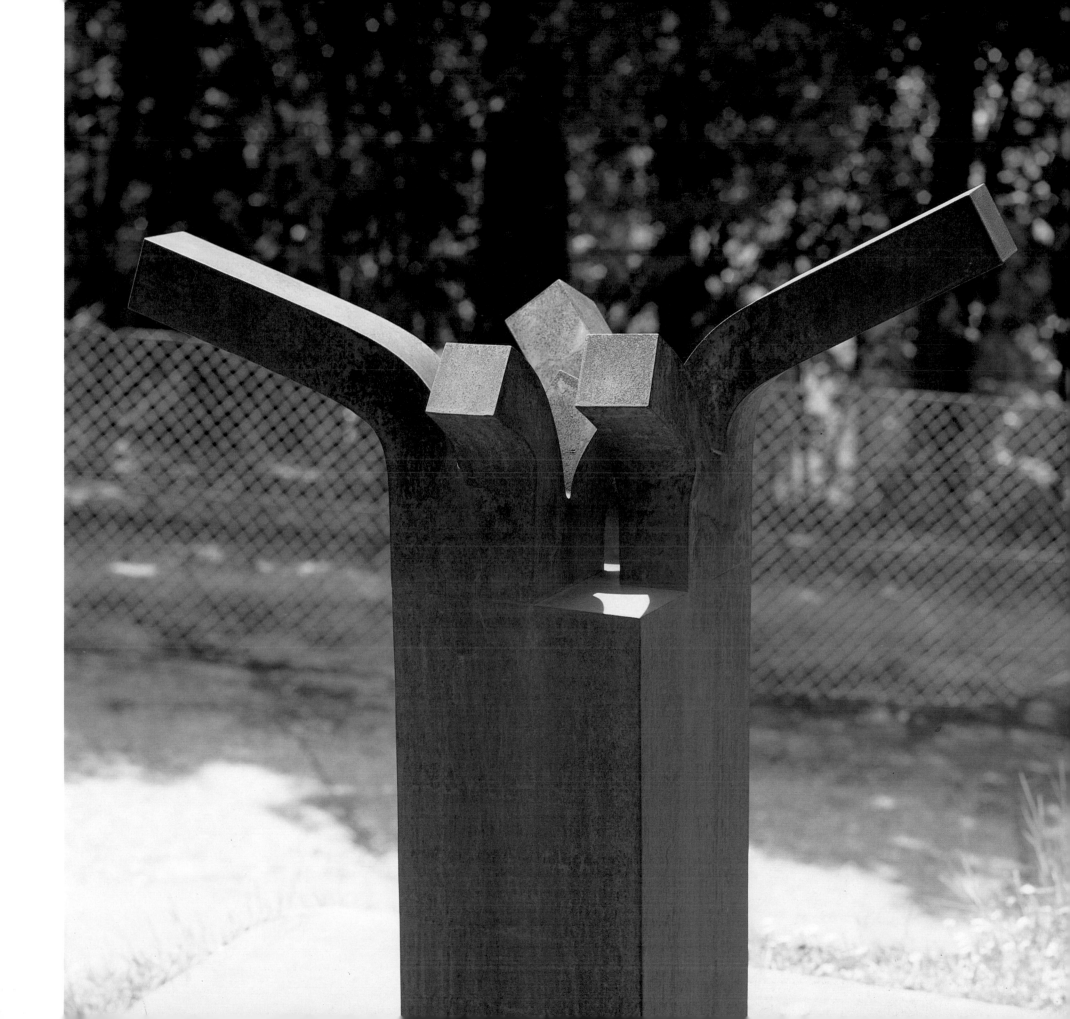

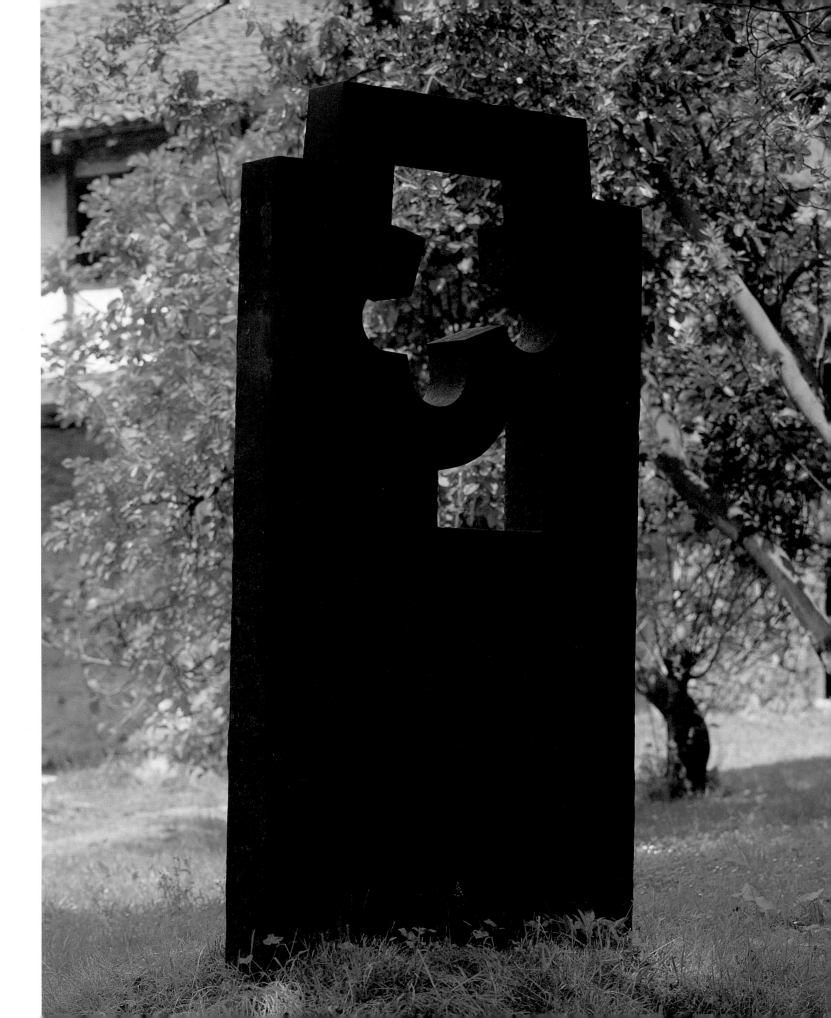

158. *Lizardiren Leioak
(Lizardi's Window).* 1984.
Steel, 88½ × 47½ ×
6½ in. (2.25 × 1.21 ×
0.16 m.). Collection the
artist

opposite: 159. *Topos I.*
1984. Steel, 36¼ ×
39½ × 36½ in. (0.92 ×
1.00 × 0.93 m.).
Collection the artist

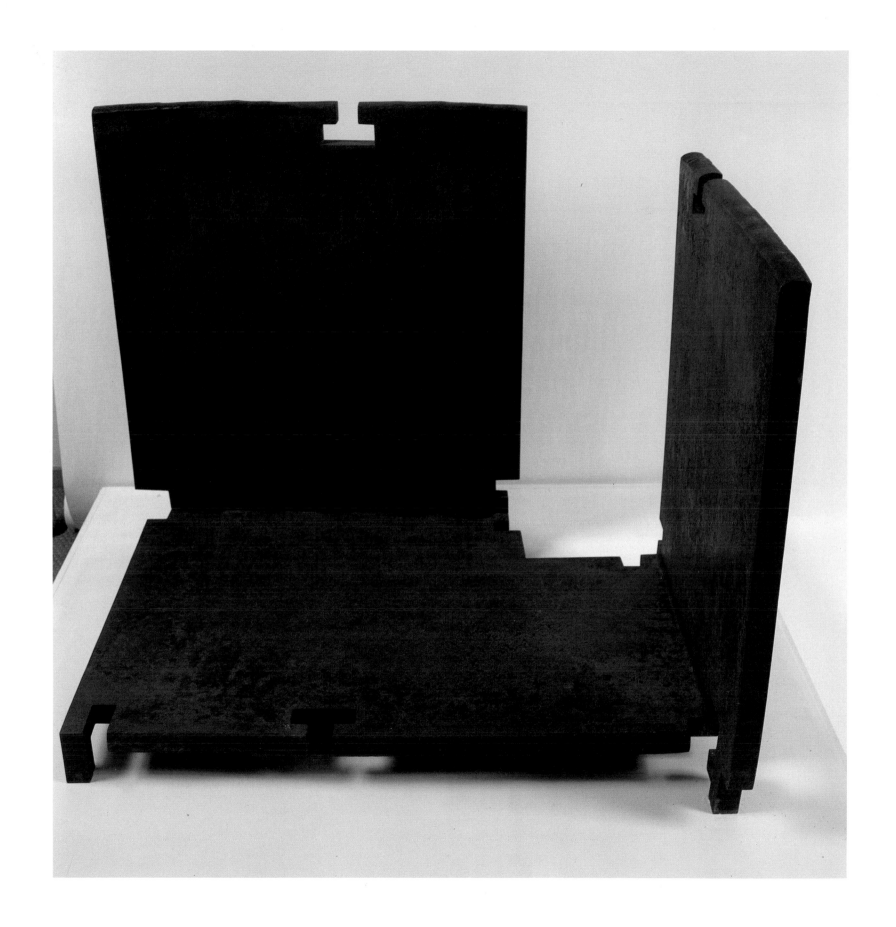

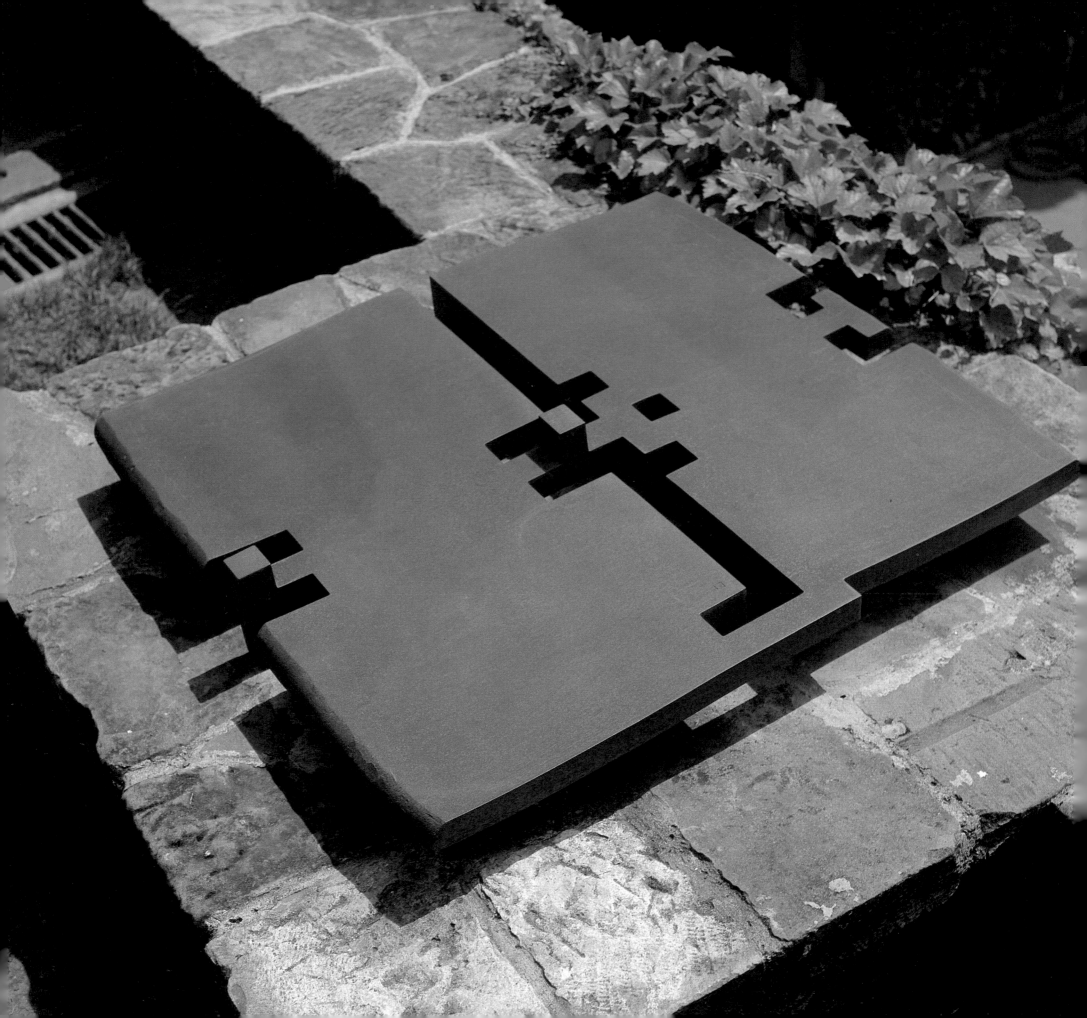

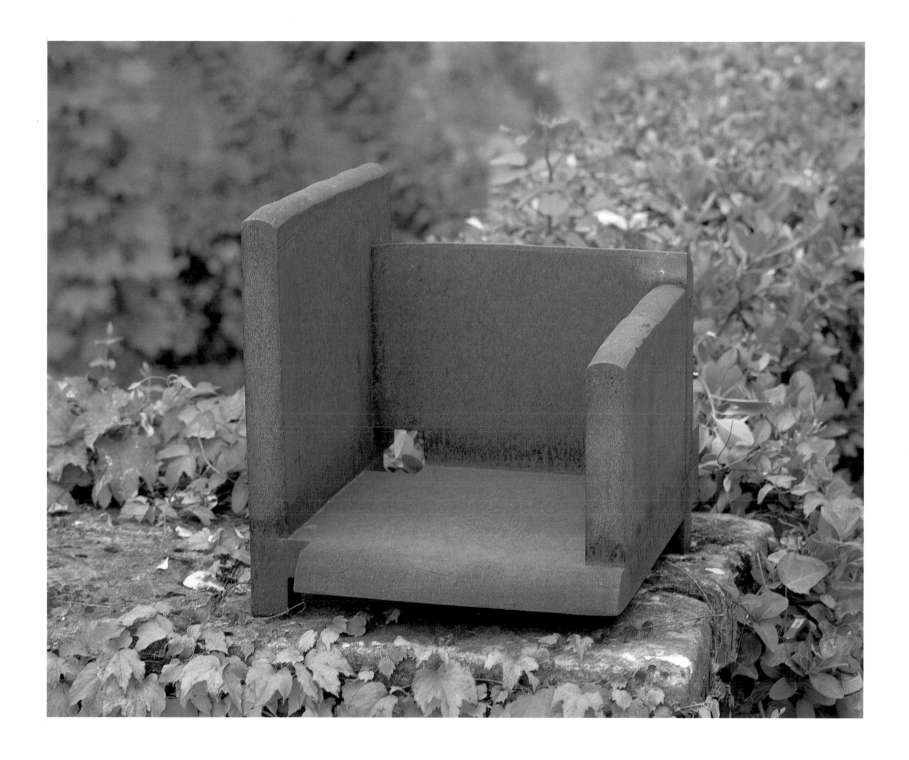

opposite: 160. *Topos II*. 1985. Steel,
7 × 36½ × 4½ in. (0.18 × 0.93 × 0.11
m.). Collection the artist

above: 161. *Topos III*. 1985. Steel, 16½ ×
17½ × 15¾ in. (0.42,5 × 0.44 × 0.40 m.).
Collection the artist

overleaf left: 162. *Topos IV*. 1985. Steel,
16 × 35 × 17½ in. (0.40,5 × 0.89 × 0.44
m.). Collection the artist

overleaf right: 163. *Topos V*. 1985. Steel,
83 × 106½ × 66½ in. (2.11 × 2.69 ×
1.69 m.). Collection the artist

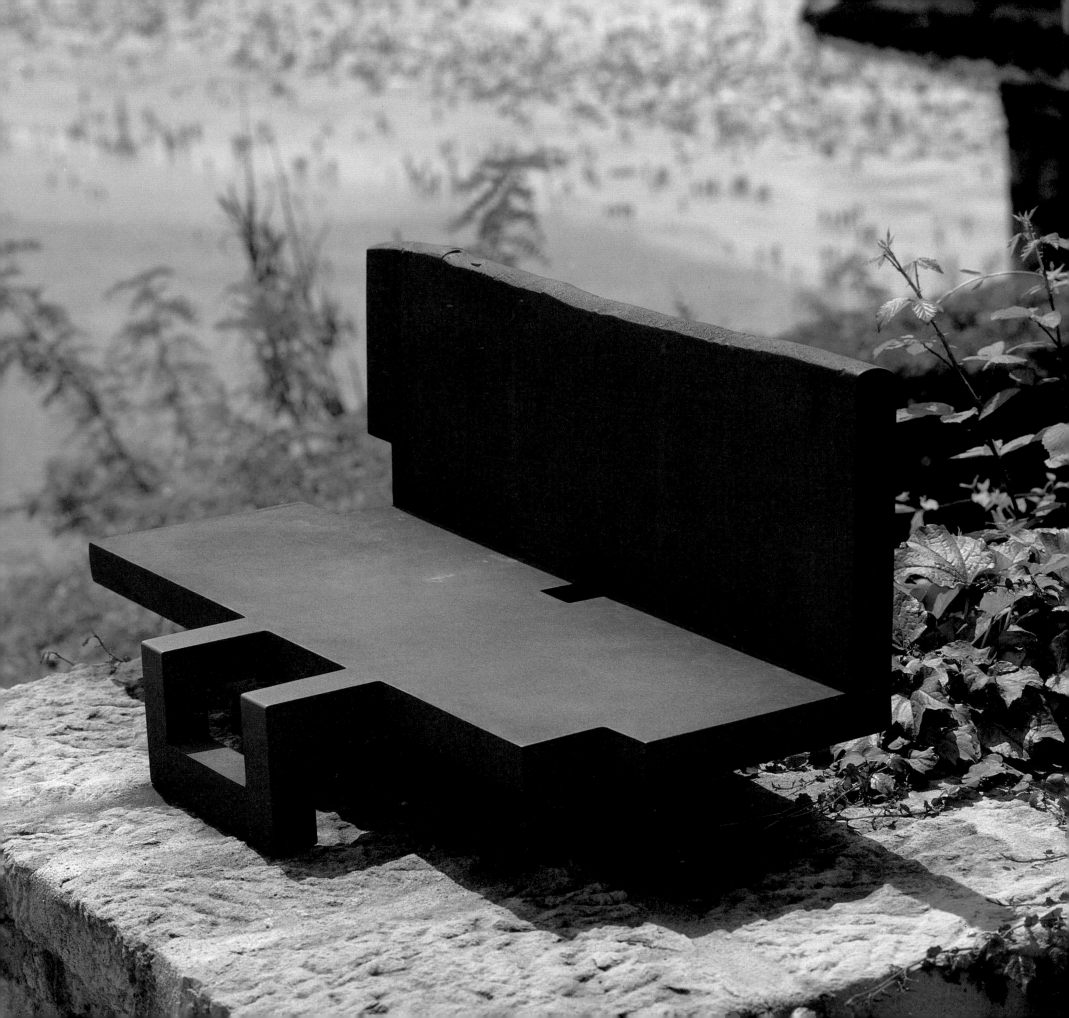

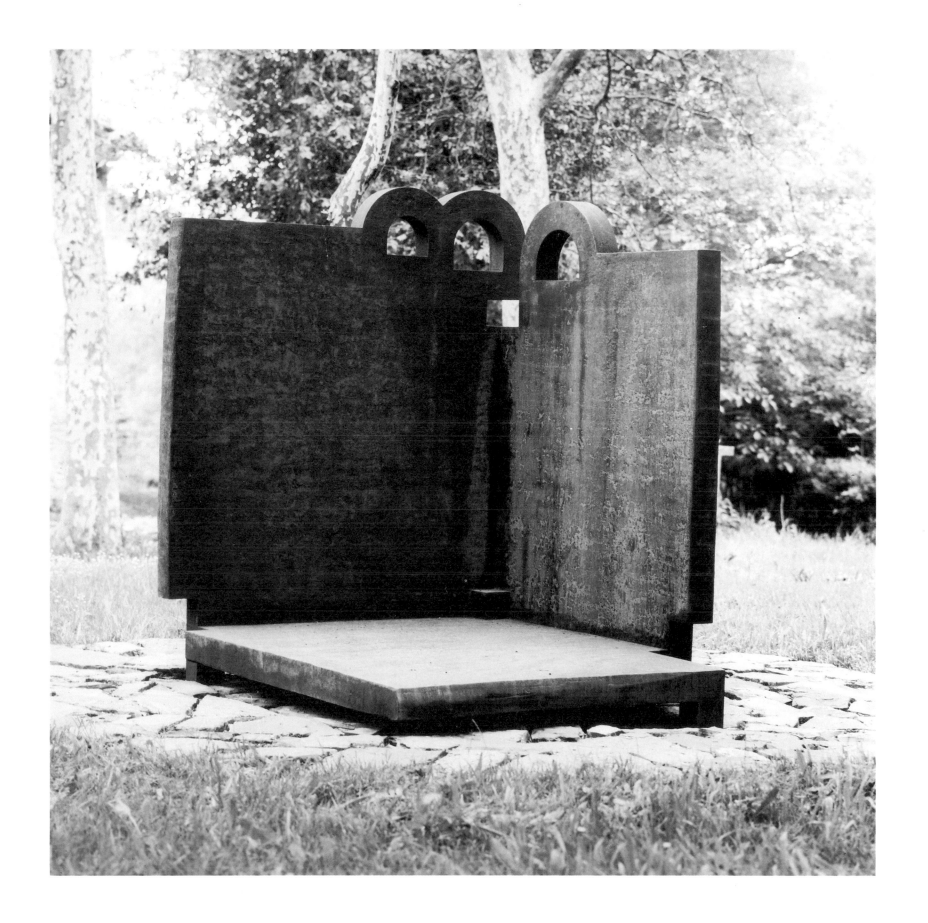

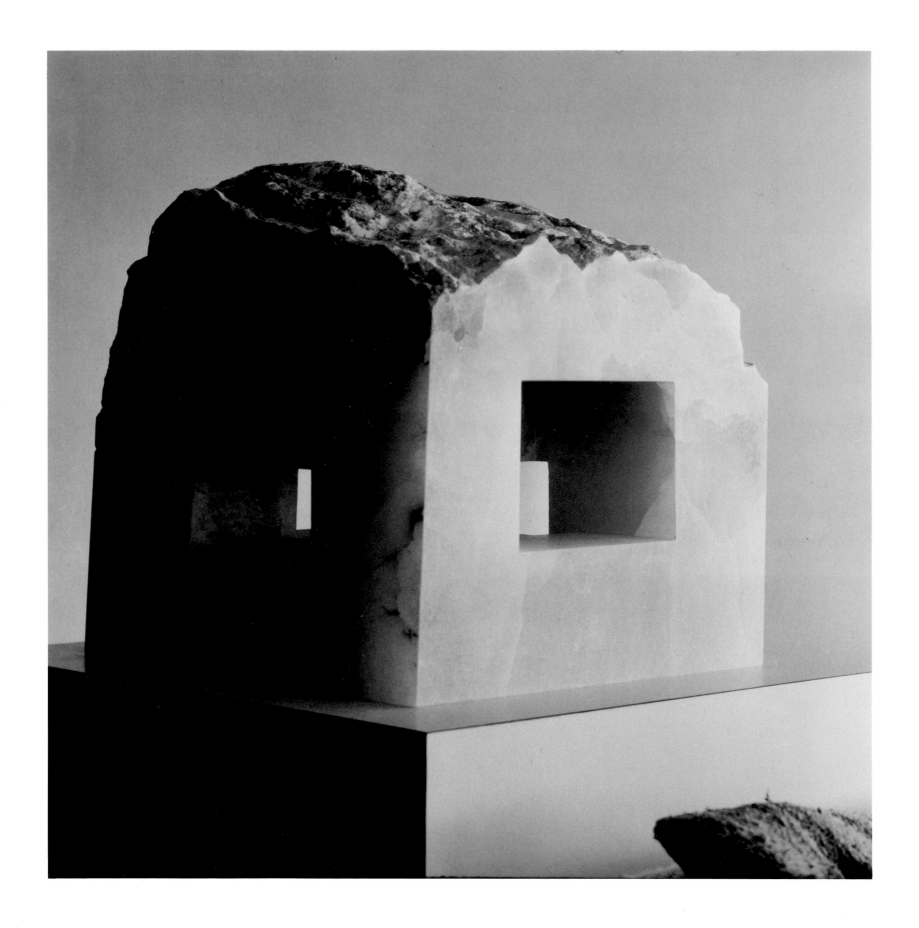

Chronology

1924
Born January 10, San Sebastián, the capital of Gipuzkoa Province, in the Basque country.
Lives with his parents and two brothers, Gonzalo and Ignacio, next door to the Hotel Biarritz, which belongs to his grandparents.

1930–42
Studies in a classical high school.
Is goalkeeper for the town soccer club, the Real Sociedad.
In 1936 spends three months in France.

1943–46
Studies architecture at the Colegio Mayor Jiménez de Cisneros in Madrid.

1947
Leaves architecture, studies drawing at a private academy, and begins to sculpt.

1948
Moves to Paris and settles in the Spanish House at the Cité Universitaire.

Models the human figure in plaster and completes a clay sculpture, *Thinker*. Meets the Spanish painter Pablo Palazuelo, who also comes to live at the Cité Universitaire.

1949
Bernard Dorival, curator of the Musée d'Art Moderne, invites Chillida and Palazuelo to exhibit at the Salon de Mai. Chillida shows his first two works: *Form* and *Thinker*.

1950
Exhibits a second time at the Salon de Mai.
Returns to San Sebastián to marry Pili Belzunce, who is of French Basque origin.
The Chillidas move to Villaines-sous-Bois in France. Palazuelo rents a studio next door.
Louis-Gabriel Clayeux, director of the Galerie Maeght, selects two of Chillida's plaster sculptures, *Torso* and *Metamorphosis* (his first abstract sculpture), for inclusion in "Les Mains Eblouies," an exhibition of work by 23 young artists.

1951

Pili and Eduardo return to San Sebastián for the birth of their first child, a daughter, Guiomar.

They settle in Hernani (Gipuzkoa Province). With the help of the village blacksmith, executes his first abstract in iron, *Ilarik* (*Funeral Stele*). Afterward installs a forge at his home with the help of his friend José Cruz Iturbe.

1954

Admiring Chillida's work of the past three years at Hernani, Palazuelo suggests to Tomás Seral, director of the Galería Clan, in Madrid, that he show Chillida's work. The one-man show opens April 19 and includes 13 sculptures, engraved slates, drawings, and collages.

The architect Ramón Vásquez Molezún, who directs the Spanish Pavilion at the Milan Triennale, invites Chillida to exhibit 10 sculptures; he receives the Diploma of Honor.

Arnold Rüdlinger, director of the Kunsthalle of Bern, asks Chillida to participate in an exhibition he is organizing entitled "Eisenplastik."

The Franciscan monks of Arantzazu (Gipuzkoa Province) commission four doors for their basilica, which Chillida executes in flat iron relief.

In Paris exhibits with 15 other sculptors at the "Premier Salon de la Sculpture Abstraite," organized by Denise René.

The Solomon R. Guggenheim Museum, in New York, acquires *From Within*.

1955

The city of San Sebastián commissions Chillida to do a monument in memory of Sir Alexander Fleming, which he creates in stone for the Ategoprieta Garden.

1956

First major one-man show, at the Galerie Maeght in Paris; exhibits 27 sculptures.

1958

Exhibits 12 sculptures in the Spanish Pavilion at the Venice Biennale; receives the International Grand Prize for Sculpture.

Travels to Chicago to receive the Graham Foundation Prize and open the accompanying exhibition.

Exhibits at the Pittsburgh International at the Carnegie Institute, which acquires the sculpture *Aizian* (*In the Wind*).

Travels to New York for exhibition at the Guggenheim Museum. Meets Edgard Varèse.

1959

Experiments with wood and begins *Abesti Gogora IV* (*Rough Chant IV*, completed in 1964), acquired by the Museo de Arte Abstracto Español in Cuenca.

Moves to San Sebastián with Pili and their five children: Guiomar, Pedro, Ignacio, Carmen, and Susana.

Continues work in wood on the series *Abesti Gogora* and for the first time works in steel, on *Rumor of Limits IV*.

1960

Nina Kandinsky gives Chillida the Kandinsky Prize, awarded to a young artist in memory of her husband.

1961

Completes monumental wood sculpture *Abesti Gogora I* for The Museum of Fine Arts, Houston.

Exhibits 23 sculptures, drawings, and engravings at the Galerie Maeght, Paris. After seeing the exhibition, Georges Braque asks Chillida for *The Anvil of Dreams II* and gives him a painting in exchange.

Participates in a group exhibit organized by Fernando Chueco Goitia, director of the Museo Español de Arte Contemporáneo in Madrid.

165. Chillida being congratulated by President Giovanni Gronchi of Italy on winning the International Grand Prize for Sculpture at the Venice Biennale of 1958

166. Aimé Maeght, Alberto Giacometti, and Chillida, Saint-Paul-de-Vence, 1958

167. Opening of the Fondation Maeght, Saint-Paul-de-Vence, July 28, 1964. Sitting: far left, Pablo Palazuelo; fifth and sixth from left, Josep Lluis Sert and Adrien Maeght; fifth and sixth from right, Joan Miró and Pili Chillida; far right, Pierre Tal Coat. Standing: from left, Jacques Dupin, Aimé Maeght, Alberto Giacometti, Marguerite Maeght; far right, Chillida and Pilar Miró

168. Kenneth Armitage, Roland Penrose, and Chillida, at the opening of Chillida's exhibition at the McRoberts and Tunnard Gallery, London, 1965

1962
Arnold Rüdlinger organizes two simultaneous exhibitions at the Kunsthalle in Basel, one for Rothko and one for Chillida. Chillida exhibits 32 sculptures. Receives the Providence (Rhode Island) Art Club Prize for *Articulated Reverie* (*Homage to Bachelard*).

1963
Travels in the Mediterranean, first to Greece, then to Rome especially to view works by Medardo Rosso, and to Saint-Paul-de-Vence, where he visits the future Fondation Marguerite et Aimé Maeght, being constructed by his friend the architect Josep Lluis Sert.

1964
Exhibits 2 large wood and 10 iron sculptures at the Galerie Maeght, Paris.

Receives the Carnegie Prize for Sculpture at the Pittsburgh International.

1965
Works in alabaster on the *In Praise of Light* series.
Exhibits in London at the McRoberts and Tunnard Gallery.

1966
Illustrates *Le Chemin des Devins,* by the poet André Frenaud.
Gerhard Händler, director of the Wilhelm-Lehmbruck-Museum in Duisburg, invites Chillida to exhibit 38 sculptures as well as collages and drawings. Receives the first Wilhelm-Lehmbruck Prize.
Receives the Nordrhein-Westfalen Prize awarded by Düsseldorf.
Works in a granite quarry at Budiño in **175**

169. James Johnson Sweeney and Pili Chillida, Houston, 1966

170. Nina Kandinsky and Chillida at the Fondation Maeght, Saint-Paul-de-Vence, 1966

Galicia with the help of Nicanor Carballo, sculpting a large three-piece work entitled *Abesti Gogora V*. Under the direction of Pili Chillida, this monumental piece is installed in the gardens of The Museum of Fine Arts, Houston, as part of Chillida's first U.S. retrospective exhibition, organized by James Johnson Sweeney. Exhibit travels to several other American museums.

1967
Exhibits at the Fondation Maeght in an exhibition organized by François Wehrlin entitled "Dix Ans d'Art Vivant 1955–1965."

1968
Participates in a show organized by Knud Jenssen at the Louisiana Museum in Denmark.
Exhibits several works at "Documenta 4" in Kassel, including *Around the Void IV*, now in the Kunstmuseum in Basel.
Exhibits at the Galerie Maeght, Paris.
Exhibits sculptures, drawings, and collages at the Galerie im Erker in Saint-Gall on the occasion of the publication of Max Holzer's book *Meditation in Kastilien*, illustrated with six of Chillida's lithographs. Meets Martin Heidegger here.
The steel sculpture *Wind Comb IV* is installed at the new UNESCO buildings in Paris.

1969
A year of retrospectives in Europe: in Basel, Franz Meyer organizes an exhibit of drawings and collages at the Kunstmuseum; in Zurich, Dr. René Wehrli assembles numerous sculptures, drawings, and collages at the Kunsthaus; this exhibit is repeated by E. E. L. de Wilde at the Stedelijk Museum, in Amsterdam; in Munich, two exhibits—drawings and collages at the Neue Pinakothek and recent engravings at the Galerie Buchholz.

In October meets Martin Heidegger again in Saint-Gall on the occasion of the publication of his book *Die Kunst und der Raum*, illustrated with Chillida's lithocollages.

1970
Installs a stainless-steel sculpture, *Around the Void V*, in the interior courtyard of the World Bank Building, Washington, D.C.
Presents the Golf Club of San Sebastián with a steel sculpture, *Homage to Rafael Elosegui*, in memory of his friend.
Exhibits works in alabaster, granite, and marble, along with 57 drawings and collages, at the Galerie Maeght, Paris.
Exhibits alabasters, drawings, and collages at Hanna Bekker vom Rath's gallery in Frankfurt.
Receives the Wellington Prize for Sculpture in Madrid.

1971
Accepts a visiting professorship for four months at the Carpenter Center for the Visual Arts, Harvard University. Here he meets the poet Jorge Guillén, who is living in Cambridge. Makes wood engravings to illustrate Guillén's poem *Más Allá*, published by Maeght in 1973.
On the occasion of its centennial, the Thyssen Company offers the city of Düsseldorf a large steel sculpture by Chillida, which he executes at Thyssen's steel works. *Monument* is installed in front of the new Thyssen building.
Mounts a one-man show at the Sala Gaspar in Barcelona.
With his friend the architect José Antonio Fernández Ordóñez, he studies methods for producing a large sculpture in concrete and begins work on *Meeting Place III*.
Receives the Crítica del Arte prize in Barcelona.
Is awarded the Encomienda de la Ciudad in San Sebastián.

172. Martin Heidegger, Chillida, and Franz Larese at the Galerie im Erker, Saint-Gall, October 1969

173. Chillida and Max Bill, Saint-Gall, 1980

opposite: 171. Alexander Calder and Chillida at the Fondation Maeght, Saint-Paul-de-Vence, 1969

1972

Completes the six-ton concrete sculpture *Meeting Place III* (installed in 1978 in Madrid).

The city of Lund invites him to the unveiling of his sculpture *Peace Field*, commissioned in 1969 and produced in black granite by Swedish artists in Karkshamm under the artist's supervision.

Erwin Treu, director, organizes the first retrospective of engravings and books by Chillida, in the Ulmer Museum.

One-man show at the Galería Iolas-Velasco, in Madrid, the first in the capital since 1954.

Receives the Engraving Prize of the International Exhibition at Rijeka, Yugoslavia.

1973

Three exhibits—of sculptures, collages, and engravings—take place in the Basque country in Pamplona, Sangüesa, and Estella.

During a stay at the Fondation Maeght, Chillida, instructed by the ceramist Joan Gardy Artigas, begins to produce sculptures in terracotta.

Receives the Engraving Prize of the International Biennale in Ljubljana, Yugoslavia.

Receives La Taula (The Table) Award of Barcelona from Josep Lluis Sert.

1974

Completes a second concrete sculpture, weighing fifteen tons, *Meeting Place IV*.

Exhibits sculptures and engravings at the Hastings Gallery of the Spanish Institute, New York.

Shows at the Galería Juana de Aizpuru, Seville.

Exhibits alabasters, collages, and prints at the Galerie d'Art Moderne in Basel.

In Milan receives the Premio Internazionale Diano Marino for his illustration of Jorge Guillén's book *Más Allá*.

Fundación Juan March, Madrid, commissions a large concrete sculpture, *Meeting Place V*.

1975

In San Sebastián receives the Rembrandt Prize from the Goethe Foundation.

Creates and donates an alabaster sculpture, *Gurutz* (*Cross*), to the Church of Santa María in San Sebastián.

At the request of the city of Vitoria-Gasteiz (Álava Province), Chillida draws plans for a large square in collaboration with the architect Luis Peña Ganchegui.

1976

Exhibits a concrete sculpture, *Leku III* (*Place III*), at the Basel Fair.

Receives first prize, awarded by the Japanese Ministry of Foreign Affairs, at the Tenth Biennale Exhibition of Prints in Tokyo for the etching *Euzkadi IV* (*Basque IV*).

1977

Retrospective graphic work exhibition at the Galería Iolas-Velasco, Madrid, and later at the city museum in Durango and in Pamplona; and then at the Carpenter Center for the Visual Arts, Harvard University.

At the FIAC, Paris, exhibits four large steles made of steel—*Gudari* (*Warrior*), *Homage to Neruda*, *Homage to Allende*, and *Homage to Millares*—as well as three alabasters.

In September a public space is opened in San Sebastián where three steel sculptures, *Wind Combs*, are attached to rocks at the mouth of the Bay of Biscay.

Completes several pieces in terracotta at the Fondation Maeght with the assistance of the ceramist Hans Spinner. Exhibits small steles, alabasters, and

174. Chillida, Saint-Paul-de-Vence, 1980

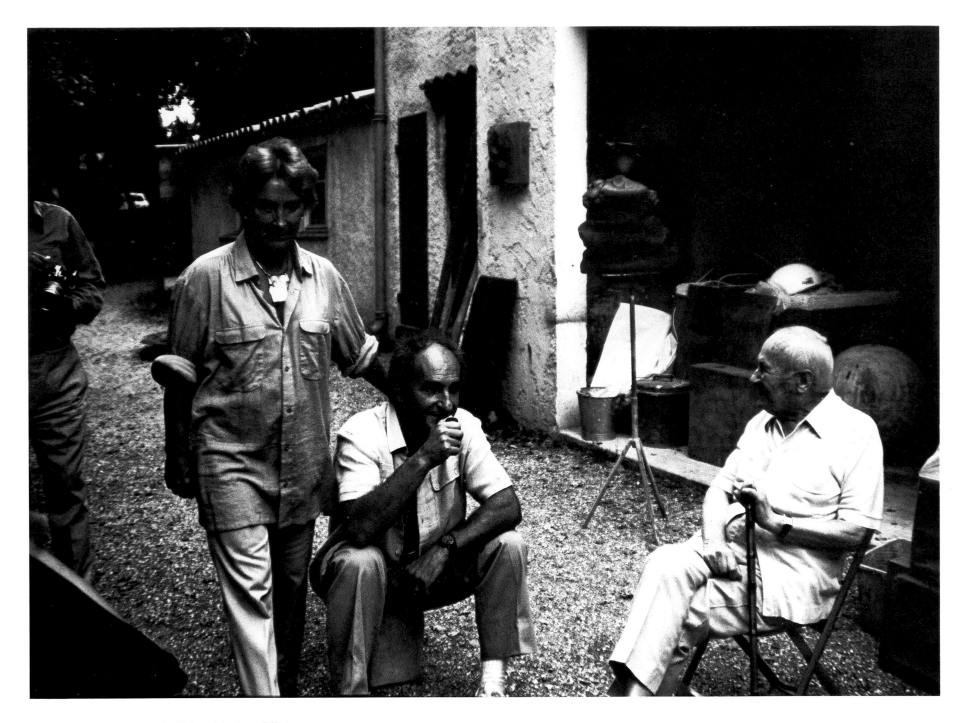

175. Pili and Eduardo Chillida with Joan Miró
at the Ceramic Atelier at the Fondation
Maeght, Saint-Paul-de-Vence, 1980

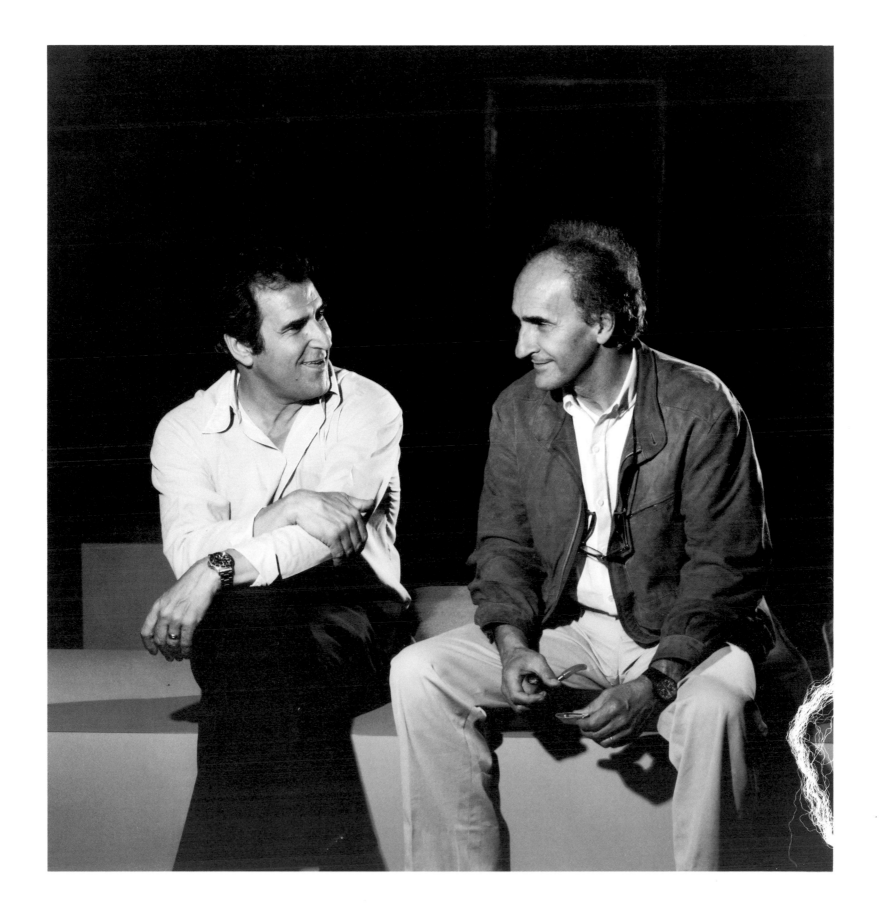

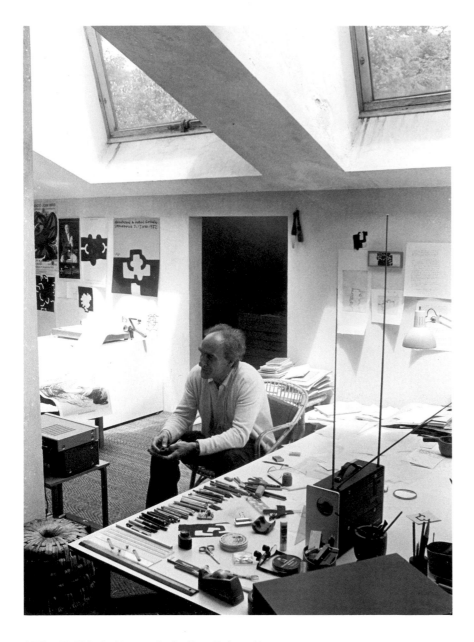

178. Chillida in his studio in San Sebastián,
1984

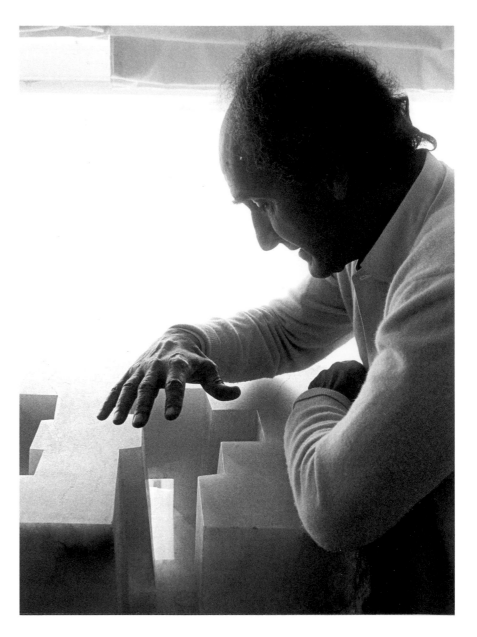

179. Chillida with *Homage to Goethe V*, Saint-
Gall, 1985

One-Person Exhibitions, with Selected Catalogues

Entries followed by an asterisk (*) were also published in *Derrière le Miroir*.

1954 Madrid, Galería Clan. *Eduardo Chillida*. Preface by Bernard Dorival.

1956 Paris, Galerie Maeght. *Chillida*. Text by Gaston Bachelard, "Le Cosmos du Fer."*

1961 Paris, Galerie Maeght. *Chillida*. Preface by James Johnson Sweeney.

1962 Basel, Kunsthalle. Foreword by Franz Meyer.

1964 Paris, Galerie Maeght. Preface by Carola Giedion-Welcker.

1965 London, McRoberts and Tunnard Gallery. *Chillida*. Preface by Roland Penrose, "Enclume de Rêves."

1966 Paris, Galerie Adrien Maeght. Text by André Frenaud.

1966 Houston, The Museum of Fine Arts. *Eduardo Chillida*. Foreword by James Johnson Sweeney.

1966 Duisburg, West Germany, Wilhelm-Lehmbruck-Museum. Preface by Gerhard Händler, "Einführung."

1966 Munich, Galerie Buchholz. *Eduardo Chillida*. Preface by Ernst Wuthenow.

1967 Düsseldorf, Galerie Alex Vomel. Preface by Werner Schmalenbach.

1967 Stockholm, Konstalongen Samlaren.

1967 Utica, New York, Munson-Williams-Proctor Institute.

1967 Saint Louis, City Art Museum.

1968 Paris, Galerie Maeght. Preface by Juan Daniel Fullaondo.*

1968 Saint-Gall, Switzerland. Galerie im Erker. Text by Max Holzer.

1969 Basel, Kupferstichkabinett, Kunstmuseum. Preface by Dieter Koepplin.

1969 Zurich, Kunsthaus. Preface by Carola Giedion-Welcker.

1969 Saint-Gall, Switzerland, Galerie im Erker. Text by Martin Heidegger.

1969 Munich, Neue Pinakothek (Haus der Kunst).

1969 Munich, Galerie Buchholz.

1969 Amsterdam, Stedelijk Museum. Preface by E. L. L. de Wilde and foreword by Carola Giedion-Welcker.

1969 Munich, Der Galerie Verein.

1970 Zurich, Galerie Renée Ziegler.

1970 Paris, Galerie Maeght. Preface by Franz Meyer.

1970 Paris, Librairie La Hune. Text by Martin Heidegger.

1970 Frankfurt, Kunstkabinett. Foreword by Hanna Bekker vom Rath and Ernst Wuthenow.

1971 Barcelona, Sala Gaspar.

1972 Lund, Sweden, Kunsthall.

1972 Basel, Kunsthalle. Preface by Franz Meyer.

1972 Madrid, Galería Iolas-Velasco. Prologue by Jacques Dupin, "Retorno al Vacío."

1972 Ulm, West Germany, Ulmer Museum. Foreword by Erwin Treu.

1973 Hamburg, Galerie Wunsche.

1973 Pamplona, Basque Country, Caja de Ahorros. Preface by J. M. Moreno Galván and Santiago Amón.

1973 Sangüesa, Basque Country, Caja de Ahorros.

1973 Estella, Basque Country, Caja de Ahorros.

1973 Paris, Galerie Maeght. Preface by Gabriel Celaya.

1974 Ratilly, France, Château de Ratilly.

1974 Barcelona, Galería 42. Prologue by Franz Meyer.

1974 Seville, Galería Juana de Aizpuru.

1974 Madrid, Galería Turner. *Eduardo Chillida—Martin Heidegger— Jorge Guillén.* Prologue by Santiago Amón.

1974 Basel, Galerie d'Art Moderne. Preface by Suzanne Feigel.

1974 Morbio Inferiore, Sweden, La Galerie d'Art Serfontana.

1974 New York, Hastings Gallery, Spanish Institute.

1975 Madrid, Galería Internacional de Arte.

1975 Neuchâtel, Galerie Numaga.

1975 The Hague, Galerie Nouvelles Images. Preface by Rudolf W. D. Oxenaar.

1976 Hellerup, Sweden, Gentofte Kommunes Kunstbibliotek. Preface by Steingrim Laursen.

1977 Madrid, Galería Iolas-Velasco. Text by Gabriel Aresti.

1977 Cambridge, Massachusetts, Carpenter Center for the Visual Arts, Harvard University.

1977 Durango, Basque Country, Museo de Durango.

1977 Pamplona, Basque Country, Caja de Ahorros.

1977 Paris, Grand Palais, FIAC (Galerie Maeght).

1977 Munich, Galerie Art in Progress.

1978 Baden-Baden, West Germany, Staatliche Kunsthalle. Foreword by Ingrid Jenderko.

1978 Düsseldorf, Galerie Schmela.

1978 Zurich, Galerie Maeght. *Chillida*. Preface by Jacques Dupin, "Wiederholungen um die Leere."

1979 Los Angeles, Landau-Alexander Gallery.

1979 Washington, D.C., National Gallery.

1979 Pittsburgh, Museum of Art, Carnegie Institute; New York, The Solomon R. Guggenheim Museum. *Chillida*. Text by Octavio Paz, "Chillida: From iron to light." 1980: Madrid, Palacio de Cristal, Parque del Retiro; 1981: Zurich, Galerie Maeght.

1980 Paris, Galerie Maeght. Preface by Bernard Noël with technical notes by Hans Spinner, "Ajours de Terre."*

1980 Barcelona, Galería Maeght. Preface by Santiago Amón, "La Unidad de la Obra de Chillida."

1981 Bilbao, Museo de Bellas Artes. Preface by Gabriel Celaya

1981 Atlanta, Frances Aronson Gallery.

1981 Hanover, Kestner Gesellschaft. Foreword by Carl Haenlein and Helmut Schneider.

1981 Hanover, Galerie Marghescu.

1981 Frankfurt, Galerie Hans Ostertag.

1982 Basel, Galerie Beyeler. Preface by Franz Meyer, "Chillida— Skulptur als Handlungsform."

1982 Zurich, Galerie Maeght Lelong.

1983 Saint-Gall, Switzerland, Galerie im Erker. Text by E. M. Cioran.

1983 León, Spain, Galería Maese Nicolás.

1983 Bordeaux, France, Casa de Goya.

1983 Frankfurt, Galerie Herbert Meyer-Ellinger.

1983 Chicago, International Art Exposition.

1984 Legazpia, Basque Country, Casa Etxea.

1984 New York, Mary-Anne Martin/Fine Art; La Jolla, California, Tasende Gallery. Text by Reinhold Hohl, "Two-Dimensional Space: The Graphic Art of Eduardo Chillida."

1984 Helsinki, Galerie Kaj Forsblom. Text by Jacques Dupin, "Répétitions autour du vide."

1984 Hanover, Galerie Brusberg.

1984 Turku, Finland, Galerie Grafiart.

1985 Chicago, Chicago International Art Exposition (Tasende Gallery).

1985 La Jolla, California, Tasende Gallery. Text by Leon A. Arkus.

1985 Arles, France, Abadie de Mont Majour.

Works in Public Collections

Alicante, Spain, Colección de Arte
Siglo XX
 Project for a Monument, 1970

Basel, Kunstmuseum
 The Anvil of Dreams X, 1962
 Around the Void IV, 1968
 The Silent Music I, 1955

Berlin, Nationalgalerie
 Gudari (Warrior), 1974—75

Bern, Hermann und Margrit Rupf-Stif-
tung, Kunstmuseum
 Iru Zulo (Three Holes), 1973—74

Bilbao, Museo de Bellas Artes
 Around the Void I, 1964
 Lurra (Earth), 1982
 Meeting Place IV, 1973—74
 The Poet's House, 1980—81
 Torso, 1950—56
 Zuhaitz IV (Tree IV), 1954—78

Chicago, The Art Institute of Chicago
 Abesti Gogora III (Rough Chant III),
 1962—64
 Around the Void II, 1965

Cuenca, Spain, Museo de Arte

Abstracto Español
 Abesti Gogora IV (Rough Chant IV),
 1964

Duisburg, Wilhelm-Lehmbruck-Museum
 Modulation of Space II, 1963

Frankfurt, Städelsches Kunstinstitut
 The Anvil of Dreams VII, 1954—59

Houston, The Museum of Fine Arts
 Abesti Gogora I (Rough Chant I),
 1960—61
 Abesti Gogora V (Rough Chant V),
 1966

Høvikodden, Norway, Sonja Henies og
Niels Onstads Stiftelser
 Relief, 1965—70

La Jolla, La Jolla Museum of Contempo-
rary Art
 Euzkadi V, 1976

London, The Tate Gallery
 Modulation of Space I, 1963

Madrid, Museo Español de Arte
Contemporáneo
 Spirit of the Birds I, 1952
 Wind Comb I, 1952—53

Mannheim, Städtische Kunsthalle
In Praise of Architecture III, 1972

Mexico City, Museo Rufino Tamayo
The Anvil of Dreams I, 1954–58
Relief, 1951

New York, The Solomon R. Guggenheim Museum
From Within, 1953
Iru Burni (Three Irons), 1966

Pittsburgh, Museum of Art, Carnegie Institute
Aizian (In the Wind), 1958

Rome, Collezione d'Arte Contemporanea, Musei Vaticani
Project for a Monument, 1969

Rome, Galleria Nazionale d'Arte Moderna
Gesture, 1957

Saint Louis, Gallery of Art, Washington University

Rumor of Limits IV, 1959

Saint-Paul-de-Vence, Fondation Marguerite et Aimé Maeght
Form, 1950
Torso, 1950

Stuttgart, Staatsgalerie
Vibration I, 1955

Turin, Galleria d'Arte Moderna
In Praise of Fire, 1955

Utica, Munson-Williams-Proctor Institute
The Anvil of Dreams XI, 1962

Washington, D.C., Hirshhorn Museum and Sculpture Garden, Smithsonian Institution
Tximista (Lightning), 1957

Zurich, Kunsthaus
The Anvil of Dreams IX, 1954–59
From the Edge, 1957

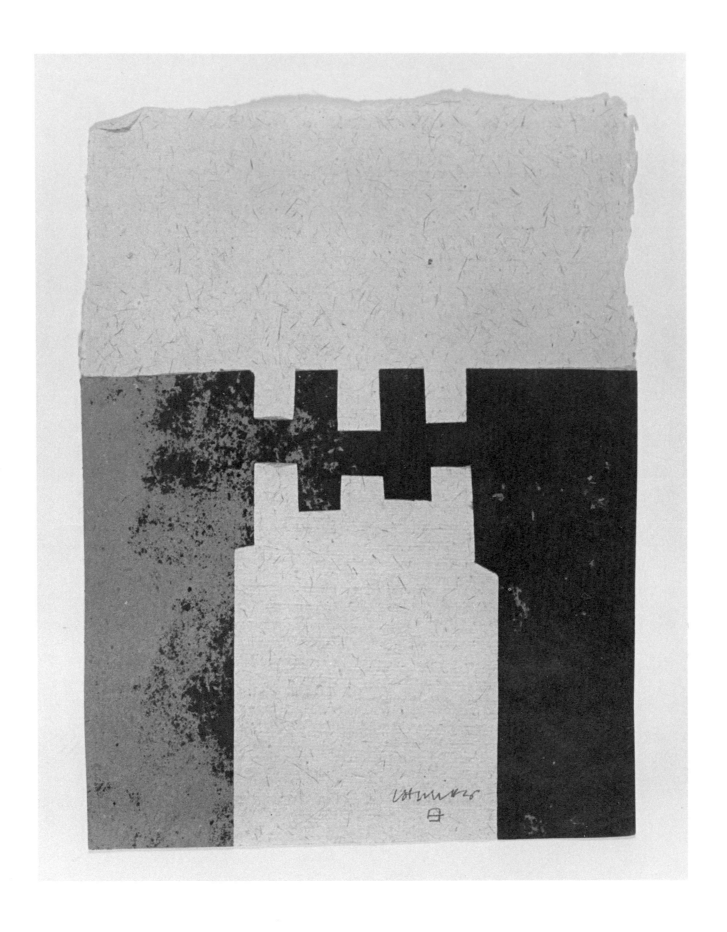

Bibliography

Selected Articles by Chillida

"2012 Auvernier." Exhibition catalogue, Galerie Numaga, Neuchâtel, Switzerland, 1975.

"Julio Gonzalez." Exhibition catalogue, Galería Turner, Madrid, 1974.

"Miró." Exhibition catalogue, Galería Theo, Madrid, 1978.

"Notebook Pages." Pittsburgh: The Museum of Art, Carnegie Institute; New York: The Solomon R. Guggenheim Museum; Paris: Maeght Editeur, 1979.

"Obra Gráfica—Eduardo Chillida." Exhibition catalogue, Sala Celini, Madrid, 1984.

"Tàpies." Exhibition catalogue, Museo Municipal de San Telmo, San Sebastián, 1984.

"Thoughts." Exhibition catalogue, Casa de Goya, Bordeaux, 1983.

Works Illustrated by Chillida

Cioran, E. M. *Ce Maudit Moi.* Saint-Gall: Erker-Presse, 1983.

Derrière le Miroir: Poètes—Peintres—Sculpteurs, no. 119. Paris: Maeght Editeur, 1960.

Derrière le Miroir: Chillida, no. 143. "La Poésie de l'espace chez Chillida," by Carola Giedion-Welcker. Paris: Maeght Editeur, 1964.

Derrière le Miroir: Hommage à Georges Braque, nos. 144–46. Paris: Maeght Editeur, 1964.

Derrière le Miroir: Chillida. "Lieu de rencontre," by Gabriel Celaya, and "La Lévitation de la masse ou la sculpture de Chillida," by Santiago Amón. Paris: Maeght Editeur, 1973.

Durango, Carmen. *Voz Acorde: Homenaje a Jorge Guillén.* Valladolid: Carmen Durango, 1982.

opposite: 180. Design for Poster. 1982. Collage, 9½ × 7 in. (0.24 × 0.18 m.). Collection Robert Vogel, Chicago

Frenaud, André. *Le Chemin des Devins*. Paris: Maeght Editeur, 1966.

Guillén, Jorge. *Más Allá*. Translated by Claude Esteban. Paris: Maeght Editeur, 1973.

Heidegger, Martin. *Die Kunst und der Raum*. Saint-Gall: Erker-Presse, 1969.

Holzer, Max. *Meditation in Kastilien*. Saint-Gall: Erker-Presse, 1968.

Melgar, Alfredo. *Doce Reflexiones al Aguafuerte sobre Juan Carlos de Borbón*. Madrid: Alfredo Melgar, 1983.

Rilke, Rainer Maria. *The Notebooks of Malte Laurids Brigge*. Translated by Stephen Mitchell. New York: Limited Editions Press, 1985.

Ugalde, Martín de. *Hablando con Chillida, escultor vasco*. San Sebastián: Editorial Txertoa, 1975.

Volboudt, Pierre. *Chillida*. German edition: Translation by Wolfgang Pehnt. Stuttgart: Verlag Gerd Hatje, 1967; French edition: Paris: Maeght Editeur, 1967; Spanish edition: Translation by J. E. Cirlot. Barcelona: Editorial Gustavo Gili, 1967; Basque edition: Translation by Nemesio Etxaniz and Luis Mitxelena. 1967. Barcelona: Editorial Gustavo Gili, 1967.

Monographs on Chillida

Aresti, Gabriel. *Chillida—Obra Gráfica Completa*. Madrid: Galería Iolas-Velasco, 1977. French edition: Paris: Maeght Editeur, 1979.

Celaya, Gabriel. *Spaces of Chillida*. Barcelona: Ediciones Polígrafa, 1974.

Esteban, Claude. *Chillida*. Paris: Maeght Editeur, 1971.

Figuerola Ferretti, Luis. *Chillida*. Madrid: Servicio de Publicaciones del Ministerio de Educación y Ciencia, 1976.

Schmalenbach, Werner. *Eduardo Chillida Kunst—Hände-Formen*. Berlin: Propyläen Verlag, 1977.

Selz, Peter. *Chillida: Two Public Spaces in the Basque Country*. N.p.: Basque Government, Culture Department, 1985.

Treu, Erwin. *Eduardo Chillida—das Graphische Werk*. Ulm, West Germany: Ulmer Museum, 1973.

Selected Articles on Chillida

Alvard, Julien. "Chillida," *Cimaise*, no. 2, November–December 1956.

Alvarez, Federico. "Con Eduardo Chillida I," *Revista de Bellas Artes*, April 1982, pp. 37–44.

———. "Con Eduardo Chillida II," *Revista de Bellas Artes*, May 1982, pp. 53–59.

Amón, Santiago. "Martin Heidegger, Eduardo Chillida," *Nueva Forma*, no. 49, 1969.

———. "Materia Experiencia y Acontecimiento Natural, Conversación con Eduardo Chillida," *Revista de Occidente*, January 1976, pp. 44–55.

Applegate, J. "Paris: Chillida, Galerie Maeght," *Art International* 14 (1970), p. 73.

Apollonio, Umbro. "Chillida et Tapies," *Siderexport*, no. 4, December 1962.

Arkus, Leon A. "Chillida," *Carnegie Magazine*, October 1979, pp. 3–11.

Ashbery, John. "Chillida and Others," *Art International*, May 1961.

Ashton, Dore. "Pittsburgh International," *Studio*, no. 168, December 1964.

Bacchi, Anna and Giorgio. "Understanding Space," *The Christian Science Monitor*, February 5, 1980, p. 20.

Bachelard, Gaston. "Chillida—El Cosmos del Hierro," *Revista de Occidente*, January 1976, pp. 24–27.

Benet, Juan. "Gravitación," *Guadalimar*, October 25, 1977, pp. 42–46.

Bulnes, Patricio. "Espacios sin Signos," *Revista de Occidente*, January 1976, pp. 40–43.

Castor Arines, José de. "Un Escultor: Chillida," *Informaciones*, April–May 1954.

Chabrun, Jean-François. "Matisse, Chillida," *L'Express*, March 30, 1961.

Chevalier, Denis. "Chillida un Moderne Vulcain," *Les Lettres Françaises*, no. 1260, October 4, 1968.

Christ, D. "Chillida und sein Windkamm," *Werk*, December 1969, pp. 850–55.

Cirici, Alexander. "Chillida Expresión de una Identitat Nacional," *Serra d'Or*, January 1981, pp. 47–50.

Cirlot, Juan Eduardo. "La Escultura de Eduardo Chillida," *Papeles de Son Armadans*, no. 43, October 1959.

Condon, Barnett. "Chillida," *Art News and Review*, no. 23, December 8, 1956.

Damsker, Matt. "Chillida Follows Own Artistic Path," *Los Angeles Times*, Part V, July 14, 1984, p. 1.

Degand, Léon. "Chillida," *Aujourd'hui*, November 1956.

Dienst, R. G. "Interview mit Eduardo Chillida," *Kunstwerk* 32, February 1979, pp. 3–11.

Dorival, Bernard. "Eduardo Chillida," *La Table Ronde*, November 1950.

Dupin, Jacques. "Répétitions autour du vide," *Art International* 23, September 4–5, 1979, pp. 109–12.

Esteban, Claude. "Sculptures de Chillida," *La Nouvelle Revue Française*, no. 194, 1969.

———. "Chillida," *Goya* 108, May 1972, p. 412.

Fernández Alba, Antonio. "La Mano—Como Huella del Hombre en los Tiempos Largos de la Historia," *Revista de Occidente*, January 1976, pp. 36–37.

Fernández Ordóñez, José A. "Las Esculturas de Hormigón de Chillida," *Revista de Occidente*, January 1976, pp. 38–39.

Figuerola Ferretti, Luis. "La Escultura de Eduardo Chillida," *Goya* 102, May 1971, pp. 393–98.

Frey, Peter. "Eduardo Chillida Plastiker und Patriot," *Tagesanzeiger*, December 1981, pp. 14–19.

Frigerio, Simone. "Chillida," *Aujourd'hui*, no. 31, May 1961.

Fullaondo, Juan Daniel. "Personalidad de Eduardo Chillida," *Nueva Forma*, no. 21, October 1967.

———. "El Laberinto en la Obra de Eduardo Chillida," *Nueva Forma*, no. 22, December 1967.

———. "Eduardo Chillida 1947–1968," *Nueva Forma*, no. 20, 1968.

———. "Chillida: Ein Spanischer Eisenplastiker im Zürcher Kunsthaus," *Tagesanzeiger*, March 15, 1969.

Gaya Nuño, Juan Antonio. "Chillida, Escultor en Hierro Caliente," *Insula*, no. 123, December 1957.

Giedion-Welcker, Carola. "Chillida," *Quadrum*, no. 20, 1966, pp. 43–58.

———. "Eduardo Chillida," *Du*, April 1969, pp. 276–89.

Giniger, Henry. "Hanging Sculpture Grounded in Madrid," *The New York Times*, August 1, 1972.

Gómez de León Contreras, J. "La Obra Bidimensional del Escultor Eduardo Chillida," *Goya* 163, 1981, pp. 28–34.

Guerrero Martín, José. "El Arte según Chillida," *La Vanguardia*, March 6, 1983, pp. 10–22.

Gullón, Ricardo. "Chillida," *Cuadernos Hispanoamericanos*, no. 85, January 1957.

Hanel, Berthold. "Dualität von Form und Raum," *Die Kunst*, March 19, 1983, pp. 171–73.

Harguindey, Angel. "Un Vasco Universal," *Semanal el País*, September 4, 1977, pp. 16–20.

Held, Jutta. "Zur Bestimmung zeitgenössischer Plastik durch Chillida und Heidegger," *Jahrbuch der Hamburger Kunstsammlungen* 20, 1975, pp. 103–26.

Hohl, Reinhold. "Two-Dimensional Space—The Graphic Art of Eduardo Chillida," *Pantheon* 23, no. 3, 1975, pp. 237–54.

Kramer, Hilton. "Sculpture: Eduardo Chillida in Houston," *The New York Times*, October 15, 1966.

Lemaine, Rolf. "Des Oeuvres de Giacometti, Chillida et César Décoreront le Cinquième Bâtiment de l'Unesco," *Le Figaro*, April 26, 1966.

Lonchamp, Pierre. "Chillida," *Arts PTT*, May 1981, pp. 41–45.

McNichols, Dinah. "The Disappearing Boundary," *Reader*, Section 2, July 19, 1984.

Marteau, Robert. "Chillida, Les Machines à Silences," *Galerie des Arts*, no. 61, December 15, 1968.

Martín Nogales, Virgilio. "La Plaza de los Fueros," *La Gaceta del Norte*, January 3, 1981, pp. 18–19.

Maugis, M. T. "Chillida, Müller, Gilioli, Les Sculpteurs Bougent," *Les Lettres Françaises*, May 14, 1964.

Mayor, Juan. "Los Hierros de Chillida," *Indice de Artes y Letras*, no. 99, March 1957.

Melquist, J. "Paris: Advances in Sculpture and Painting," *Apollo*, no. 75, May 1961.

Meyer, Franz. "Notes sur les Dessins d'Eduardo Chillida," *Derrière le Miroir*, no. 183. Paris: Maeght Editeur, 1970.

Mitxelena, K. "Eduardo Txillidari" (Basque text); Luis Michelena, "A Eduardo Chillida" (Spanish text), *Revista de Occidente*, January 1976, pp. 33–35.

Netter, Maria. "Der baskische Bildhauer Eduardo Chillida," *Werk*, no. 49, June 1962.

———. "Der baskische Eisenplastiker Chillida: Ein moderner Künstler von Weltrang," *Genossenschaft*, no. 49, December 6, 1969.

Peppiat, M. "Paris Letter," *Art International* 13, January 1969, p. 54.

Pérez Ferrero, Miguel. "Chillida o el Espíritu de los Vascos," *ABC*, May 10, 1964.

Petzel, H. W. "Graphische Blätter von Chillida," *Weltkunst*, no. 7, April 1, 1969.

Power, K. "Spain: Democracy in the Arts," *Arts Review* 29, July 1977, p. 478.

Prieto Barral, F. "Los Hierros de Chillida en Paris," *España*, no. 73, May 1961.

Puch, Joaquín. "Del Viento," *Guadalimar*, October 25, 1977, p. 50.

Ragon, Michel. "Chillida," *Cimaise*, nos. 88–89, 1968.

Restany, Pierre. "Un Janseniste Basque: Chillida," *Cimaise*, no. 60, July–August 1962.

Roberts, C. "L'Internationale de Pittsburgh au Carnegie," *Aujourd'hui*, no. 95.

Russell, John. "Two Men Share the Carnegie International," *The New York Times*, November 18, 1979, pp. 39–40.

Schmidt, Doris. "Häuser für das Licht, Kämme für den Wind," *Süddeutsche Zeitung*, April 25, 1981, p. 141.

Schneider, Helmut. "Der Plastiker und Zeichner Eduardo Chillida," *Die Zeit*, no. 10, March 3, 1978, p. 46.

Schwartz, Ellen. "Chillida's Silent Music, de Kooning's Eloquent Ambivalence," *Art News*, March 1980, pp. 68–70.

————. "Eduardo Chillida: 'I Sculpt for the World but My Roots Are in the Basque Country,' " *Art News*, March 1980, pp. 70–71.

Seldis, Henry J. "Letter from Houston," *Art International*, no. 10, December 1966.

Seuphor, Michael. "Homenaje a Chillida," *Goya*, March 1959.

Solier, René de. "Chillida," *La Nouvelle Revue Française*, August 1961.

Sottsass, Ettore, Jr. "Eduardo Chillida, Escultor," *Domus*, no. 300, May 1955.

Spencer, C. S. "Chillida Sculptor of Space," *Studio*, no. 169, June 1965.

Sweeney, James Johnson. "Eduardo Chillida," *Derrière le Miroir*, no. 124, Paris: Maeght Editeur, 1961.

————. "Eduardo Chillida, Sculptor," *The Texas Architect*, February 1967.

————. "Chillida Regaló el Peine del Viento a Donostia," *Txindoki*, no. 3, March 1967.

Torres Murillo. "Eduardo Chillida," *Revista Obras*, no. 98, 1962.

Trier, Eduard. "Bericht über Eduardo Chillida," *Kunstwerk*, December 1969, pp. 23, 34–47.

Ullán, J. M. "Ventana para Chillida," *Guadalimar*, October 25, 1977, p. 47.

Volboudt, Pierre. "Chillida," *XXe Siècle*, no. 8, January 1957.

————. "Espace Sacré, Espace Profane," *XXe Siècle*, no. 24, December 1964.

————. "Chillida autour du Vide," *XXe Siècle*, no. 32, 1969, pp. 57–64.

Winter, P. "Eduardo Chillidas Skulpturen," *Kunstwerk* 34 (1981), pp. 75–76.

Zharrats, J. J. "Artistas de Hoy: Eduardo Chillida," *Revista*, no. 33, 1958.

Film on Chillida

Bakedono, José J. *Chillida at Home: A Portrait*. Durango, 1985.

Selected Catalogues of Group Exhibitions

Houston, The Museum of Fine Arts. *Three Spaniards: Picasso, Miró, Chillida*. 1962.

London, The Tate Gallery. *Painting and Sculpture of a Decade 54–64*. 1964.

New York, The Museum of Modern Art. *New Spanish Painting and Sculpture.* 1960.

Pittsburgh, Museum of Art, Carnegie Institute. *The Pittsburgh International Exhibition of Contemporary Painting and Sculpture.* 1958.

Pittsburgh, Museum of Art, Carnegie Institute. *The Pittsburgh International Exhibition of Contemporary Painting and Sculpture.* 1961.

Pittsburgh, Museum of Art, Carnegie Institute. *The Pittsburgh International Exhibition of Contemporary Painting and Sculpture.* 1967.

Venice, Biennale. *La Nuova Scultura Spagnola.* 1960. Text by Vicente Aguilera Cerni.

Index

Photograph Credits